Jan Vermeer

MASTER ARTISTS LIBRARY

Series directed by
Antonio Paolucci

Copyright© 1998 by Octavo

This edition published in 1998 by SMITHMARK Publishers,
a division of U.S. Media Holdings, Inc.,
115 West 18th Street, New York, NY 10011.

SMITHMARK Books are available for bulk purchase for sales promotion and premium use.
For details write or call the manager of special sales,
SMITHMARK Publishers, 115 West 18th Street, New York, NY 10011.

Library of Congress Cataloging-In-Publication Data Is Available
ISBN: 0-7651-0863-1

Printed in Italy

10 9 8 7 6 5 4 3 2 1

Graphic design: Auro Lecci
Layout: Nina Peci
Prepress: Alfacolor, Bluprint
Printed by: Baioni Stampa

Jan Vermeer

Erik Larsen

SMITHMARK

Jan Vermeer van Delft

The "Golden Century" of Dutch art in the seventeenth century culminates in three artistic personalities: Rembrandt, Hals, and Vermeer. Rembrandt was the dreamer, the interpreter of deep humanity and profound psychological insight. His main concern was man in all his aspects, as well as his integration into a wider cosmos, of which earthly nature remained but one part. The tools by which he expressed himself—brush, pen, and burin—were only the means by which to attain depth, universality, and hence reaching greatness and sometimes even the sublime. One can sit in front of a Rembrandt canvas for hours, and at each instant, the master will convey new aspects and thoughts to the onlooker desirous to commune with the genius and receive through him never before thought-of impulses and inspiration.

Frans Hals was the complete opposite. Content, in his case, was of secondary importance. What counted was the execution, obtained by throwing upon the canvas a dazzling array of strokes that the artist coordinated into a whole of unheard-of surface brilliancy. His technique featured bravura, braggadocio in the expression, and swagger, especially in his earlier and middle periods. He becomes more inner-directed in his late portraits. Thus, Rembrandt thinks introspectively, and paints what one does not see. Hals exclusively and integrally represents the world as it appears to the eye. Both artists, however, thrill and affect with reflections of their very personal conceptions. Both impress upon the viewer the primacy of spirit over matter; and hence touch upon the hidden springs of genius.

Jan Vermeer van Delft stands out for none of these qualities. In spite of a spate of recent monographs devoted to him, the questions "why is Vermeer exceptional and what reason do we have to link him to immortality?" remain largely unanswered. The only author who has attempted to elucidate what constitutes Vermeer's claim to greatness and to come up with some satisfactory answers was not a learned art historian, but a painter.[1]

Let us therefore approach the "Sphinx of Delft," as Thoré-Bürger[2] dubbed the artist, from the two levels of art-historical cognition established by the late Hans Sedlmayr.[3] The first one contributes the data pertaining to the object, such as documents, provenance, size, state of preservation, and so forth. It also includes the study of the milieu that influenced the choice and manner of portraying the subject matter; and as an outcropping, iconography that is emblematic and elucidates the "hidden" content of the work. One can add to this preliminary inquiry comparisons of form and criticism of style. The real activity of understanding and exegesis begins, however, according to Sedlmayr, with the second level of approach. On this plane, all direct and indirect data are excluded, and the sole aim remains to perceive the work of art as an undivided whole. Or, in Sedlmayr's words, we attempt to look into its "inner laws." In medieval exegetical methodology, this means our search for the *sensus plenior* of its spiritual meaning. We reject the purely phenomenological approach based on "what the work itself shows," but also the current art-historical bent that almost exclusively relies upon the gathering of extraneous details that contribute to the construction of a mosaic, but fails to see the forest for the trees. In simple words: it

is both the artisanal and spiritual qualities, which make an artist a great master, as opposed to the myriad of honest craftsmen who labored in the field. A value judgment imposes itself from the outset, in order to draw the lines between genius, talent, and mediocrity.

Amateurs and art historians alike have always encountered difficulty explaining what the most striking aspects of Vermeer's art are and the essence of his genius. Certainly, it was not his inventiveness, although it may have been underestimated, as we are going to demonstrate. All recent monographs devoted to him abound with supplementary illustrations tending to document the sources for his compositions, or similarities with those of his contemporaries, the "fine painters" of the period. Nor do his paintings convey any message to the spectator. None of the spirituality of a Rembrandt is evident, nor the *paillardise* inherent to Hals's characters. Writers and aestheticians are incapable of defining the impress of the artist's conception upon the eye as well as the intellect, although it undoubtedly exists. Gilles Aillaud speaks of the "purified atmosphere...in the literal chemical sense of the term, freed from the pollution of our overpopulated world." André Lhote speaks of "the difficulty to analyze an oeuvre that has no outstanding characteristic, that conceals its processes, in which an irreducible abstraction assumes always the outward show of necessity."

His themes are simple. They do not differ very much from those of his Dutch contemporaries from the same milieu—de Hooch, Jan Steen, G. Metsu, and many others. Interiors constitute the major part of the works that can be called his with reasonable certainty, that is, twenty-three paintings. Then there are two town views, one allegory (the *Allegory of Faith* at the Metropolitan Museum, New York), and the *Procuress* in Dresden—a rather bawdy composition and a dubious ascription, to boot.

There are thirty generally accepted paintings, and nine possible attributions that have survived. It must be added that we cannot trace a single painting directly back to the artist's studio. Thus, there applies with increased intensity Hulin de Loo's famous dictum: "the doubt begins at the moment when the painting leaves the hands of the artist." Given the length of Vermeer's career, and the fact that the first—though not certain—work by him is dated 1656, his complete output did not exceed fifty works (some of which are known to us from documents), or, about two paintings per year. This confirms what we know from tradition and annotations by contemporaries—namely, that Jan Vermeer worked exceedingly slowly and painstakingly.

Only a dozen of his works known to us, at the utmost, appear of prime excellence and in a satisfactory state of preservation. The extremely limited production of the artist is therefore further reduced and narrowed in scope on account of the unequal quality of the paintings with which we are now confronted. Nevertheless, there are incontestable common characteristics that emerge from a study of his oeuvre. What distinguishes Vermeer from his contemporaries is, according to one of his best connoisseurs, P. T. A. Swillens, the presence of four principal elements: light, color, stillness, silence. The first two elements are tied in with the technical execution.

The light in Vermeer's paintings is always sunlight—no artifices, such as torch or candlelight, or that of the moon. The artist has taken nothing from Caravaggio, and evinces no interest in chiaroscuro. Vermeer's canvases are filled with sunlight, and where he wants to indicate distance, he tempers the luminosity by weakening the intensity. His

shadows are never dark or half-dark, but indicated through a lowered scale of pigments, or, as Swillens puts it: "shadow is tempered light, or tempered light with reflected light. The light thrown back eliminates the darkness."

Thus, Vermeer's figures are never enveloped in penumbra, but stand out clearly and distinctly, not at any time presuming upon the spectator to supplement the artist's rendering by his own imagination. In some of his works, such as the *View of Delft*, the light is so hard— almost crude in its original state—that the modern public, professionals as well as laymen, deemed it inordinate. Thus, after cleaning, the painting was recovered with a slightly tinted varnish, the famous *Galerieton* of yore, to give the painting more warmth and attenuate its pitiless harshness, and render the pictorial impact more palatable to contemporary taste.

Light and shade constitute in Vermeer's paintings a whole, a unity. They are never sharply contrasting, but delicately and gradually modulating the passages of tone from the highs to the lows of the scale. Again, Swillens: "the color chords are threaded onto each other into a melody." Vermeer's light does not caress or envelop his figures. It is limpid, conveys the untaintedness of the *plein air*, and enables the viewer to contemplate the image as through a looking-glass featuring transparent, bright, and jewel-like colors. There is no tenderness, no thrill but inexorable cold beauty and reality.

He who says light, means also color. The palette of the Old Masters was relatively limited, considering the number of colors then available, owing to the improvements of modern chemistry. As far as the northern Low Countries were concerned, the first and basic research and scientific determinations are due to the great Dutch restorer Dr. A. Martin de Wild,[4] who obtained his academic degree at the Technical College of Delft. We find that the masters of the seventeenth century used only a dozen different pigments, and resorted to mixtures and admixtures to produce further variations. They eschewed certain known colors, such as green, for their own version, by mixing blue and yellow. The usage of pigments in Holland (to give the region its modern name) and Flanders differed slightly during the period under scrutiny. Rembrandt's and Rubens's palettes were not alike, but aside from various preferences, often due to the use of another painting medium, there was no major cleavage between them.

Some pigments were abandoned in certain periods, in favor of newly fashionable ones. This can help with the dating of paintings suspect of being, for example, eighteenth-century imitations. On the whole, we have for the period 1600–1700 four blues, one white, two yellows, two reds, three greens, and one black. Most of them had a mineral basis, such as the ochres and lapis lazuli; or they were metallic, such as lead white; or organic— the reds and blacks, constituting a minority.

Jan Vermeer stands out for favoring in the choice of his colors the complementaries blue and yellow, setting them off with red and black. He must have owed the predilection for this color combination to his contemporaries of the Utrecht school, or even to Asiatic references, as we shall see when discussing style. His white pigment must have been lead white, also called *ceruse*. It was not only used as a single color, but as an ingredient in his mixtures, and, of course, for putting in highlights.

According to the numerous books of recipes that have survived, the preparation of lead white differs only slightly from that used in our times. It has a strong covering capacity, and rapid siccity, which explains its eventual admixture to other pigments for the pur-

pose of speeding up the drying process. In 1779, zinc white was proposed as a color by Courtois of Dijon. Its use, however, did not become common until modern times, because of the long period of hardening when this color is admixed to linseed oil. The invention of siccatives marked the turning point for its steady appearance on the painter's palette, thus much later than the seventeenth century.

Among the blues, ultramarine, or natural outremer, as it was also often called, was the most beautiful but also the most expensive paint. Its price equaled that of gold. One had to extract it from lapis lazuli, of which ultramarine constitutes the coloring part. The process, which consists of separating the ultramarine from the limestone to which it is bound, is time consuming, tedious, and difficult.

In spite of repeated efforts to this effect, limestone and parts of the blue coloring tend to adhere to each other, and impede the obtainment of pure ultramarine, which alone possesses the depth and sparkle of the blue that we so much admire. Not entirely purified ultramarine varies from blue-gray to light blue-gray, and can be found in many Dutch pictures of the period. Artists who could not afford its price used azurite or smalt. Vermeer obviously painted with the most costly ultramarine, which must have added considerably to the intrinsic worth of his works. However, he was a perfectionist in this, as in his painting methods—of which more anon. The going price for this rare pigment in an unadulterated state was 60 guilders per quarter of a pound, much more than what many of his paintings fetched during his lifetime. A synthetic substitute, artificial outremer, was described in 1828 by Guimet of Toulouse, who received an official French award for this discovery. The coloring mass seems, however, to have been found accidentally in a soda kiln as early as 1814, although its properties as a coloring agent were not recognized at the time.

Vermeer's yellow, lemon-colored and of great intensity, must primarily have been massicot. This is a yellow oxide of lead, gently roasted. Originally orange until heating, it was used as an intermediate product in the manufacture of lead white, and subsequently became known and appreciated for its attractive shade. De Wild established its widespread use in Holland until the end of the seventeenth century. Its presence in the *Lacemaker*, at the Louvre, seems unquestionable.

Other possible sources for the artist's yellow pigments were ochres. These were earth or clay colors, found in many parts of Europe, and common enough so that we have little evidence of any organized trade in them. The normal yellow ochre stems from deposits of limonite and varies according to local origin in tint and opacity. Some of these clays also come in shades of brown and red. Their depth can be artificially enhanced through heating, and one thereby obtains the so-called burnt ochres. Umbers and siennas belong to the same family and are today still part of the artist's palette. It is possible that Vermeer also availed himself of this pigment, because it strikes us as "the diapason of yellow," as Daniel V. Thompson characterizes it.[5]

It certainly matches the Delft master's deep ultramarine in the desired effect of producing conspicuous oppositions. Together, the two combine to dominate the color gamut of his pictures. Another yellow in use during the seventeenth century in Holland was orpiment, a sulfide of arsenic, found in nature as a stone and imported into Europe chiefly from Asia Minor. It was not avoided by painters of old because it was a deadly poison, as Swillens asserts, but because one cannot mix it with either verdigris or lead white, without

its sulfur content attacking the other compounds. Cornelius Janssen condemned it roundly in the period, writing: "Orpiment will ly faire on any culler, except verdigris, but no culler can ly faire on him, he kills them all."

Red was the main counterpoint in Vermeer's palette, destined to complete and set off the blue-yellow color combination. Although a great choice of red colors is known in the literature, many names applied to one and the same paint. As far as the Dutch seventeenth century is concerned, the reds used belonged to two categories only:[6] vermilion and organic colors. Vermilion was derived from cinnabar, and the best deposits of the latter were located in Spain in classical times. These were pebbles found in the sand of the River Minium (today, Menjo) in Spain and constituted practically the only source for this color in the times of Pliny. Later, cinnabar was also found in other parts of Europe, but not every deposit yielded good pigments. The main attraction of cinnabar, which is a sulfide of mercury, was the synthesis of the latter. Mercury and sulfur were regarded in medieval alchemy as the parents of all metals. The separation of vermilion from cinnabar is a relatively simple process. One has only to heat the mercury in the presence of sulfur, mixed and ground together.

The outcome, black sulfide of mercury, recondenses at the proper temperature in the top of the retort and can be taken out and ground. Black at first, the vermilion slowly turns red. Repeated grinding enhances the depth of the color. "Know," says Cennino Cennini (ca. 1400), "that if you grind it for twenty years, the color would still become finer and more handsome." By the time that interests us here, the manufacture of vermilion had become common knowledge. Its normal shade varies from scarlet to a more violet cast, and because of its standard of intensity, it could only be matched on the painter's palette by equally brilliant blues, yellows, and greens. Hence, we can expect to find it among the gamut of colors employed by Vermeer.

Unfortunately, vermilion has a serious drawback. It can, unpredictably, turn black, because of internal molecular changes that alter the red sulfide of mercury to black. It was therefore often blended with minium, orange lead, to stabilize the color. Sometimes one added a little saffron, probably with the same intention, or in order to increase the warmth of the color. To obviate this serious inconvenience, the Dutch painters made use of reds stemming from organic materials, which were called "lakes" in a generic fashion. The most conspicuous of the paints, which also graced the palette of Pieter Paul Rubens, was carmine. It is higher in tint than vermilion, more like scarlet (of insect, cochineal, origin), and made into dye by means of a complex process. Whereas vermilion strikes deeper chords, carmine permits effects that are more vivid. At the time, the color was called "Florence lake" or "Haarlem lake."

Another common pigment at the time was madder lake. It was produced from the juice of the root of the madder plant, and its manufacture yielded a crimson coloring matter. The plant came originally from the Near East and Asia, but was acclimatized in the southern Holland islands. Its production rapidly rose to make it one of the most sought-after export articles of the republic. It was only in 1870, when a chemically obtained red replaced madder lake, that this Dutch quasi-monopoly ended.

As all organic red pigments have strong colors, they, as well as vermilion, are likely candidates for Vermeer's palette. Few green colors appear on de Wild's chronological table, especially after 1650. Terre verte is one of them. One generally regards it as an

ochre, but the name was applied to various minerals of which celadonite seems to have been the most common. This color is not very strong and was usually used with admixtures of ochre or a little black, to give it a stronger consistence and relieve the dullness of its tone. A better pigment, much used during medieval times, but seemingly out of fashion by the second third of the seventeenth century (see de Wild's table), was malachite. It is a parent of azurite, which is a blue carbonate of copper. The green variety differs chemically from azurite, in that it contains a higher proportion of combined water. Malachite can best be described as a bluish green, and it is referred to by Cennino Cennini as *verde azzurro*. We can assume that most Dutch painters of the period obtained their greens through the mixture of blue and yellow. I signaled in 1946 that several groups of trees in Vermeer's *View of Delft* had become blue, and that this was due to the absorption of the yellow that was part of the original green.[7]

A few words about Vermeer's blacks, which also stand out by their intensity: although different methods for obtaining black pigments were known, it seems highly probable that Vermeer used either lampblack or vine-charcoal black. Both yield deep and stable pigments, and both are of organic origin. Lampblack was known in very early times. In fact, the Chinese used it for their stick inks, which they formed by addition of gum. In the Middle Ages, the color primarily served for ink making, and later, fairly extensively, as a painting pigment. Its manufacture is relatively simple.

A flame plays on a cold surface and the resulting soot can be collected. The flame can come from a beeswax or tallow candle, or from a lamp burning oil: linseed oil, olive oil, hempseed oil, or a similar ingredient. Pitch or incense can also be used. In all variations, the end product is carbon, which acts as the coloring agent. The best of blacks for painters of the period, however, was made of certain kinds of charcoal. In medieval recipes, charcoal made from young shoots of vine is referred to as *nigrum optimum*. Samuel van Hoogstraeten (1678) calls it "burnt vine-tendril charcoal." The paint was obtained by burning the vine sprigs under exclusion of air so that the product was carbon, not ashes. The carbon was then finely powdered and ground up dry, then mixed with water and ground again. The resulting paste furnished a deep blue-black color, which can be seen in many of Jan Vermeer's canvases.

Having established the basics of Vermeer's palette, we will now describe their application upon the canvas by the artist. Fifteenth- and sixteenth-century painters still adhered to the methods stemming from the invention of oil as a painting medium. One knows that its principal advantage over wax or tempera as mediums consisted in the fact that oil dries slowly and can be rendered more siccative by certain processes that can be controlled.

Therefore, the painter who "tempers" his colors with an oil medium can work at leisure—as opposed to fresco or tempera painting, which dry almost instantly—and then can mix and mesh his colors, obtain smooth transitions, and possibly correct himself while the oil film that he spreads on the support is still moist. Medieval oil was a thick fluid, and although its manufacture was known and documented since the times of Pliny, its use as a medium for artistic purposes such as painting on panel or canvas dates only from the first third of the fifteenth century. In principle, one obtained, according to A. P. Laurie,[8] its extraction from the seed or the nut by heat, pressure, or boiling with water. This product of the first extraction can be purified by boiling, passing air through it, or exposing it to

the sun (see also Cennino Cennini). However, even when purified, it still remains an un-wieldy tool, as long as it is not sufficiently thinned so as to allow the brush to paint delicate lines. Modeling, drawing hair or brows, and so on require that the brush be tapered to a point, without globules of the medium accumulating at the end and interfering with precise handling and inpainting of minute detail.

It was only after a technique was perfected that permitted the successful thinning of the oil medium that the fine work of the Van Eycks and their followers became possible. We still ignore what exactly constituted their secret. Eibner suggested that the Flemish added oil of turpentine or a similar volatile medium. This would, of course, have required a knowledge of the art of distillation.[9] Without attempting to settle the still-open question of whether the Van Eycks made use of an emulsion, or rather, one of the essential oils, to arrive at the new aspects that characterize their paintings, we refer to the clear and convincing account by Alexandre Ziloty.[10]

For us, we accept the admixture of a volatile oil, or perhaps of alcohol, which departed from the narrow realm of alchemy during the fifteenth century and was for the first time manufactured in commercial quantities. It is only in this manner that the signal novelty of the Van Eyckian technique can be, at least partially, explained. To this medium, the Van Eycks obviously added a certain quantity of resin, either directly incorporated into the oil, or combined with the oil colors upon the palette of the painter. Van Dyck still used the latter method, admixing varnish to his colors, as reported by Dr. De Mayerne.[11] Mixing linseed or any other similar pressed and purified oil with an essential oil (e.g., essence of turpentine) or another thinner allowed the use of highly resinous colors—hence, the astonishing state of conservation and the enamel-like glossy surface of the Van Eyck period. We have already pointed out the extreme finesse of detail permitted by this technique, which hitherto was only attainable with tempera.

The build-up of the paintings belonging to the middle part of the fifteenth century can be summarized in a few words. The priming of the support (mostly wood, occasionally canvas) consisted of several superposed layers of chalk or plaster mixed with glue. Each layer was carefully smoothed and polished, the uppermost coated with glue only, to render it impermeable to oil. The composition of the painting-to-be was then carefully drawn with a neutral color, such as can be seen in the unfinished panel by Jan van Eyck in the Antwerp museum representing Saint Barbe.

After the preliminary stage, color was applied in successive layers. Each layer was separated after drying from the next one by a thin coat of varnish. As the artist was at liberty to render his painting medium more or less fluid, he was able to control the opacity of the paint: thicker applications of color in the lower strata, glazes in the upper ones. The process enabled one to work with translucencies, using glazes for modeling the underlying layers of paint, adducing light and shade, adding folds and wrinkles, as well as finely shaped details. This manner of painting with oils survived well into the seventeenth century. An outstanding example is Jan van Goyen, whose use of thin glazes mixed with varnish remains to this day a nightmare to the restorer.

The Flemish system was brought to Italy by Antonello da Messina, various Italians who worked in the studio of Rogier van der Weyden, and probably others. It evolved in the cisalpine regions in the direction of a more spirited application of the colors, making the most of the natural unctuosity of the vehicle. From the end of the fifteenth and the begin-

ning of the sixteenth century, the original white plaster-glue preparation was first covered with a layer of oil paint—called in Flanders the *primuersel* and generally featuring a flesh tone—before starting the preliminary drawing of the composition. In time, artists experimented with other colors for the *imprimatura*: red (*bolus*), pearl gray, and even black. The initial priming had a great effect on the luminosity and the orchestration in depth of the subsequent layers of paint.

The Italians were also the first to thicken the layers of paint and to apply them upon the pictorial surface by means of large strokes of the brush. The late Titian is a good example thereof. In the seventeenth century, Luca Giordano, also called *fa presto*, pushed the technique to the point where he had abandoned the old tradition of superposed layers and spread the paint directly and liberally upon the canvas, modeling while covering, thus becoming the forerunner of the moderns.

Rubens, Van Dyck, and most of their Flemish contemporaries, having resided in Italy and learned there not only composition but also technique, brought back to their native soil adaptations of the methods in fashion in the South. They thereby influenced many of the artists working in the northern Low Countries. However, Rembrandt and his immediate school seem to have adopted a different painting medium, the "Stand Oil." The vehicle was known of old, and its preparation is described in several medieval manuscripts. Essentially, it consists of linseed oil thickened and polymerized by prolonged boiling in the absence of air. Applied with a broad brush loaded with color, this medium enables the artist to model with thick paint, providing a glossy and uneven surface that facilitates the play of light and shadow.

Other Dutch schools, especially that of Utrecht, strongly influenced by the Italians and specifically, by Caravaggio, remained susceptible to cisalpine technical expressions.

Technique

Returning to Jan Vermeer, we now will describe how he brought about his painted harmonies and obtained the effects that we admire. However, here we encounter our first discord. There is what we like to characterize as the traditional Vermeer: his interiors, landscapes, and portraits. Then we encounter the so-called early paintings, including: *Christ in the House of Mary and Martha*; *Diana and Her Followers*; *Saint Praxedis*, the most dubious of all these ascriptions; and the *Procuress*, bearing a date 1656. The latter group is executed in broad brushstrokes, but each in a technique dissimilar to the others. We shall examine these works more under another heading, so we leave them out of consideration for the moment, and concentrate on the traditional bulk of Vermeer's oeuvre.

There are great differences in the degree of luminosity among the artist's paintings. One of the earliest, the *Girl Asleep*, of the Metropolitan Museum, New York, is, coloristically speaking, treated in a rather subdued manner. The general tonality remains in the warm browns, with the exception of a few white areas to the left. Even the red streaks of the Oriental rug do not stand out strikingly.

Obviously, the aspect of the painting is reminiscent of what Gérard de Lairesse had to say in his *Livre des Peintres*[12] with respect to the importance of priming and its influence upon the general gamut of colors. Vermeer worked in the old tradition, when the trans-

parency of the oil colors was still in vogue. He must have prepared this particular canvas with a dark brown layer—hence, the deep and warm shades that unite the entire composition. Here, as in all the later works, Vermeer builds up his painting in consecutive layers, each separated from the next one by a thin coat of varnish. X-rays reveal that the artist often made significant changes in his compositions, adding and eliminating figures or objects, as well as changing their stance and position.

In other paintings, such as the *View of Delft*, Vermeer confronts us with a bright and dazzling luminosity. To obtain this effect, the artist, like Rubens, must have used a tempera or watercolor priming, which was then separated from the ensuing layers of oil colors by a thin coat of varnish. In the case of this outstanding landscape, Wurzbach[13] surmised that he underpainted with carmine, which impregnated the entire composition and was, according to the great Austrian connoisseur, only capable of producing the intense color harmony that entrances, fascinates, and bewitches the viewer. Another of the painter's best works is the *Milkmaid*, in the Rijksmuseum, Amsterdam. Here, too, the striving was for luminosity, which pervades the work. The technique and execution appear similar to the preceding.

Vermeer painted very slowly, as attested by the small number of works that he produced. In a way, he emulated the *Feinmaler* of the period, such as Gerard Dou and the Mieris. His *forte*, as I wrote in 1955,[14] lies in the rendering of details, in the jewel-like precision and consummate perfection of parts into which his compositions can be divided.

To E. Plietzsch[15] we owe the penetrating remark that one cannot speak of genius with respect to Vermeer, unless one is willing to equal "genius" with "application." Thomas Craven abounds in the same sense, and even A. B. de Vries[16] had to admit that "the creative impetus springs not from the vitality of the artist who seeks to incarnate ideas and events, but from the intuitive certainty that contemplation is the sole source of painting."

Vermeer showed himself often as a master of the blurred contour. He was the first to introduce its use, which consists in the melting of pigments of different colors into an absorption of dividing line with no overt separation of, for example, the borders of a face from the dark background. Rather, the flesh tones on one side and the low-key zones from which the face stands out are only characterized by less radiation of light. This technique is opposed to the work of other masters, where there is a clean blocking off of color particles. Thus, the light is allowed in Vermeer's paintings to flicker and play around the figures, thereby conveying a telling effect of plasticity.

The artist has elevated this feature to masterly heights of execution. It is not a simple trick of craftsmanship, but amounts to an entire gamut of very personal expressiveness. One is sometimes reminded of the *sfumato* first used by Leonardo and his school. The latter is, however, obtained by softening large areas of paint, probably even with the palm of the hand. In the case of Vermeer's "blurring," the artist minutely fuses the pigments with a thin brush, slowly and with great patience. The impression of coolness that is frequently imparted by Vermeer's paintings is enhanced by the frequent avail of light backgrounds, starting with the works from the late 1650s. Their use was reintroduced to Dutch painting in the seventeenth century by Carel Fabritius. Vermeer and Pieter de Hooch, at roughly the same time, might well have incorporated the device in imitation of their famous departed fellow townsman.[17]

Another aspect of Vermeer's painting technique is his frequent use of pigments in *pointillé* fashion, which seem to be put on the canvas like droplets of pure color. The most striking examples of this technique can be found in the *View of Delft* (see the boat in the distant right) and the *Lacemaker*, at the Louvre. *The Girl with a Red Hat*, adduced by Wheelock in this connection, cannot be taken into account, because it is a nineteenth-century pasticcio painted on a scraped-down seventeenth-century panel from the Rembrandt school, very much like H. van Meegern's faked *Christ at Emmaus*.

Before we examine the use of optics by Vermeer, which can explain the uncommon-for-the-period *pointillé* highlights just referred to, it may be relevant to say a few words concerning the state of preservation on which we base our evaluation and judgment. As already stated, Vermeer's pictorial build-up followed the traditional method of superposed layers of paint, employing a resinous painting medium, which, like that of Rubens or the Van Eycks, gains through hardening in depth and transparency. The layers were separated by means of easily soluble varnishes. Thereby, his canvases became extremely vulnerable to cleaning and were repeatedly shorn of their glazes in the process. This explains why no more than about eleven of his preserved pictures can be considered in an acceptable state of conservation. The others have been variously, and sometimes often, restored; their current aspect reflects the conception of the restorer rather than that of the author. One of the most famous, or rather, infamous, instances of the sort is the *Girl with a Pearl Earring* at the Mauritshuis, The Hague. Sometimes celebrated as the "Gioconda of the North," it is nothing but a ruin.

Another case in point is the well-known *Allegory of Painting*, in Vienna, much commented about. The female figure (Clio or Fama), evidently overcleaned, has now been "reconstituted" in a way that only superficially resembles Vermeer's technique. Instead of the artist's blurred contours, we encounter precise drawing and a handling of the brush that imitates de Hooch rather than Vermeer. Other parts of the picture have suffered likewise. It is possible that the flatness, lack of plasticity, and bad and wooden drawing of arms and hands in a number of paintings stemming from the artist's late period are partly due to the overcleaning and rubbing off of the uppermost glazes, thereby seriously contributing to the critics blaming a gradual decrease in the artist's talent, which is, unfortunately, evident in these pictures. In some instances, only the rough underpaint is left.

This writer has encountered such damage in portraits by Anthony van Dyck at a period in his career when he was at the peak of his technical skills. He, like Rubens, can be likened in some ways to Vermeer, as far as painting processes were concerned. It becomes plausible that canvases similarly executed suffered an identical fate. Earlier works by Vermeer, which escaped this lot, were executed with paint applied in impasto fashion (see, e.g., the arms in the *Milkmaid* in Amsterdam. The same painting offers a good example of the artist's use of pointillism in the still life, left foreground).

Art in the northern Low Countries in the seventeenth century took a decided turn toward naturalism and realism. There are many attempts at explanation for this phenomenon. We have tried to show that one of the reasons must have been economics.[18] The rise of Calvinism had contributed in these regions to the flourishing of a capitalistically-oriented middle class, which, through power of the purse, influenced and even dictated the form and content of visual expression.

Many writers call this new art the "National Dutch Art." It required the artist to show the people their land, their houses, and finally, their environment. Aside from the fact that

Calvinism indicated the path toward an art more preoccupied with secular objects and compositions than with the religious sphere, the reformer also overtly encouraged naturalism and a bent for portraiture. All that in Vermeer's compositions, and very rarely at that, smacks of paganism, humanism, the Renaissance, classical antiquity, or Catholicism are inroads stemming from the master's Catholic background, or impulsions received from Utrecht, where the local school of painters in this sole Catholic bishopric in the Dutch republic was strongly influenced by Italy. Realism meant the adoption of perspective, so that landscapes, interiors, or city views looked "natural." One did not expect photographic resemblance in the period, but, as suggested by Descartes,[19] "There are no images which must altogether resemble the objects that they represent."

The flourishing of experimental as well as theoretical activities in the natural sciences in Protestant Holland encouraged artists to find mechanical devices constituting a shortcut in the rendering of perspective foreshortening.[20] Theoretical treatises were available,[21] but the possibility of replacing calculations with a gadget opened new horizons for the simple craftsman. The salient point was, since Alberti, to construct the picture in such a way so that all lines joined in a single vanishing point, with the horizon elevated to the height of the eyes of the average viewer.

The most primitive aid was the glass frame, already recommended by Albrecht Dürer in 1525 in his *Underweysung der Messung*. By the seventeenth century, a concave lens was either placed behind the square frame, or inserted into it. In his biography of Gerard Dou, J. B. Descamps[22] reports that Dou made use of a concave lens inserted into a screen and placed between himself and the object he wanted to paint. This had the advantage of shrinking his composition into a tractable size; it might well have been widely used by topographical landscape painters. It stands to reason that a considerable amount of dabbling with optical instruments, such as mirrors and wide-angle lenses, must have gone on in interested and nonprofessional circles.

Two other inventions attained a measure of popularity during the first half of the seventeenth century, and were to exercise a decisive influence in countries like Holland, where they could be correlated with concurrent scientific theories. The first one was the *camera obscura*, first introduced into Holland in 1622 by Cornelis Drebbel, as flows forth from letter no. 138 of Constantijn Huygens's correspondence.[23] It was in its primitive stage simply a box, with a small hole in the front wall, and an opaque glass sheet as back wall, upon which rays of light and the image to which the device was pointed were reflected. The clarity and luminosity of the device were soon improved by the insertion of a convex lens into the aperture directed toward the object. While the image can thus be traced from the glass surface, it is inverted. It cannot be projected onto a screen, or, in the case of the painter, directly upon canvas, panel, or any other support. In the case of landscape painting, only such parts or objects as are properly in focus produce neat images, whereas all others are blurred. The artist would therefore have to move the instrument to obtain different visions, which could then conceivably be juxtaposed, but would still not produce a reliable and consistent image. However, the camera obscura certainly proved its value to interior painters with less pronounced spatial-depth problems, as already brilliantly demonstrated by Charles Seymour in 1957.[24]

The second great invention of the period was the telescope of the type we call *Galilean*. It consists of the combination of two lenses, a convergent and a divergent one,

the latter being used as ocular. Owing to the concave, that is, divergent, lens being used as ocular, the Galilean telescope produces an image that is erect but virtual. An image is said to be real when it can be received on a screen; it is said to be virtual if, although perceived by the eye, it cannot be projected onto a screen. One will remember that the camera obscura produced an inverted real image, because there was no divergent ocular, and the only lens used for the refraction of the rays of light was a convex one. If one reverses the Galilean telescope, one uses the convex lens as ocular and points the concave on toward the object. This is no mere speculation. An engraving showing the device used in such a manner appears in 1630, in Christophorus Schemer, *Rosa Ursina Sive Sol*. I published this positive proof in 1977, of what was previously only an educated surmise arrived at by the inductive method.[25]

The telescope directed toward a landscape, or eventually an interior; one obtains the following results: 1. a strongly condensed view of a given sector (see, e.g., the *View of Delft*); 2. a smaller than normal magnification; and 3. a foreground marked with a surprising clarity and standing out in the manner of stage scenery, whereas the remainder of the pictorial image recedes into unsuspected depths. The contrasts of light and dark are enhanced, colors heightened, and *pointillé* highlights in the foreground are now explained as representations of effects pertaining to the peculiarities of the optical device.

Although no documentary proof exists of Vermeer having used either the camera obscura or the inverted telescope, these artistic aids were well known in the period. It would, on the contrary, be difficult to explain why Vermeer would not have availed himself of them, while other interior, landscape, and townscape painters evidently relied to a great extent on these devices. In fact, certain distortions in form and composition, reflections, and treatment of highlights leave no doubt that Vermeer did not eschew the help of what contemporary science had to offer in the artistic field. This has by now become art-historical consensus. What divides scholars is simply the degree of his involvement. It seems reasonable to this author that Wheelock's interpretation, i.e., the use of the aids without complete dependence and artistic freedom in their interpretation, is the correct one.[26]

The fact remains that Vermeer is one of the most "realistic" painters whom we encounter in Holland. Contrary to current opinion, we believe, as further explained in this book, that the primacy of the so-called breakthrough—putting the figures of his interiors into brightly lit chambers with clear creamy backgrounds, and using optical instruments for the rendering of perspective—belonged to Vermeer; De Hooch was simply his follower in that respect.

The new approach, which became overt during the late 1650s, constituted a distinct "first." Pieter de Hooch, who was three years Vermeer's senior and was settled in Delft approximately during the years 1653 to 1662, switched toward the end of the 1650s from painting soldiery scenes to interiors. It is our contention that he was greatly influenced in doing so by Vermeer, who was the initiator of the new manner, having brought a new-found clarity to the envelopment of his figures in interior scenes. Each artist worked according to his own genius.

De Hooch conquered the interior space in a precise and imitative manner. Vermeer's painterly qualities were of a higher level. He obtains renditions of light of the utmost brightness and diffusion with all the nuances. His method of composition, starting with the middle to late 1650s, features closeness to the object in many instances, not only in the

figures but also the objects, and maps on the wall, so accurate that they can often be precisely identified. The *Soldier with a Laughing Girl*, from the Frick Collection in New York, and the *Milkmaid* in Amsterdam provide striking examples. De Hooch appears pedestrian in contrast to the more fanciful conception of Vermeer.

Stillness and Silence

With the two last characteristics cited by Swillens that emerge in a parallel manner, we confront at least one of the riddles of the Sphinx from Delft. Vermeer's *forte* was not invention. His choice of subject matter in the group of works that can be attributed to him with certainty does not feature anything new: interiors, with a room that mostly seems to have been the same, either closed with a window that lets in the light; or the typical perspective view into another chamber providing intimacy of space; a single figure—or at most, very few figures—shown in domestic occupation or making music. The formula is well known from contemporaries, from whom borrowings as to content abound. Occasionally, we encounter a bust portrait of a girl, and in two isolated instances, landscapes that are indeed great art.

The originality of the artist is not the attempt to dazzle the beholder by flights of imagination. It is only by the perfection of the rendering that Vermeer is unique. The break with his contemporaries in Holland appears in the complete stillness of his figures and the lack of expression in the faces. None of them is an individual statement, but evidently a generalization bereft of any depiction of mood or sentiment. As I wrote in 1985,[27] they represent a cook, a lady at the virginal, a woman reading a letter, and never a distinct personality.

The detachment and the monumentality of his subjects are completely outside the norm of his times, and for this reason alone, the artist finds himself pursuing a path that no one else ventured to tread. Another characteristic is the complete spiritual aloofness of all his figures. Each one is contained in itself, and even when two or more are grouped together, each person might be defined as playing a solo. There is hardly any communication or interaction. Whether it be the *Music Lesson*, the *Concert*, or a *Lady Receiving a Letter from her Maid*, the actors seem posed individually and in particular, and no spark flies from one to the other—barely a gesture of the hand, or a turn of the head, to indicate the theme.

The overwhelming majority of Vermeer's biographers were content to remark upon this stillness, grandeur, and monumentality, without drawing any nearer to the solution of the "riddle" of Vermeer. It will surprise no one that the most intuitive of modern writers on art most closely bordered on the truth[28] when he wrote, "His anecdotes are not anecdotes, his atmospheres are not atmospheres, his sentiment is not sentimental, his scenes are barely scenes, twenty of his pictures (and we know of fewer than forty all told) contain only a solitary figure, and yet they are not precisely portraits. He seems always to strip his models of their individuality, obtaining not types, but an extremely sensitive abstraction, not unreminiscent of certain Greek kouroi." Lawrence Gowing,[29] the best English-language critic of Vermeer, had to admit that in certain instances, such as the Berlin picture (Cat. No. 5), "the figures have a mummified quality, shrouded and unmoving. The scene as

we look at it takes on the character of an exquisite tomb."

As first suggested by this author in 1955[30] and further developed in 1985,[31] the artist's psychological approach constitutes a complete reversal of normal Western self-assertion in the way he presents his figures. They stand out for depersonalization, which can be summed up as monumentality, stillness, and lack of expression. Comparisons with, for example, the *Amateurs of Music* by Gabriel Metsu at the Mauritshuis, or Pieter de Hooch's the *Country House* at the Rijksmuseum, show us depiction of mood and liveliness. In Metsu's painting, the entire composition is connected in such a manner that all the actors play their parts in a pleasant, coherent, and logical entity. De Hooch's participants are vivacious in their gestures, animated in expression, and the whole promotes an intimate but stimulating aspect of country vigor.

In Vermeer's works, all these characteristics are either lacking or reversed. In the *Milkmaid*, the complete epic stillness of the Delft master stands out. Even the fact of pouring milk into the basin is done with the utmost lack of initiative or enterprise. Another good example of this dehumanization can be found in *Young Woman with a Water Jug* at the Metropolitan Museum, New York. Again, we encounter a total absence of activity, a still and impersonal stance, which lacks expression and turns the model into a pensive puppet that eschews all exterior participation. The same distance from feeling becomes obvious in the *Head of a Girl* at the Mauritshuis, and the *Head of a Young Woman* at the Metropolitan Museum, New York. Their trancelike immobility remains at variance with that of all contemporaneous painting in any European country or school. These are only a few examples among many.

André Malraux's allusion to the resemblance of Vermeer's figures to certain Greek kouroi is seminal and representative of the writer's great insight in artistic matters. I must admit that I had not read his *Les voix du silence* at the time that I first suggested Asiatic influences in Vermeer's work in 1955. However, both ideas pursue similar paths. Greek sculpture of the early archaic period (ca. 660–580 B.C.) was dependent for its inspiration upon the East. Egypt had conquered Assyria in 672 B.C. and from then on, the East was opened to Greek trade,[32] and with it the appearance of the earliest known large statues by Greek artists. The latter adopted and repeated a few Eastern types such as the kouros and *kore* figures. As in literature, they "avoided the appearance of originality" and "treated a traditional theme in a conventional style and form."[33] A comparison with such works as the *Kouros from Sounion*, Athens, National Museum (ca. 615–590 B.C.) or the *Kouros*, Metropolitan Museum, New York (ca. 615–590 B.C.) bears out Malraux's contention.

For Greece, the East was Egypt and Mesopotamia. For a Dutchman of the seventeenth century, the East meant Indonesia, the former Dutch East Indies. The company of the same name had in 1602 its seat in Batavia. It traded with many islands and with the Asian continent, and thrived on the exchange of exotic products—among them works of art—with the homeland. Numerous examples of Indonesian art were part of Delft private collections during Vermeer's lifetime. He obviously was acquainted with them. We know that the Dutch public of the period took great interest in exotica, such as Frans Post's Brazilian landscapes, Rembrandt copying after Moghul miniatures, and Dutch artists traveling and sometimes even settling in the Far East. Michael Sweerts, though Flemish by birth, worked for some time in Amsterdam and died in Goa.

The art of Indonesia consisted of two streams, one Buddhist and one Indian (worship

of Siva). They continued side by side all over the archipelago, with occasional mingling. Buddhism's main goal is the attainment of *nirvana*, which we can characterize as a state of trance, a psychophysiological state that meant liberation from *samsara*, the condition of flux and sorrow.

The art of Java, Bali, and so on, and especially the reliefs from Barabadur, reflected styles that were based on texts from the Maireya and other Buddhist writings. Telling examples can be found reproduced in our relevant publication,[34] but the most striking one is the *Head of a Monk* from Candi Sewu, in the museum in Batavia. A similar approach can be observed in two portraits at The Hague and at the Metropolitan Museum in New York. In both canvases, the two young women feature oval heads, wide-open eyes, crisp, carved-like, eyebrows; and light floating draperies. Their faces tend toward aloof withdrawal and serenity. The pose, as well as the distance from feeling or intent, reflects a psychological approach that remains at variance with that of all contemporaneous painting in Europe, as well as the adopting, in both these paintings, of Oriental canons of beauty. To these traits, absolute stillness and introspection must be added.

Hence, one of the secrets of Vermeer's artistic conception is the acceptance of Eastern (Indonesian) influences and thought processes, which left a perpetual mark on his performance.[35]

Vermeer's Life

Documents concerning Jan Vermeer are relatively scarce. The basics were published by Abraham Bredius between 1885 and 1916. Since then, new documents have come only recently to light, owing to the diligent research of J. M. Montias. Though of great interest with respect to the artist's family and origin, they inform us primarily of external facts, secondary in importance: for instance, Vermeer's maternal grandfather was a counterfeiter, his paternal grandmother was in difficulties for fraud, and his mother-in-law was separated from her husband in 1641 after a series of quarrels that degenerated, in one instance, into a family fight. What we know now can be summed up by stating that Vermeer was descended on his mother's side from Flemings who had left Antwerp for reasons of faith. On his father's side, he stemmed from Dutch Calvinists. The family was not prosperous, belonged to the lower middle class, and was of questionable reputation.

Jan Vermeer was baptized as Joannis on 31 October 1632 in the New church of Delft. His father was Reynier Jansz, who received his training as a caffa weaver in Amsterdam. Caffa is a blend of silk and cotton. The craft demanded a good aptitude in design, to execute the complicated patterns traditional for the cloth. His brother, Jan's uncle, was a sculptor (or stonecutter) and had twice departed for the East Indies with the intention of making his fortune. He did not return from his second voyage. Father Reynier's profession as a caffa weaver does not seem to have been sufficiently profitable to provide for the family.

He therefore also became an innkeeper, and registered additionally in 1631 with the Guild of Saint Luke as an art dealer. In 1615, he married Digna Baltens, the daughter of Balthasar Gerrits, a Flemish immigrant from Antwerp. The couple had their first child in 1620, a daughter named Gertruy. When Reynier became an innkeeper, first at the *Flying Fox* and later in the large *Mechelen*, he adopted the name Vos. Subsequently, he called himself Vermeer, using that name for his business dealings in artwork, and remaining Vos as innkeeper.

From the date of Jan's baptism until his appearance before a notary in Delft on 5 April 1653 in connection with the proposed banns of his marriage with Trintje Reijniers, there is a gap concerning his whereabouts and studies. The marriage took place on 20 April of the same year in Schipluy.

The bride came from a wealthy Catholic family of landowners; it is commonly assumed that Jan Vermeer converted to the Catholic faith during the days preceding the nuptials. Some eight months later, the young man was received as Master Painter into the Guild of Saint Luke of Delft. The date was 29 December 1653, and Jan was only able to pay one guilder and ten stuivers on account toward his master's fee. It took him almost three years—until 24 July 1656—to acquit himself of the remaining debt. A week after his marriage, we find Vermeer's name, with that of Gerard Ter Borch, as witness to a deed in the office of a Delft notary.

We have no information whatsoever as to Jan's master in the art of painting. The Delft guild required six years of apprenticeship with at least one recognized master painter, be he from Delft or elsewhere. However, there is much doubt whether the guild rules were as strictly applied in Vermeer's times as previously. Carel Fabritius became a master in the Delft guild in October 1652. He was born in 1622, and was referred to until 1641 as a *timmerman* (carpenter); he then spent two years as an apprentice in Rembrandt's studio and called himself a *schilder* (painter) thereafter. We know of no one else

with whom he studied. Nevertheless, he obtained his inscription as a master painter in the guild of Delft, seemingly without any difficulty and in spite of the fact that his output until that time had been minimal. Other painters, such as Jacob Ruisdael in Amsterdam, had been active for twelve(!) years before bothering to regularize their situations with the guild.

It is therefore not so astonishing that the name Jan Vermeer cannot be found as an apprentice in the guild registers, be it in Delft or other cities such as The Hague, Amsterdam, or Utrecht. We are left to our speculations in this respect, and my suggestions are the following: Jan's earliest instructor would be his father, Reynier, who, as we recall, was a trained caffa weaver. He must therefore have been a much better than average designer, and perfectly competent to teach his son in the basics, both the drawing and handling of color. Considering that money was not plentiful in the Vermeer household, these lessons were preferable to putting young Jan into a formal apprenticeship with some accepted teacher. I see Jan's further development and study in Amsterdam, which was reasonably close to Delft, and, as Montias points out, easy to reach at little cost.

I have much confidence in the fidelity of old traditions, and I would like to take up again the possibility of Vermeer having attended the Rembrandt workshop. A Rembrandt disciple, Leonard Bramer, lived and worked in Delft, and apparently had social and business relations with the family.

Although his style, as well as that of the still-life painter Evert van Aelst, who also had dealings with the Vermeers, seems to be far from Jan's artistic conceptions, we must not forget that Bramer not only was the author of small, dark, religious panels in the manner of Elsheimer; he also painted in the "grand style" and was one of the very few fresco painters in northern Europe. He must have been flexible enough to have taught the young Vermeer.

Finally, Carel Fabritius had moved to Delft. He is first mentioned there in 1650, but could have been living there previously. Although he only became a master in 1652, connections with Vermeer could have been established through the Rembrandt studio in Amsterdam prior to these years; a loose, if not formal, apprenticeship remains a possibility. Vermeer was certainly inspired in his own paintings by Fabritius's handling of color and light. Montias's proposal of a master from Utrecht, Abraham Bloemaert, who died in 1651, as a possible teacher of Vermeer stands and falls with the acceptance or rejection of the so-called early Vermeer paintings, including the *Procuress* from 1656. Bloemaert was a mannerist, and there is nothing evident from his style in Vermeer's oeuvre. The supplementary argument that it was through his intermediary that Vermeer became acquainted with his future wife because Bloemaert was a relative by marriage of his subsequent mother-in-law, Maria Thins, seems farfetched. Two young people in a small town had many opportunities to meet, other than family connections—one of them simply through skating on the frozen canal during the winter, where young and old regularly had a good time.

We submit that the inscription as a master in any guild of Saint Luke in the northern Low Countries, and especially in a small town like Delft, was not any more subject to the stringent rules of former times.

As I wrote in 1979,[36] "the guilds were less powerful and all-inclusive in the northern Netherlands than in Flanders, and we know the names of excellent artists who exercised

their calling for up to twelve years in Amsterdam and elsewhere, before deciding finally to solicit membership in the guild of Saint Luke."[37]

Jan's father had been a member of good standing in the Delft guild, though, of course, as a dealer in paintings and not as a painter himself. His friends were obviously in a position to pull some strings and get the son admitted without any further ado. Considered from this angle, all speculations concerning Jan Vermeer's teachers become extremely tenuous.

The next document concerning our artist was an act before a notary, dating from December 1655, in which Jan and his wife guaranteed a debt contracted by Vermeer's father in 1648.

In June 1657, a picture in the estate of the art dealer Johannes de Renialme is described as a "Visit to the Tomb by Van der Meer—20 guilders." It is not known which Van der Meer was meant.

By 1660, Jan Vermeer and his family lived in the house of his mother-in-law, Maria Thins, who, being well-off, helped to support the family. The couple had a first child, a daughter, by 1657, and were to have fifteen children altogether. Four of them died young. We have a description of the house based on an inventory drawn up in February 1676, two months after Jan's demise. It must have been spacious and comfortable, to lodge the adults and children who occupied it. It also contained a large studio for painting and for conducting the art trade that constituted a sideline for the often impecunious artist.

As far as his personal life, Vermeer seems to have adopted the Catholic side of his family, their friends and acquaintances, for social life and business relationships. His Protestant roots had not helped him much during the first stages of his life, and it appears natural that he turned to the new friends whose aid was much more beneficial.

Vermeer was twice honored by the local Saint Luke guild to serve as one of their headmen: the first time in 1662, when he was not yet thirty years old; the second time in October 1671.

The year 1672 was catastrophic for the republic. The French invaded its territory, and England also declared war. Forced to resort to their old method of defense—opening the sluices and flooding the land—the economy was hard hit. As usual in such circumstances, the art trade was the first to stand completely still; paintings had suddenly become unsaleable. It is no wonder that the dealer Gerard Uylenburgh had tried to sell to the grand Elector of Brandenburg, Friedrich-Wilhelm, a lot of twelve Italian paintings at exorbitant prices.

Jan Vermeer and a certain Johannes Jordaen were called upon to travel to The Hague to appraise the canvases. Their opinions were devastating: they called the paintings "great pieces of rubbish...not worth the tenth part of the proposed prices....The items have no value to speak of." This is the only time, to our knowledge, that Vermeer had been called out of town for a valuation of paintings. The document before the notary is dated 23 May 1672. It does not signify, as often avowed, that Vermeer had a reputation as a specialist in Italian art. Rather, we can take it to mean that as a painter-dealer, he knew pictorial quality and was familiar with the going prices of paintings on the market. Vermeer's father had already been an art dealer; Jan the same.

It is in that capacity that the elector's artistic adviser, the painter Hendrick Fromentiou, called on Vermeer to come to The Hague. Perhaps Fromentiou wanted to sell some-

thing else to the grand elector. Shortly after the deal came to naught, Uylenburgh declared bankruptcy.

As far as Vermeer's relations with other artists, our knowledge is again limited. We have already mentioned the document establishing that he knew Gerard Ter Borch. How intimately, we don't know. Leonard Bramer was a friend or at least a business acquaintance of the family. No document links Vermeer directly to Pieter de Hooch, although the two artists must have seen each other frequently. De Hooch was inscribed in the Delft guild in February 1655, and continued to pay his dues in 1656 and 1657.

The only literary reference linking Vermeer to Carel Fabritius (we have mentioned stylistic threads connecting the two artists) is a poem by Arnold Bon, bookseller and publisher in Delft of Dirck van Bleyswyck's *Beschryvinge der Stadt Delft* (Description of the Town of Delft). The book came off the press in 1667. Bleyswijk lists the artists working in Delft, as long as they were natives of the town, the sole exception being Carel Fabritius, whom he included because he ignored didn't know his place of birth. Arnold Bon, the publisher, contributed a poem, whose last stanza gave rise to much discussion:

> *Thus expired this Phoenix to our grief,*
> *In the midst and at the best of his power*
> *But happily there arose from his fire*
> *Vermeer, who masterly trod his path.*

(Carel Fabritius perished in the explosion of the Delft powder magazine in 1654 at the age of thirty-two. The tragedy occurred while he was painting a portrait of Simon Decker, a sacristan.)

A change in this stanza seems to have been made during the printing of the book, which is otherwise a single edition. In such a copy at the Royal Library, The Hague, the first and fourth line appear as follows:

> *Thus died this Phoenix when he was thirty years of age*
> *In the midst and at the best of his power*
> *But happily there arose from his fire*
> *Vermeer, who masterly was able to emulate him.*

Albert Blankert was the first to point out the variation. It seems to him that Bon first considered Vermeer to be a follower of Fabritius, and on second thought elevated him to the same level as the "Phoenix." Perhaps he had seen a painting by Vermeer while the book was in press, which impressed him to the point of amending his initial judgment. Clearly, for Bon, Vermeer was now Delft's shining light in the art of painting.

Vermeer's business affairs do not seem to have recovered from the calamities brought upon the land in 1672. He was short of money during his last years. In July 1675, he went to Amsterdam to borrow fl 1,000. A few months later, he suddenly died. Vermeer was buried on 15 December 1675 in the Old church of Delft. He left his widow, Catharina, and eleven children, eight of them underage and still living in the family home.

Vermeer was forty-three years old at the time of his demise, and his finances were in complete disarray. The situation is best explained in the wording of a petition that his wid-

ow submitted on 30 April 1676 to the high court of Holland to obtain permission to defer the payment of her debts. She wrote: "During the long and ruinous war with France, not only could (my husband) not sell his work, but in addition, at great loss to himself, the pictures by other masters that he bought and traded were left in his hands. In consequence of that and because of the large burden of his children, having no personal fortune, he fell into such frenetic state and decline that in one day, or a day and a half, he passed from a state of good health into death."

Catharina became, from then on, involved in a long series of legal proceedings. We only mention that on 30 September 1676, Anthony van Leeuwenhoeck became the official administrator of Catharina Bolnes's (Vermeer's widow) estate on behalf of her creditors. Leeuwenhoeck was of the same age as Vermeer and, given his reputation as a scientist, conjectures have been made concerning his possible connections with the artist in the use of the camera obscura. No proof of any sort exists in this respect. Furthermore, his attitude in the administration of the estate was definitely inimical to the family. Leeuwenhoeck's appointment by the Delft magistrates is simply one of the coincidences inherent to life in a small town.

Vermeer's Reputation During and After His Lifetime; Sale of His Works

Delft was, during Vermeer's lifetime, a small town—not comparable, as an artistic center, with Amsterdam, The Hague, or Utrecht. Much has been made of the Delft school after 1640. But with the exception of a few better-known artists, it was and remained a backwater.

Vermeer was thus considered a local artist, and his contemporaries had little to say about him. Aside from Bleyswijk's aforementioned book of 1667 and the connection, or rather, parallel, with Carel Fabritius established through Bon's poem, there is no *Rezeptionsgeschichte*. Samuel von Hoogstraeten, a fellow student of Fabritius in the Rembrandt studio, in his 1678 *Inleyding tot de Hooge Schoole der Schilderkunst*, ignores him totally. Arnold Houbraken, *Groote Schouburg der Nederlantsche Konstschilders en Schilderessen* (1718), simply copies Bleyswijk's entry on Vermeer, and leaves out the last stanza of Bon's poem. It means that only his name is given, without mention of any of his works, neither blame nor praise.

It has been argued that the small size of Vermeer's oeuvre was responsible for the contemporary chronicler's forgetfulness. But Fabritius had left even fewer paintings, and everyone sang his praises during and after his lifetime. One must conclude that Jan Vermeer was considered a respectable artist without arousing great enthusiasm. This is also borne out by the prices that his works attained: an appraisal of 20 guilders in 1675 for a *Visit to the Tomb* in the estate of the art dealer Johannes de Renialme (if the work was by our Vermeer, which is questionable); 20 guilders 10 stuivers for a painting in a black frame from the estate of the innkeeper Cornelis Cornelisz. de Helt, sold at auction on 14 June 1661.

Another canvas by the artist was mentioned by the Frenchman Balthazar de Monconys in the diary of his travels. He had visited Vermeer in his workshop in August 1663, and the artist had no pictures to show him, but de Monconys reports that he did see one at

a baker's "for which six hundred *livres* had been paid, although it contained a single figure, for which six *pistoles* would have been too high a price in my opinion."[38] The baker, Henrick van Buyten, was a wealthy man. His estate included three paintings by Vermeer. The two others were those accepted by van Buyten from Catharina Bolnes, the painter's widow, on 27 January 1676, in settlement of a large bread bill. They were valued together at 617 guilders 6 stuivers.

A large collection of paintings by Vermeer was auctioned in Amsterdam on 16 May 1696. According to Montias's research, these twenty paintings were collected during Vermeer's lifetime by Pieter Claesz. van Ruijven and his wife, Maria de Knuijt, who seem to have been close friends of the painter. Van Ruijven was independently wealthy and exercised no trade or profession. He was apparently the most important single patron of the painter and bought most of his artistic production after 1657. After van Ruijven's death in 1664, the collection went by inheritance to his daughter Magdalena, who had married the Delft printer Jacobus Abrahamsz. Dissius.

At the demise of his wife, at the age of only twenty-seven, the collection passed into his hands, to be finally sold off in 1696. We shall print the description of the works under the following heading. For the moment, suffice it to mention that the prices achieved were honorable but not outstanding, the high points being fl 175 for the *Milkmaid*, and fl 200 for the *View of Delft*.

Other works by Vermeer mentioned in the hands of collectors include *A Head*, bought by the sculptor Jean Larsson during a visit to Delft in 1660. He died in The Hague in 1664. The Antwerp banker Diego Duarte owned "a small piece with a woman at the clavecin with accessories by Vermeer" for 150 guilders (inventory of 1682). Herman Stoffelsz. van Swoll, a banker residing in Amsterdam, owned the *New Testament* (now, the *Allegory of Faith*, Metropolitan Museum, New York), which fetched in the sale of his estate on 22 April 1699 in Amsterdam the sum of fl 400.

A comparison with the going prices of paintings in the northern Netherlands at the time shows that the valuations or prices obtained for works by Vermeer remained within a reasonable average. Paintings were relatively cheap in the republic, much lower than, for example, in the Catholic southern provinces.[39] We have a document according to which in 1661 the excellent still-life painter Abraham van Beyeren had ordered a suit of clothes in The Hague for 101 guilders, and had promised to pay one half in paintings and the other half in cash.

The case came to court, the tailor having received only the paintings—three items worth 66 guilders! When the Amsterdam dealer Johannes de Renialme had to pledge part of his stock in 1640, about thirty landscapes by Hercules Seghers were subject to appraisal. Only the most important one was deemed to be worth 30 guilders; all the others less. In 1644, at Renialme's again, a capital work by Rembrandt, the *Woman Taken in Adultery*, was appraised at 1,500 guilders; but a self-portrait by the same fetched only 150 guilders. We could cite many other examples, but the salient point is that paintings, even relatively good ones, were low-priced. Exceptions to the rule were only the *Feinmaler* such as Gerard Dou or one of the Mieris family. Their works regularly obtained 800–1,000 guilders, and occasionally, more.

During the eighteenth century, a number of Vermeer's paintings passed repeatedly through Dutch salesrooms, and their prices remained steady. Vermeer's name was syn-

onymous for quality, although occasional mix-ups with artists of the same name occurred. The patronymic was by no means uncommon in Holland. At least four artists called Vermeer or van der Meer are known to have been active in Harlem. They were mostly landscape painters, and their works became intermingled with those of the author of the *View of Delft*. There was a Jan van der Meer of Utrecht, about whom more can be learned in the section "Oeuvre." Jan Baptiste van der Meiren was sometimes confused with one or the other van der Meer. Generally speaking, the painter continued to be a recognizable trademark for his compatriots in the eighteenth century, and the auction catalogs were full of praise when a work of his came under the hammer.

Abroad, however, a curious transformation took place. The superior quality of his works was recognized by many enlightened collectors. But his name had been more or less forgotten, and his paintings sailed under various flags. Frans van Mieris, Gabriel Metsu, and, of course, Pieter de Hooch were credited with the authorship of his best works. Sometimes Rembrandt or his school can be found among the attributions. The *Young Woman Reading a Letter* at the Dresden Staatsgalerie was in 1783 still engraved as a work by Govaert Flinck! The acquisition of the *View of Delft* by the Mauritshuis for the more than respectable sum of 2,900 guilders startled many foreign collectors, and some critics in France began to mention him favorably. Nevertheless, it was only when the French art critic Théophile Thoré, writing under the pen-name Bürger, wrote three short essays in the *Gazette des Beaux-Arts* of 1866 about Vermeer, that the wide public accepted him as a major master.

The time was right for a reevaluation. Politically, the trend favored the abandonment of authoritarianism, and instead, republican ideals—hence, Thoré's adoption of the surname Bürger (which means "citizen") and his long years of exile. Vermeer's art was essentially bourgeois, and in keeping with the new French standards. What impressed the French critics was the parallelism of the painter's artistry with their own "moderns," the painters who had chosen a path divergent from that of the academy.

They, too, were wrestling with problems of light, freedom of brushstroke, and the broken color palette. It certainly was a striking coincidence to find a seventeenth-century artist who evidently was more preoccupied with painterly rendition than with subject matter, and thereby could be considered a matching complement to the striving of the "irregulars." Vermeer furnished not only a justification but established a hallowed tradition for the outlook of Manet, Monet, Sisley, and all the other impressionists. A kinship could be traced to his detachment from content, to his curious stillness and monumentality, and abstraction from anything that was not space, light, and color. Verily, here was the great ancestor![40]

Thoré-Bürger's articles introduced Vermeer into art history, but did not immediately provoke a complete turnaround. It took about forty more years to establish the painter as a universally acclaimed master. Ten years after the articles in the *Gazette des Beaux-Arts*, Fromentin had in 1876 in his *Maîtres d'autrefois* little to say of Vermeer, except that he appeared an oddity (*"il a des côtés d'observateur assez étranges"*). Abroad, the famous Jacob Burckhardt criticized "the overrated single figures of the Delft painter Meer: women reading and writing letters and such things" in his three lectures "On Netherlandish Genre Painting" from 1874.

But Maxime du Camp, Charles Blanc, and others followed Thoré-Bürger in his admi-

ration for Vermeer, and H. Havard brought out in 1883 a remarkable monograph with a much improved catalog. Thoré had still attributed more than seventy-four paintings to Vermeer, including works by Koedijck, C. de Man, J. Vrel, P. de Hooch, G. Metsu, Eglon van der Neer, Jan Vermeer van Haarlem, and many others. Most twentieth-century scholars devoted their efforts to pruning the master's oeuvre and eliminating wrong ascriptions. Their endeavors were complicated by the sudden appearance of new "discoveries," which were either over-optimistic attributions or outright fakes—made profitable by the vogue unexpectedly enjoyed by the master's paintings. On the other hand, works attributed to, or even fitted with, fake signatures of formerly more fashionable artists, could be restituted to their true author.

The cleansing process is now in its final stages. The revolutionaries of the second part of the nineteenth century have become the classics of modern art. Consequently, despite the spate of monographs recently devoted to Vermeer, much of the original excitement has abated.

Instead of a reevaluation from the aesthetic standpoint that would be indicated, recent authors have focused upon incidental, accessory, and subordinate aspects. Vermeer and Catholicism, amply treated by Swillens in 1950, have been insufferably dilated and flogged to death. Influences from that corner are infrequently apparent in Vermeer's artistic production. Compared with Jacob Jordaens, for instance, who, after his conversion to Protestantism, continued to accept commissions from both sides of the religious pale without any discrimination, Catholic influence seems much less weighty in the case of Vermeer, and more a matter of convenience and financial competency. Aside from his *Allegory of Faith*, which was a commissioned painting (by a Protestant, to boot), his paintings were totally uninfluenced by religion.

Montias's discovery of many documents shedding light upon his and his wife's family, contribute nothing to Vermeer the artist. Rather, they bear out the age-old admonition given by fathers to impecunious sons: it is as easy to fall in love with a rich girl as with a poor one—and look at the difference! In fact, the painter from Delft and his family would have starved without the continuous support of the wealthy Catholic mother-in-law. As for his conversion, suffice it to say with Henry IV, king of France: *"Paris vaut bien une messe."*

Other authors deal with problems of iconography, influences, and borrowings from other artists, the milieu, optics, the school of Delft, and other extraneous subject matter. The core of the desirable cognition, the artist himself, has been abandoned and neglected as "inexplicable," which is not astonishing, given the more materialistic turn that art history has taken during the last decades. Many books were also written by cultural historians, which are of interest as long as their authors do not venture into the realm of connoisseurship, of which they are blissfully ignorant.

The Vermeer literature of the twentieth century owes a great debt to Dutch art historians. We owe the basics to Abraham Bredius and Cornelis Hofstede de Groot. A great German connoisseur is often neglected or patronizingly given a pat on the back: Eduard Plietzsch, sometime helper and collaborator of Hofstede de Groot. His monograph of 1911 and the second edition of 1937 are among the best ever written on the subject. Around the same time, Philip L. Hale's *Vermeer* (2d ed., Boston 1937) appeared, which constituted a markstone for pre–World War II Vermeer scholarship. After the last world war, A. B. de Vries and P. T. A. Swillens stand out. Lately, A. Blankert and Arthur K. Wheelock, Jr., have

successfully pruned Vermeer's work catalog, the latter being more generous in his attributions and less reliable. Aesthetic contributions by Vitale Bloch have to be mentioned, and the great André Malraux, not sufficiently read outside French boundaries. The language barrier still remains apparent in English and German-language publications. As for the French, they still believe, with Montesquieu: *"comment peut-on être Persan!"*

As mentioned, the renewed fame of Vermeer gave rise to a series of new attributions, especially to the "young" Vermeer, which disappeared rapidly. Some were more stubborn, such as *Girl with a Flute* and *Girl with a Red Hat*, both at the National Gallery, Washington, D.C. Both are French pasticcios from the nineteenth century. Among outright fakes that came to the fore since the 1920s, I mention: *Girl with a Blue Ribbon*, collection of Mrs. Louis F. Hyde, Glen Falls, New York. Probably by the same hand as *Young Woman with Hat*, formerly at the Thyssen-Bornemisza collection, Lugano, and the *Lacemaker*, National Gallery, Washington. Essentially, they are all composed of parts borrowed from authentic paintings, put together in the manner of a jigsaw puzzle. The execution mirrors the formal image of Vermeer according to the way scholars and the public conceptualized him at the time. Thus, while today these fakes are glaringly inadequate because we changed our approach to the artist, they remained dangerous for the contemporary viewer.

The story of Han Anthonius van Meegeren, who died in 1947 in a Dutch prison, is too well known to be retold here in detail. Briefly, van Meegeren, who was an unsuccessful painter, shifted in the 1930s into the production of fakes. Vermeer was only one of the artists whom he successfully forged.

Given the artist's importance, and the large prices obtained by van Meegeren for his products, they were indirectly responsible for his downfall. In Holland, as well as in Belgium, the current banknotes were exchanged after the German occupation, mainly to stem the inflation caused by excessive printing of paper money during the war. Van Meegeren, who was known previously to be penurious, as evidenced by his income-tax declarations, suddenly arrived with a wheelbarrow full of paper money at his bank, in order to change the by now worthless banknotes into new ones. Arrested on the spot, he claimed that he had not collaborated with the enemy, but acted as a patriot by having sold his forgeries to Hitler, Goering, and others for huge sums.

Called upon to prove his allegations, he painted in prison *Jesus and the Doctors*, which convinced the judges that he was also the author of a series of other Vermeer forgeries. The most famous and earliest of the fakes was *Christ at Emmaus*, acclaimed by the art world in 1937 as a very important unknown Vermeer, and accepted and published as such by the great Dutch authority Abraham Bredius. Acquired for hfl 550,000 by the Rotterdam Boymans museum, it was put on exhibit there, and its significance hailed by all. It was the Caravaggesque character of the canvas that convinced the critics. At about that time, one had started to think about the possibility of an early Italianizing period of Vermeer. *Christ at Emmaus* seemed to bear out this contention and uphold what was until then but a hypothesis. Some isolated voices doubted the attribution and the painting's authenticity. Among them was Margaretta Salinger of the Metropolitan Museum in New York. But they were drowned out by the highly efficient propaganda machine of the museum, and officialdom.

The van Meegeren story was certainly one of the most colorful of the kind during the century. It tells us different things: connoisseurship in the field of arts, and more especial-

ly, Old Master paintings, is and remains a matter of personal opinion. Technical and scientific examinations can be fooled as well as the simple human eye. *Christ at Emmaus* tested positive in chemical as well as radioscopic and microspectroscopic examinations. As a matter of fact, the debate is not closed yet. The late Belgian expert Jean Decoen spent almost forty years trying to prove the authenticity of at least some of the paintings ascribed to the Dutch forger.[41] Some aspects of the affair are still troubling, but I am inclined to believe van Meegeren's boast that he was the author of a good half dozen "Vermeers" to be now definitely eliminated from the master's oeuvre.

Oeuvre

At the start, we encounter difficulties when trying to provide an overall view of the artist's oeuvre and artistic approach. Since the 1930s, an art-critical consensus has evolved that the artist had started his career as a history painter, that he was strongly subject to Italian influences during his early years, and that it was only after having overcome these early predilections that he indulged for the remainder of his lifetime in the subjects for which he is primarily known and that are responsible for his fame: interiors, landscapes, and a few portraits.

In view of the fact that the "early" group is totally different in style and execution from the Vermeer that we believe to know, it is relevant to review the attributions with a critical eye. The cornerstone for the hypothesis "Vermeer—history painter" is the *Procuress* in Dresden, signed and dated 1656 on the lower right. It is considered "a touchstone for his early style,"[42] dependent upon a painting of similar content by Dirk van Baburen from 1622(!) in the Boston Museum of Fine Arts, and said to depict an episode from the story of the Prodigal Son. The fact that Vermeer seemed to have owned the Baburen canvas, and used it in the background of two of his own compositions, does not constitute proof for Vermeer's having painted the Dresden picture. After all, Vermeer was also a dealer, and Baburen's picture might well have been part of his stock in trade.

Vermeer's signatures, as we encounter them on various paintings, attributions as well as unquestionable ones, differ considerably in the form. The one on the Dresden *Procuress*, for instance, distances itself significantly from, let us say, the way that the *Little Street* in the Rijksmuseum is signed.[43] As already stated, the name was not uncommon in the republic. A number of painters with the same or a similar patronymic are known and identified. It is logical to assume that signatures with different graphical characteristics belong to various individuals, and not to a single one, as previously assumed. The Dresden *Procuress* appears for the first time in 1741, when it was acquired by the elector of Saxony. Whereas almost all the "regular" Vermeers are known to us or described from seventeenth-century catalogs or mentioned in various documents, the *Procuress* as well as the three other so-called early works: *Christ in the House of Mary and Martha*, *Diana and Her Companions*, and lately and entirely improbably, *Saint Praxedis*, are all newcomers. They appeared either in the later part of the nineteenth century (*Diana*) or in the twentieth century. I repeat: no document, no sales catalog, or any other indication exists that Vermeer ever did such "histories," the sole exception being *A Visit to the Tomb*, mentioned in an estate inventory of 1657 and appraised at the low price of fl 20. There is no proof that

the title really signified *The Three Marys at Christ's Tomb*, as currently asserted; I firmly believe, *contra* Montias et al., that this painting was by another Vermeer than the one of Delft.

If these four paintings, which, by the way, are each unlike the other in style as well as in technique (which eliminates the argument of some cultural historians that they are bound together by the motive of female servitude!) are not by Vermeer van Delft, who could be the possible author of them?

When one delves into the realm of attributionism, one must be aware that we know the names of many artists; on the other hand, we know a mass of anonymous works. Art connoisseurship has for a long time attempted to bring the two together, often to no avail. Attributionists work with about 10 to 15 percent of known artistic identities, with less-known ones coming to the fore almost every day, the "case Rembrandt" being a good example. Finally, "attributions to Vermeer in the eighteenth and nineteenth centuries were by no means reliable.[44]

There was one painter active during roughly the same period as Jan Vermeer van Delft, who was often considered in older documents as the author of various paintings now given to Vermeer van Delft, and who has been downsized beyond recognition by modern scholarship. It is Jan van der Meer of Utrecht, who was born in Schoonhoven between 1630 and 1635, and died in Utrecht in 1688. This van der Meer or Vermeer was a painter of histories and portraits. His name was well known to Houbraken, Weyerman, van Eynden, and more recently, to Kramm and Nagler.[45] We are informed that he went to Rome with Lieve Verschuier, lived there several years with Drost and Carol Lot, and painted figures in the "grand style." He married a well-to-do widow after his return to Utrecht, and in 1664 became dean of the Utrecht guild of Saint Luke. Although he lost his assets in 1672 on account of the French invasion, he seems subsequently to have regained his fortunes.

In their eagerness to diminish the image of this artist in order to credit Vermeer van Delft with his works, modern critics leave us with little knowledge of what his paintings were really like. Some rare portraits given to him do not agree with the reputation that he enjoyed during his lifetime. These paintings might very well be by another Vermeer van Utrecht. Wurzbach lists him as Jan van der Meer III(!). There were thus at least two more painters by the same name active in Utrecht.

Two works by the "early" group used to be attributed to him, before considering the master of Delft as the author. This was the Dresden *Procuress*; and *Diana with Her Companions* in The Hague. The former was purchased as a work by Jan van der Meer van Harlem, later changed to Jan Vermeer van Utrecht. It is only Smith, who proposed Vermeer van Delft—on very little evidence, all considered. The *Diana* in The Hague was first given to Nicolas Maes, then to Vermeer van Utrecht. The signature, now hardly visible and blurred, does not constitute credible evidence. Furthermore, the painting is crude in the execution, as far as one can still ascertain, given its very poor state of preservation. It has been cut down on the right side.

Christ in the House of Mary and Martha came to light in 1901, the signature (quite uncommon in the form) a year later, while the painting was in dealer's hands! This painting has nothing to do with Vermeer van Delft, as already stated by Wurzbach in 1910.[46] Hofstede de Groot had his doubts, as reported by Swillens, whose opinion is also decidedly neg-

ative. *Saint Praxedis* turns out to be the weakest part of the construction, which artificially attempts to make the young Vermeer van Delft a painter of histories and has him therefore study in Utrecht.

To summarize: there is not a shred of evidence, documentary or otherwise, that Vermeer ever stayed in Utrecht for any length of time or studied there. The hypothesis of his having been a painter of histories in the early years is purely circumstantial. If we consider that the whole group consists of works that are each entirely different in style, conception, and technique from the others, the only thread that binds them together are the signatures. However, they vary in each case in the form of their writing and are therefore highly suspect. Nothing proves that they were not the mark of one of the—at least—six Vermeers or van der Meers known to have been active during the same period. The known-to-be authentic Vermeers bear, when they are signed, signatures of a different handwriting. Even there, one must take into account that Vermeer van Delft—having become a sort of collective name in the eighteenth and nineteenth centuries—signatures, such as on the *Astronomer* and the *Geographer* (works obviously dating from the 1660s), have been adjudged either questionable or outright spurious.

On the other hand, Vermeer's namesake from Utrecht was well known as a painter of histories, and had built a respectable reputation and fortune on such works. Common logic, or an application of Occam's razor, demands that the simplest of competing theories is preferred to the more complex. This writer submits that the current thesis is nothing but a fad, attractive to authors given to theoretical speculation and building of scholarly-sounding card houses. In due time, all this will pass.

The chronological sequence of Vermeer's paintings is uncertain. One commonly adduces two dates: the one from the *Procuress*, which bears the date 1656, can be discounted because the painting is by another master. The *Astronomer* at the Louvre bears a doubtful signature and date (1668). It, as well as the two signatures and the date 1655 on the *Saint Praxedis*, can be disregarded. Hence, we must rely, for the chronology of Vermeer's paintings, upon stylistic and technical characteristics. Groups of works can be placed accurately. Individual paintings within the specific group can then be assigned probable dates.

The first such ensemble are paintings that avow a decidedly Rembrandtesque influence in the composition as well as the use of light. We consider the *Girl Asleep* at the Metropolitan Museum in New York as the first known and certain work by the master. Its closeness to the style of Nicolas Maes has been stressed by various authors, and if Vermeer himself had not spent some time in Rembrandt's studio, as I surmise, we have at least direct connections to the Leyden master through Carel Fabritius and Leonard Bramer. Having eliminated the erroneous early attributions, this painting can be dated as early as Vermeer's inscription in the Delft guild of Saint Luke, i.e., 1653.

The Rembrandt impact continues with *Girl Reading at an Open Window* at the Gemäldegalerie, Dresden. It was, in fact, purchased as a work by the Leyden master for August II, elector of Saxony in 1742, and reattributed to Vermeer van Delft in 1806. A date of 1654 seems probable.

With the *Officer and Laughing Girl* from the Frick Collection in New York, we arrive at the de Hooch–related period of the master. Vermeer still remains close to the Rembrandtesque technique of his earlier works in the use of heavy paste and impasto high-

lights. But the intensified use of light and the shift to more pronounced action make it evident that we stand here at the threshold of a new pictorial experience. With the elimination of the so-called early works, it becomes plausible that it was Vermeer who inspired Pieter de Hooch in his interiors and genre scenes that begin in the mid-1650s. His, rather than de Hooch's, was the creative mind that brought about the change of emphasis, subject matter, and new approach that were responsible for the relatively short blooming of the master from Rotterdam during these years. When de Hooch moved on to Amsterdam, his imagination declined. Vermeer went on to new heights.

The high point of these years was certainly reached in the *Milkmaid*, now at the Rijksmuseum. Although picturing a scene from a lower stratum of society, the grandeur and aloneness of the single figure was never again matched in Dutch painting. Still dependent in this canvas upon the granular pigmentation inherited from Rembrandt when he painted the *Nightwatch*, the light creamy background owes a distinct debt to Carel Fabritius. The use of some optical instrument, probably the inverted Galilean telescope, appears evident in the presence of the globules of paint that are spread over the still life in the left foreground.

With Vermeer's two known landscapes, the *Little Street*, at the Rijksmuseum, and the *View of Delft*, at The Hague, we arrive at the end of a series of works that are executed in heavy and bold paint. One of my masters, the late and regretted Leo van Puyvelde, used to alert his students to the fact that artists do not evolve according to an evolutionary curve, but may use different manners and techniques at the same period. One cannot therefore assert that paintings executed in a smoother manner must be later than the preceding ones. However, it seems that with the aforementioned series, the early manner peters out, giving way to an artist more conscious of his social standing and therefore preferring settings that picture upper-class life. We would therefore range all the preceding group into the 1650s, beginning with Vermeer's admission to the Delft guild in 1553, and setting as the final date, also for the landscapes, of about 1660.

The ensuing group features genre paintings on a genteel level. Parallels have been drawn with more or less contemporary works by Pieter de Hooch, Gabriel Metsu, Frans Mieris, Jan Steen, and less-known artists such as J. Vrel and Cornelis de Man. The latter preceded Vermeer as board member of the guild of Saint Luke, when Vermeer took his place in 1670. We have here first the *Glass of Wine* at Berlin-Dahlem; the *Girl with the Wine Glass* at the Herzog-Anton-Ulrich Museum, Braunschweig; *Girl Interrupted at Her Music*, Frick Collection, New York; the *Music Lesson*, collection of the Queen, Buckingham Palace, London; and the *Concert*, from the Isabella Stewart Gardner Museum, Boston. Generally speaking, these genre scenes feature two or more figures in an elegant, light-filled interior, which is more of a pattern than a realistic representation of a given *locus*. Sometimes, Vermeer places his well-dressed and elegantly clothed figures back in the space; at other times, he draws them forward to give them more emphasis. The whole group cannot easily be set into a chronology. It seems that they were interspersed over a period of about ten years, starting around 1658, and ending around 1668. The brushstroke in these paintings becomes extremely refined, fitting with the subject matter; every detail is exquisitely modeled.

Aside from these interior scenes, which must have strongly appealed to a newly prosperous public, Vermeer produced during these years a series of single figures that

stressed more domestic aspects. One of the first is *Woman in Blue Reading a Letter* from the Rijksmuseum; it is different in the execution from the *Milkmaid* or the *Girl Reading a Letter at an Open Window*. Here, the painting is flooded with light; though the woman is portrayed in profile, the shift from the former Rembrandtesque conception to greater abstraction becomes apparent. It must have been around 1660 that Vermeer had his first encounters with Indonesian art and Buddhist philosophy. The stillness, quietness, and spiritual aloneness of the *Woman in Blue* reflect the awareness of contemplation taught by these Asiatic creeds, and reinforces the Asian's rejection of the outer world by the simplified, though luminous, color scheme that reaches out for inner enlightenment of the soul.

A Woman Holding a Balance at the National Gallery, Washington, D.C., continues the series. The light is more intimate and diffuse, but in attitude and lack of individuality, this woman is a sister to the *Woman in Blue*.

In his *Woman with a Pearl Necklace* at Berlin-Dahlem, the same model is placed more to the right and shown at the exact moment when she tightens the ribbons of her jacket around her neck. Although shown in a moment of stillness, this representation does not seem to be imbued with spiritual meaning, unless one allows a woman contemplating herself in a mirror the benefit of intense inward preoccupation. *Woman with a Lute*, at the Metropolitan Museum in New York, must have been a reversion to Rembrandt's dramatic chiaroscuro effects. It shows the great and continuous influence of the master of Leyden. Unfortunately, the painting is a ruin and cannot be considered anything but a document. *Young Woman with a Water Jug*, from the Metropolitan Museum, and *A Lady Writing*, at the National Gallery, Washington, round out the group, which might find its terminal date around 1668.

There are two known girl's heads, which may or may not have been conceived as portraits. They were dubbed *tronies* during the seventeenth century, meaning any kind of head or bust, whether products of the artist's imagination or individual representations. The first is *Girl with a Pearl Ring* from the Mauritshuis. It is a head wearing a blue and yellow turban, turned toward the viewer, that stands out plastically against the dark background.

As in the following item, *Portrait of a Young Woman* in the Metropolitan Museum, the artist stresses the abstract side and generalization of features. We do not have here an individual, but in both instances, an idealized type. The concept of depersonalization and Oriental canons comes strikingly to the fore in these portraits, and confirms the empathy with, and dependence upon, Indonesian art forms that can be regarded as one of the explanations for Vermeer's atypical productions in a Dutch environment.[47] I would propose to date the paintings close to each other, perhaps from the mid-1660s. The portrait from The Hague is, unfortunately, in bad shape.

Aside from the *Milkmaid* and the *View of Delft*, the *Allegory of Painting*, now in the Vienna Kunsthistorische Museum, counts among Vermeer's most famous creations. Not only is it an allegory, but the composition of only two figures with the painter seen from behind is filled with paraphernalia and emblematic allusions. Its size alone establishes it as an important work, but it was also extremely carefully executed, to judge by what is left after the restoration. It must date from the late 1660s.

The *Lacemaker*, from the Louvre, Paris, almost equals the other three works in the favor of the public. Who could resist this brilliant study of the lacemaker's craft, small in

size, executed with the patience of a jeweler, and, at the same time, featuring a loose brushstroke? The highlights of the threads in the foreground and the ensuing withdrawal of the young girl into the middle-ground are typical for the use of the inverted telescope. The painting dates from the end of the 1660s.

Two curious works in the oeuvre of Vermeer are the *Astronomer*, from the Louvre, and the *Geographer*, at the Städelsche Kunstinstitut, Frankfurt, which seem to have been conceived as companion pieces.

Their signatures, as well as the date "1668," are questionable. However, it seems probable that the paintings were indeed executed around 1668–70. Both represent men engrossed in their professional pursuits.

A connection with Vermeer's interest in optics may well have brought about the commission for what are possibly portraits. In both professions, an interest in the Galilean telescope seems plausible.

Two compositions from about the same time—the late 1660s—introduce us to mistresses receiving a letter from the hands of their maids. *Mistress and Maid*, at the Frick Collection, focuses on figures in bust-length, drawn near the viewer and thereby establishing an interrelationship between him and the painted scene. The background is again dark, but both mistress and maid are plainly illuminated. The second version of the theme, *The Love Letter*, at the Rijksmuseum, presents us with an entirely different *mise en scène*. The actors, in a compact group, are seen through a doorway. The room is sunlit, and the use of the inverted telescope becomes clearly discernible in the rendering of the framework, the remoteness of the main scene, and the clearness of the paraphernalia on the back wall, as opposed to their blurring in the part of the picture closest to the viewer. A third related theme is that of *Lady Writing a Letter with Her Maid*, collection of Sir Alfred Beit, Blessington, Ireland.

With this painting, we enter the last phase of Vermeer's artistic evolution, announcing his decline. It is cold, the standing maid stiff, and the whole lacking the psychological impact of his works of the 1660s. Although the artist remains a powerful craftsman, the excitement of the preceding paintings is lacking. This, and the following canvases that date from the 1670s, show the slow burnout of Vermeer's genius. Little by little, his technique becomes shallower, his imagination less suggestive, until the artist's sudden passing away terminated a thrilling career, and what could have become a banal *finale*. There was a last flare-up of the painter's genius, the *Guitar Player*, at the Iveagh Bequest, Kenwood, London. Free in the brushstroke, and glowing in colors, this work is a true masterpiece. On the other hand, *Allegory of Faith* at the Metropolitan Museum in New York, interesting for its iconographical content, strikes us only as a well-executed exercise in academic painting.

With the two canvases *A Lady Standing at the Virginal*, and *A Lady Seated at the Virginal*, both at the National Gallery, London, we come to the end of Vermeer's known works. The artist veers here into a purely decorative style.

The technique has become flat, the faces expressionless dolls, and the design, especially of the arms, wooden and insipid. He remains a competent technician in the rendering of paraphernalia, but the spark is extinct. These paintings are not "a natural culmination of Vermeer's evolution as an artist," as Wheelock would have it, but an obvious and depressing example of creative decay.

We ignore whether Vermeer had any disciples. Neither the guild books, nor other documents or contemporaneous sources make any mention to that effect. Given his slow and meticulous technique, it seems more than probable that he worked alone. It seems therefore tenuous to assign questionable paintings to the "circle of Vermeer," the more so because we know of neither followers nor imitators of his style. Most of these attributions, of which more are in the ensuing catalog, are simply later pastiches, or falsifications, primarily from the nineteenth century and fabricated in France.

We reprint hereafter from the "Catalog of Paintings. Sold on 16 May 1696, in Amsterdam" the list of paintings by Vermeer, which stemmed most probably from the collection of Jacob Abramsz. Dissius, with the prices fetched. The catalog constitutes the principal source of our knowledge of Vermeer's oeuvre.

1. A young lady weighing gold in a box by J. van der Meer of Delft, extraordinarily artful and vigorously painted; fl 155.
2. A maid pouring out milk, extremely well done, by ditto; fl 175.
3. The portrait of Vermeer in a room with various accessories, uncommonly beautiful, painted by him; fl 45.
4. A young lady playing the guitar, very good, of the same; fl 70.
5. In which a gentleman is washing his hands, in a see-through room, with sculptures, artful and rare, by ditto; fl 95.
6. A young lady playing the clavecin in a room, with a listening gentleman, by the same; fl 80.
7. A young lady who is being brought a letter by a maid, by ditto; fl 70.
8. A drunken sleeping maid at a table, by the same; fl 62.
9. A merry company in a room, vigorous and good, by ditto; fl 73.
10. A gentleman and a young lady making music in a room, by the same; fl 81.
11. A soldier with a laughing girl, very beautiful, by ditto; fl 44-10.
12. A young lady doing needlework, by the same; fl 28.
31. The town of Delft in perspective, to be seen from the south, by J. van der Meer of Delft; fl 200.
32. A view of a house standing in Delft, by the same; fl 72.10
33. A view of some houses, by ditto; fl 48.
35. A writing young lady, very good, by the same; fl 63.
36. A young lady adorning herself, very beautiful, by ditto; fl 30.
37. A lady playing the clavecin, by ditto; fl 42.10
38. A "tronie" in antique dress, uncommonly artful; fl 36.
39. Another ditto Vermeer; fl 17.
40. A pendant of the same; fl 17.

A number of these paintings can be identified from the subject matter.

Notes

[1] Lawrence Gowing, *Vermeer* (New York and Evanston, 1952 and 1970).

[2] Th. Thoré-Bürger, "Van der Meer de Delft," *Gazette des Beaux-Arts* 21 (1866): 297–330, 458–70, 542–75.

[3] Hans Sedlmayr, "Zu einer strengen Kunstwissenschaft," in *Kunstwissenschaftliche Forschungen*, vol. 2 (Vienna, 1931), pp. 7–32.

[4] Dr. A. Martin de Wild, "L'Examen Chimique des Tableaux," in F. E. C. Scheffer, *Mouseion, Office International des Musées* 13–14, 1931.

[5] Daniel V. Thompson, *The Materials and Techniques of Medieval Painting* (New York, 1956), passim.

[6] De Wild, op. cit.

[7] Erik Larsen, "L'Exposition de la Peinture Hollandaise. Réflexions peu orthodoxes," *Pictura* 1–2 (1946): 37.

[8] A. P. Laurie, *The Painter's Methods and Materials* (London, 1960), passim.

[9] cf. E. Berger, *Beiträge zur Entwicklungsgeschichte der Maltechnik* (Munich, 1893, and following years).

[10] Alexandre Ziloty, *La Découverte de Jean van Eyck* (Paris, 1941).

[11] T. De Mayerne, *Pictora Sculptoria et duae subalternarum artium*, 1620. New ed. by J. A. van de Graaf (Utrecht, 1958), passim.

[12] Gérard de Lairesse, *Le Grand Livre des Peintres* (Paris, 1787).

[13] A. von Wurzbach, *Niederländisches Künstlerlexikon* (Vienna, 1910), vol. 2, pp. 774–77.

[14] Erik Larsen, "The D'Arenberg Vermeer Redivivus," *Apollo* (Oct. 1955), pp. 102–4.

[15] E. Plietzsch, *Vermeer van Delft* (Leipzig, 1911; Munich, 1939).

[16] A. B. de Vries, *Jan Vermeer van Delft* (Paris, 1948).

[17] Light backgrounds occur already during the fifteenth century in portraits by Rogier van der Weyden and his school. In the sixteenth century, they were a constant feature with Lambert Lombard, to be replaced by dark backgrounds in the later part of the century, as, e.g., in the works of Antonis Mor.

[18] Erik Larsen, with the collaboration of Jane P. Davidson, *Calvinistic Economy and Seventeenth-Century Dutch Art*, University of Kansas Publications, 1979, Lawrence, Kansas.

[19] "Discours Quatrième"; cf. Victor Cousin, *Oeuvres de Descartes*, vol. 5 (Paris, 1824).

[20] Cf. Erik Larsen, *Frans Post, Interprète du Brésil*, Amsterdam and Rio de Janeiro, 1962. See chapter 4, "Descartes et la Conception Visuelle de la Nature," pp. 75–93. Idem, "Descartes and the Rise of Naturalistic Landscape Painting in Seventeenth-Century Holland," *The Art Journal* (fall 1964): 12–17; idem, "The Proof of the Use of the Inverted Telescope in Dutch Seventeenth-Century Landscape Art," *Gazette des Beaux-Arts* (May–June 1977): 172–74.

[21] E.g., Leo Battista Alberti, *Della Pittura...*, 1435–36. Viator (Jean Pélerin), *De artificiali perspectiva* (Toul, 1505). Albrecht Dürer, *Underweysung der Messung* (Nürnberg, 1525); Jan Vredeman de Vries, *Artis perspectivae formulae...*, (Antwerp, 1568). Guido Ubaldi, *Perspectivae* (Pisa, 1600). Abraham Bosse, *Manière universelle de Mr. Desargues pour pratiquer la perspective* (Paris, 1648).

[22] J. B. Descamps, *Vie des Peintres Flamands et Hollandais*, orig. ed. (Amsterdam, 1752–63); my reference, the Marseille 1842 ed., vol. 2.

[23] Cf. J. A. Worp, *De Briefwisseling van Constantÿn Huygens*, 's Rijks Geschiedk. Publ., 1911–17. See also letter no. 143.

[24] Paper read at the 1957 C.A.A. meeting.

[25] Larsen, 1962, 1964. See n. 20.

[26] The literature with respect to optical aids in seventeenth-century painting and in eighteenth-century Venice has grown inordinately during these last decades. Charles Seymour and this author were among the forerunners, closely followed by Heinrich Schwarz (1966). The 1970s and 1980s brought further contributions and polemics, often from authors who were not very thorough in their methods of research.

[27] Erik Larsen, "Jan Vermeer van Delft and the Art of Indonesia," *Revue Belge d'Archéologie et d' Histoire de l'Art*, 54 (1985): 17–27.

[28] André Malraux, *Les voix du silence* (Paris, 1951).

[29] Gowing, op. cit.

[30] Op. cit.

[31] Op. cit., 1985.

[32] See for this and the following, G. M. A. Richter, *A Handbook of Greek Art* (London, 1959).

[33] Cf. J. A. K. Thomson, *The Greek Tradition*, p. 22, *apud* Richter.

[34] Op. cit., 1985.

[35] This reasoning is not "highly speculative," as it appears to A. Blankert (*Vermeer*, 1988, p. 163). Eastern, especially Chinese, influences are predominant in Vermeer's own hometown, Delft, since the beginning of the century. Compare with this the famous Delftware. Jan Vermeer's uncle, also an artist (either a sculptor or stonecutter) had journeyed twice to Indonesia. He had certainly brought back examples of this exotic art and shown them to his nephew. A hundred years later, all of Europe bowed to the fashion of the *chinoiseries*. Still later, all the "modern" French nineteenth-century artists drew inspiration from Japanese prints. Blankert is certainly a meritorious author, knowledgeable in the field of connoisseurship. But he never exceeds what Sedlmayr called the first level of art-historical cognition.

[36] See also Larsen, 1979, passim.

[37] Cf. H. Floerke, *Studien zur niederländischen Kunst* (Munich and Leipzig, 1905), pp. 71, 87. Contra Montias, 1977.

[38] *Journal de voyages de Monsieur de Monconys* (Lyon, 1666), p. 147.

[39] See Larsen, 1979.

[40] See Larsen, 1985.

[41] See, e.g., Jean Decoen, *Vermeer-Van Meegeren. Back to the Truth. Two Genuine Vermeers* (Rotterdam, 1951).

[42] Arthur K. Wheelock, Jr., *Vermeer* (New York, 1988).

[43] See for reproductions of signatures: A. Blankert, *Vermeer* (New York, 1981), p. 4.

[44] See A. Blankert et al., *Vermeer* (New York, 1988), pp. 159, 196.

[45] See Wurzbach, op. cit., vol. 2, p. 129.

[46] Wurzbach, op. cit., vol. 2, p. 777, "Impossible by Vermeer."

[47] *Pace* A. Blankert.

Color Plates

Girl Asleep at Table

New York, Metropolitan Museum of Art

[cat. 1]

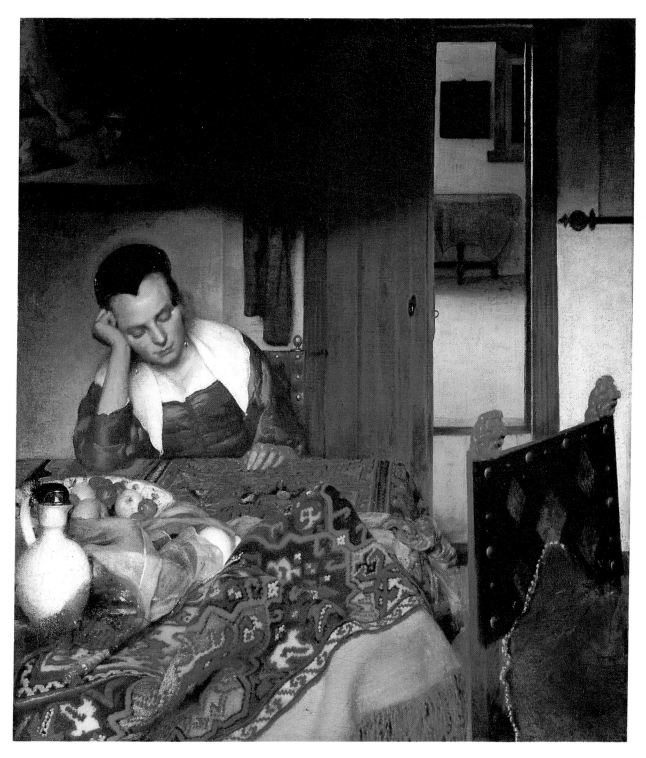

Girl Reading a Letter at an Open Window
Dresden, Staatliche Kunstsammlungen, Gemäldegalerie
[cat. 2]

facing and following page: *details*

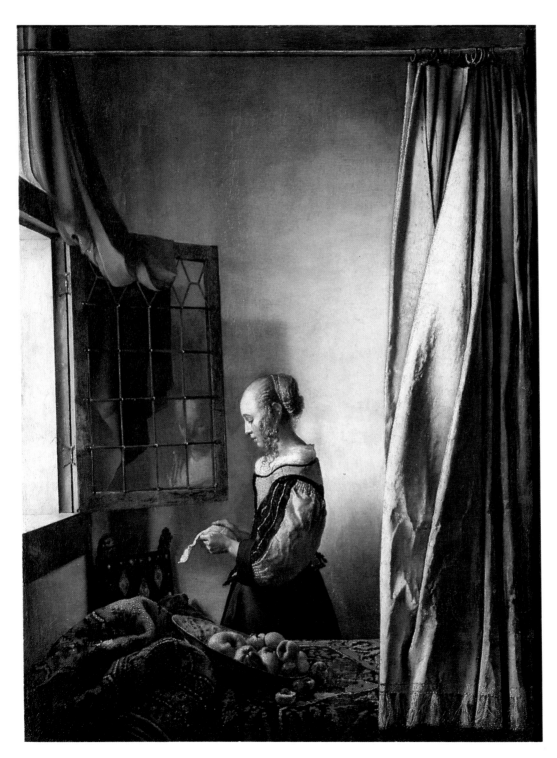

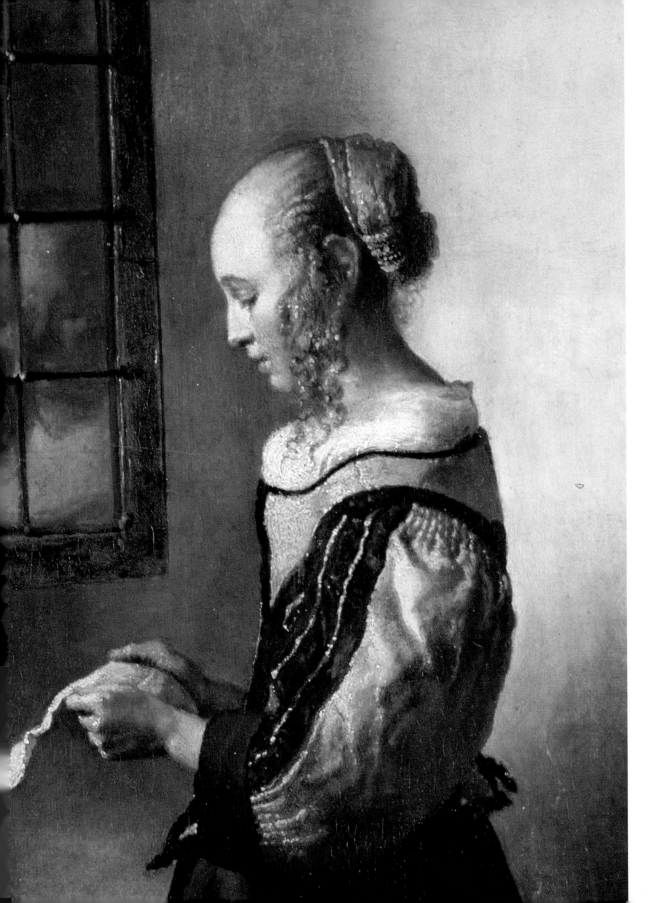

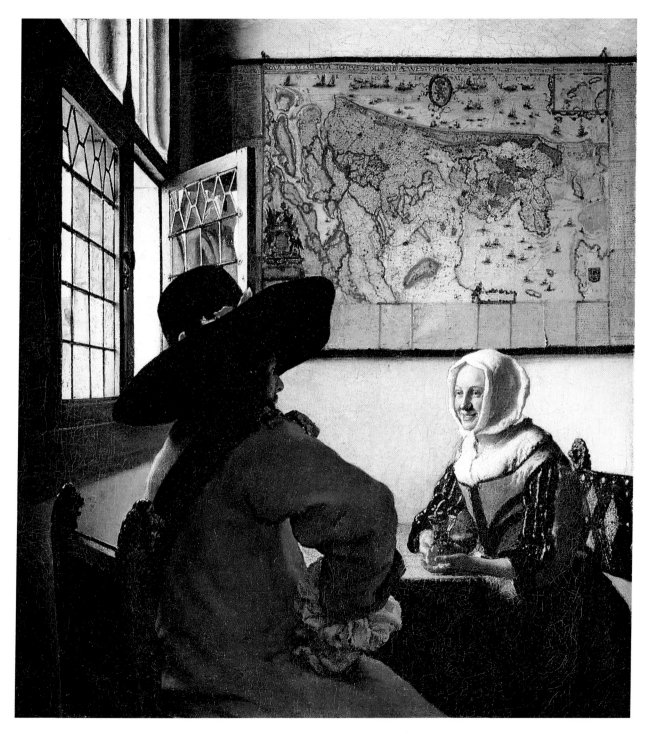

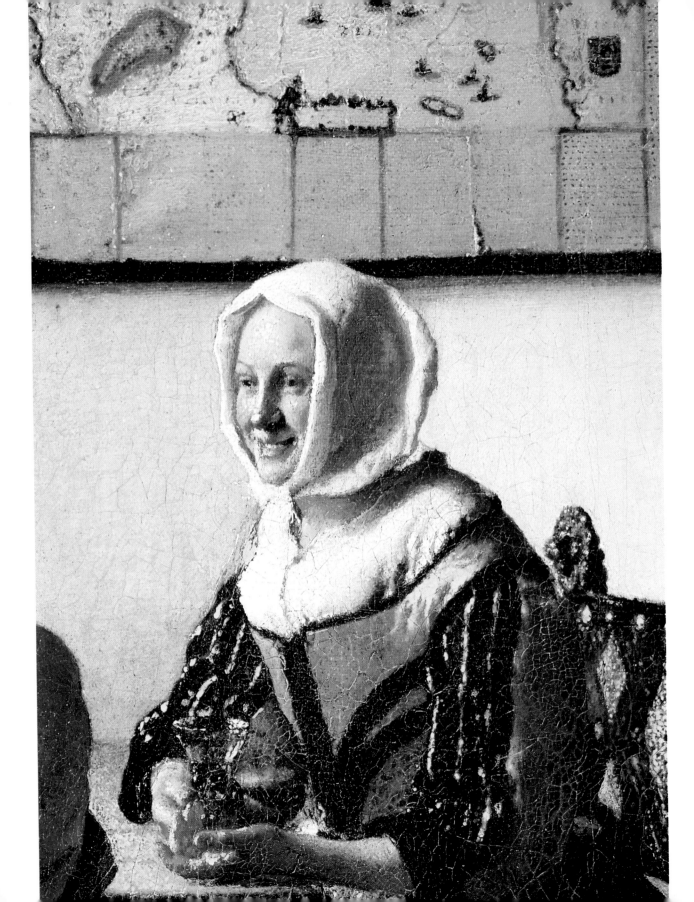

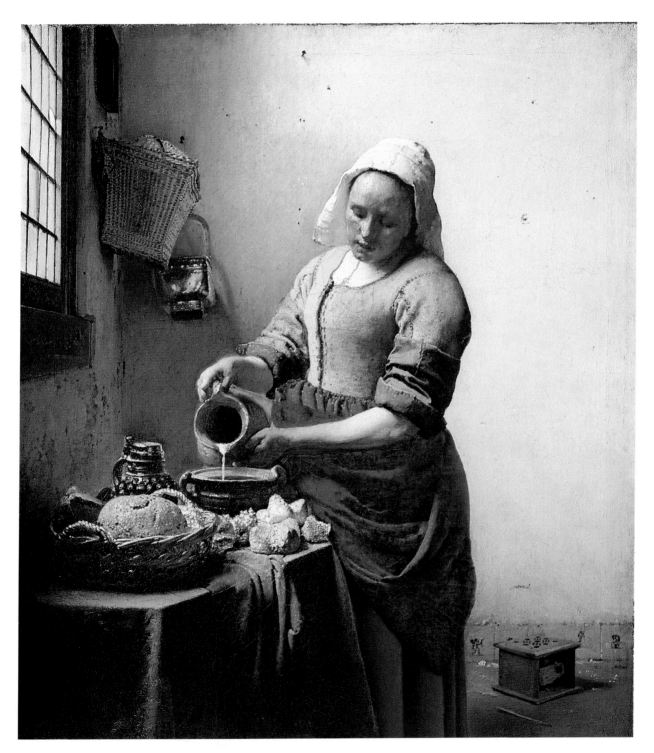

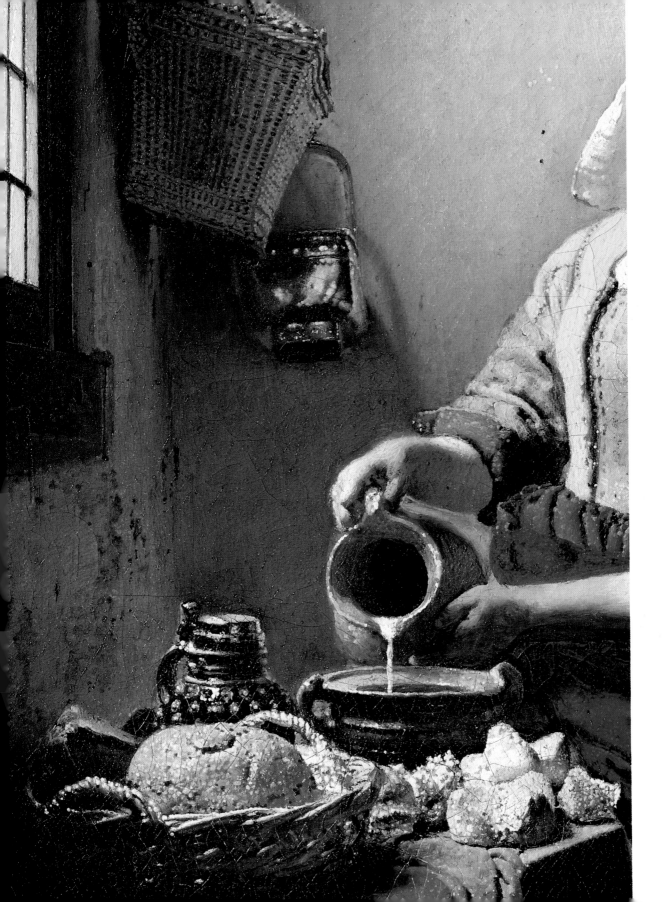

left page: [cat. 4] *detail*

A Lady Drinking and a Gentleman
Berlin-Dahlem, Staatliche Museen,
Gemäldegalerie
[cat. 5]

pages 48-49: *details*

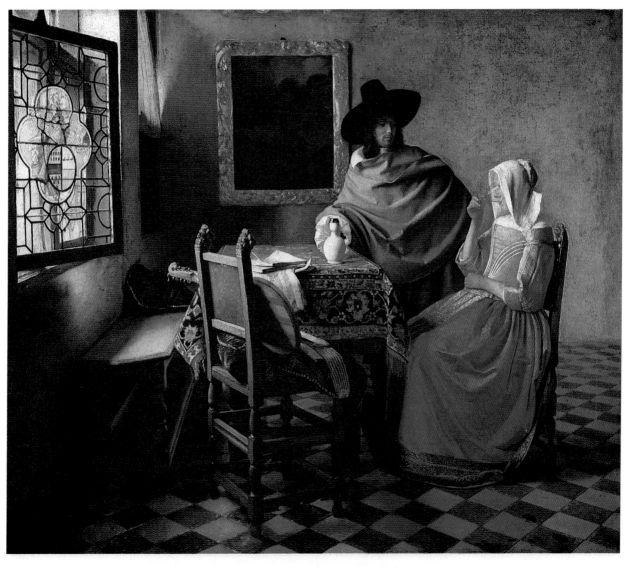

A Lady and Two Gentlemen
Braunschweig, Herzog Anton Ulrich Museum
[cat. 6]

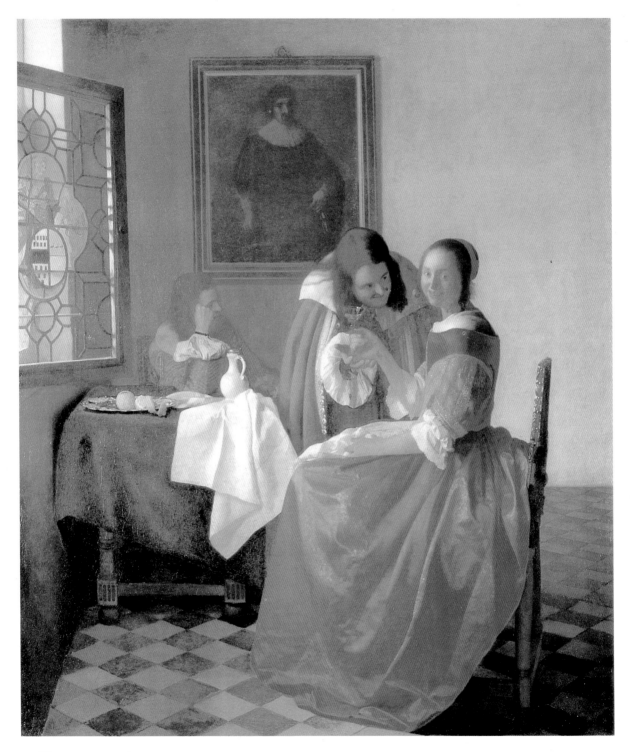

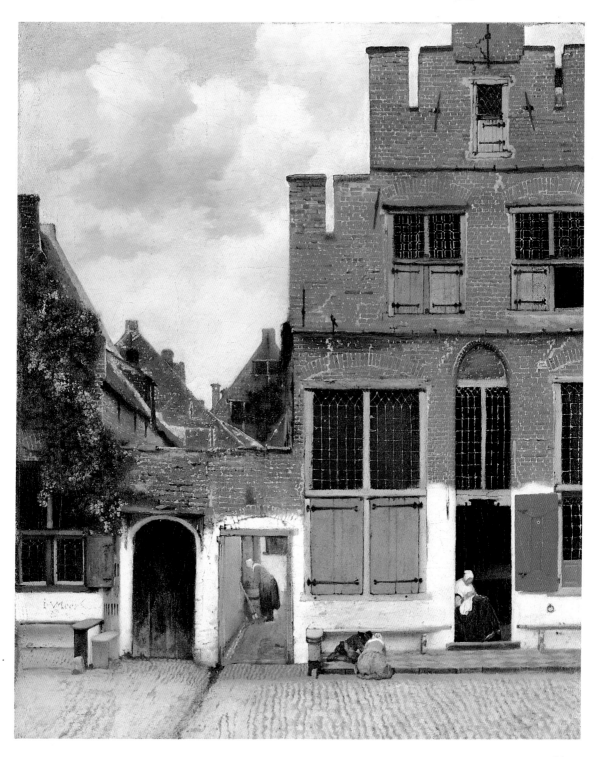

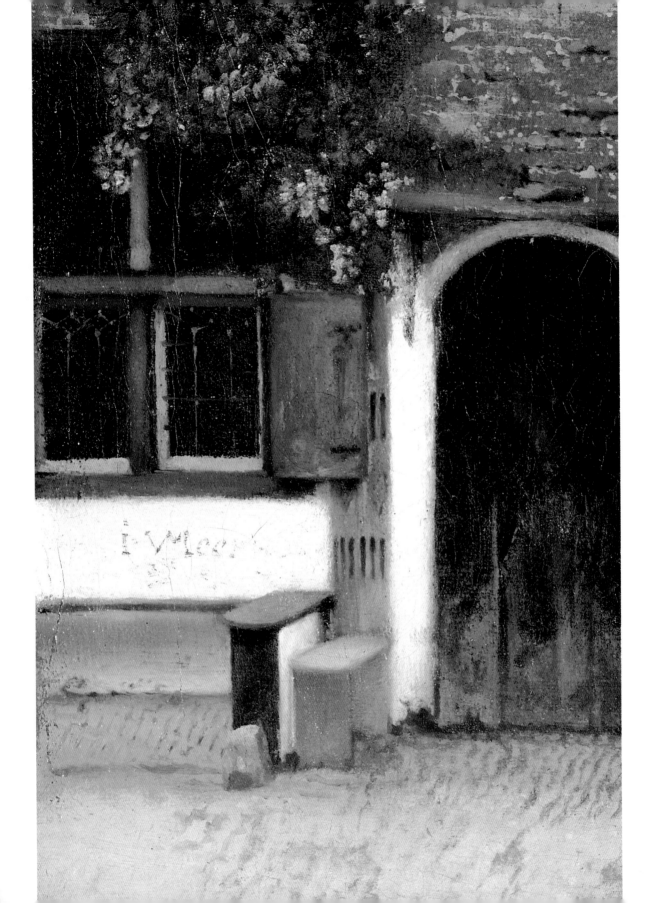

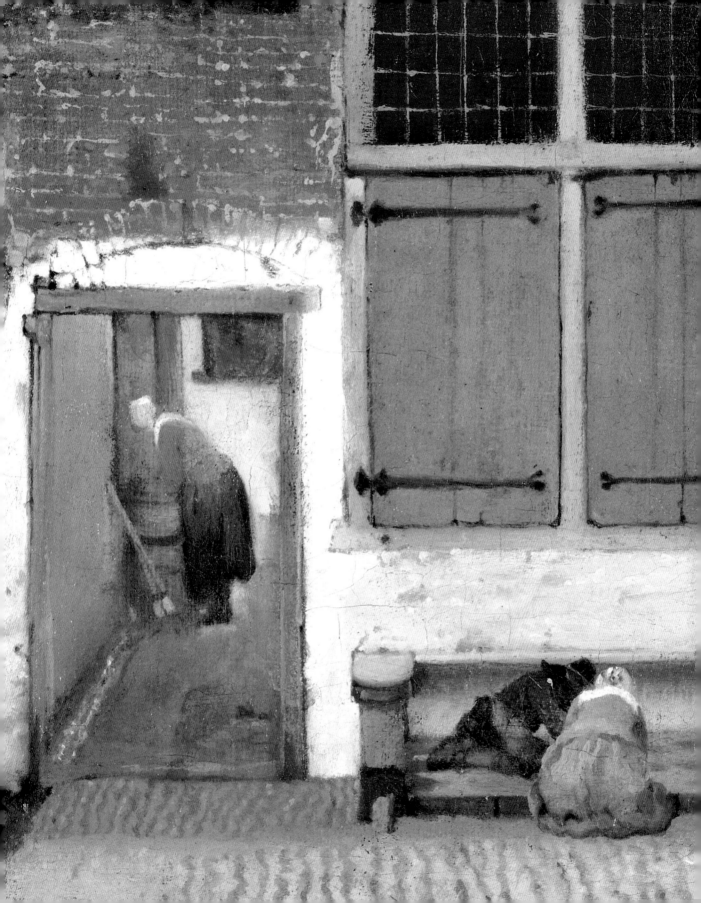

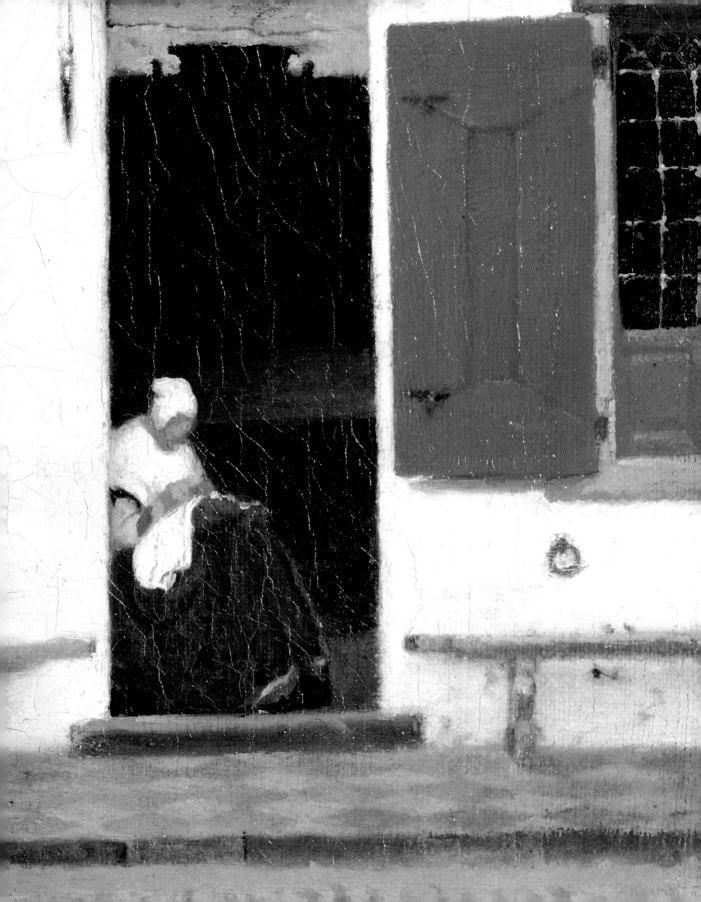

The View of Delft
The Hague, Mauritshuis
[cat. 8]

pages 56-57: *detail*

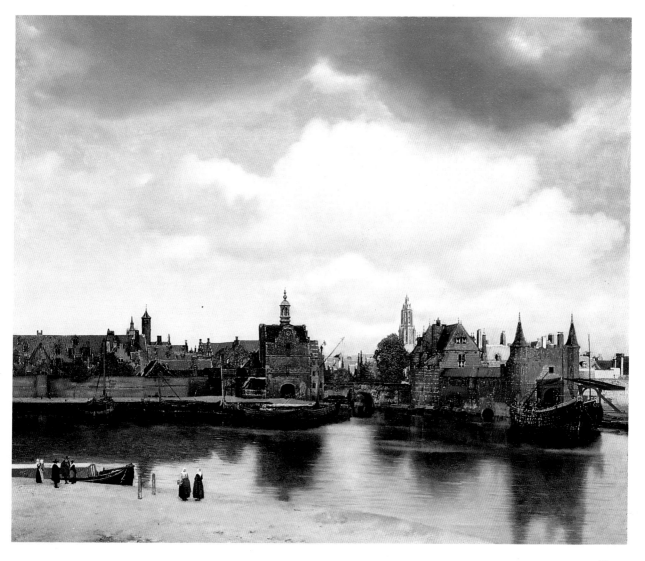

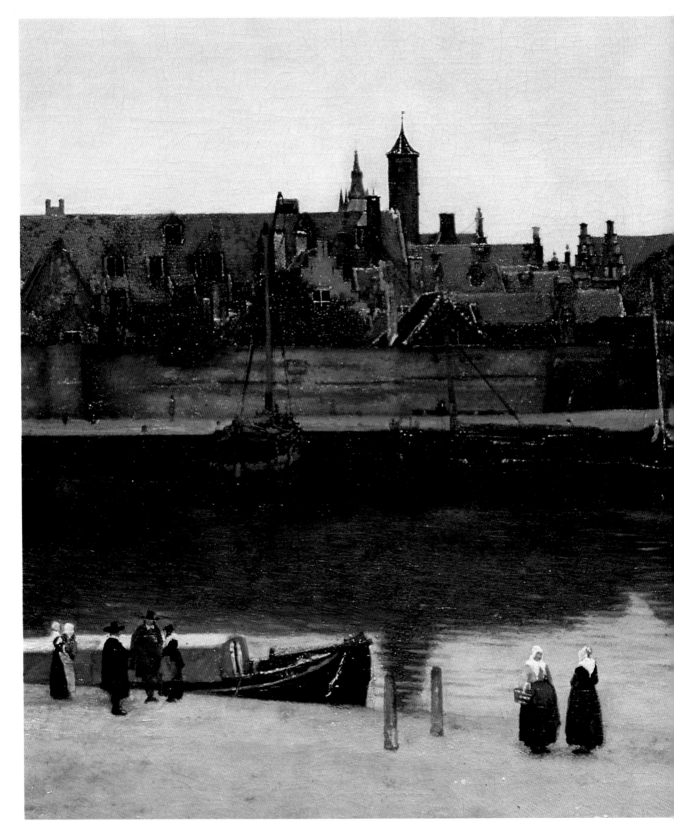

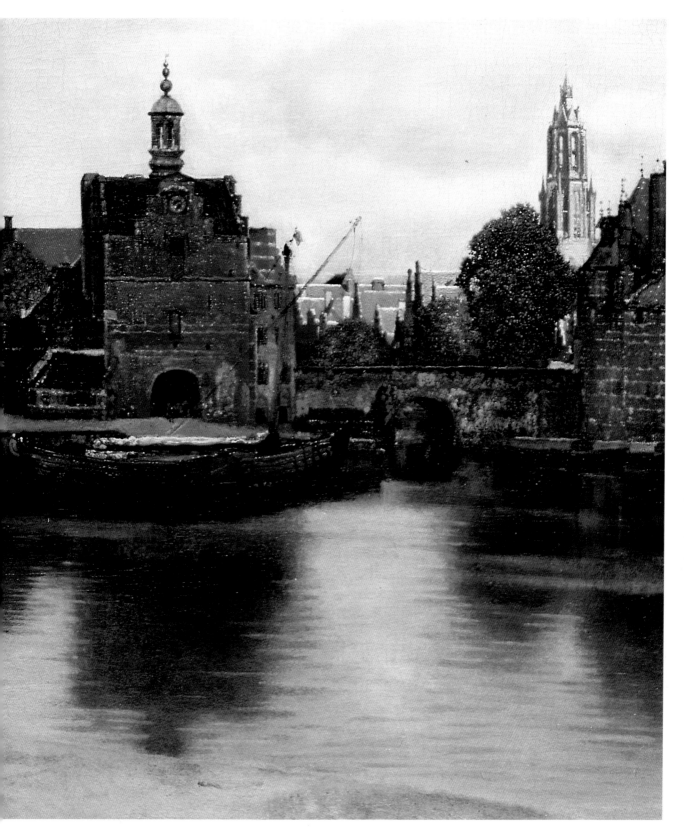

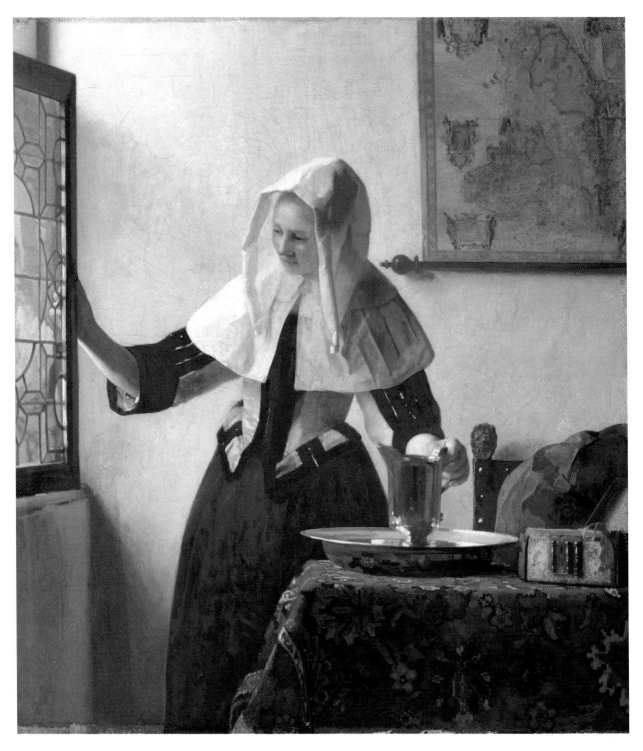

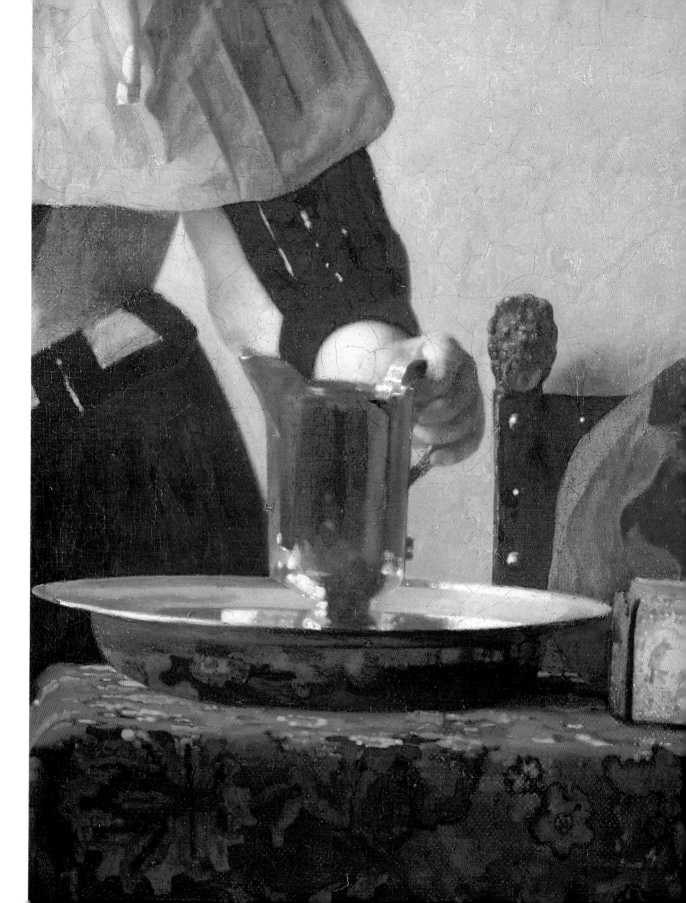

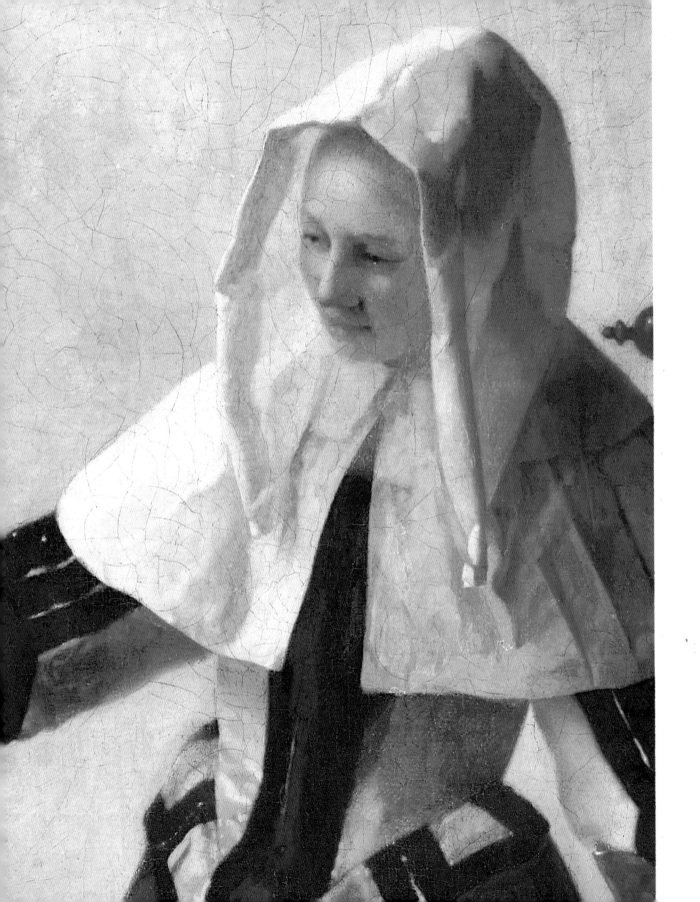

Woman with a Pearl Necklace
Berlin-Dahlem, Staatliche Museen, Gemäldegalerie
[cat. 10]

following page: *detail*

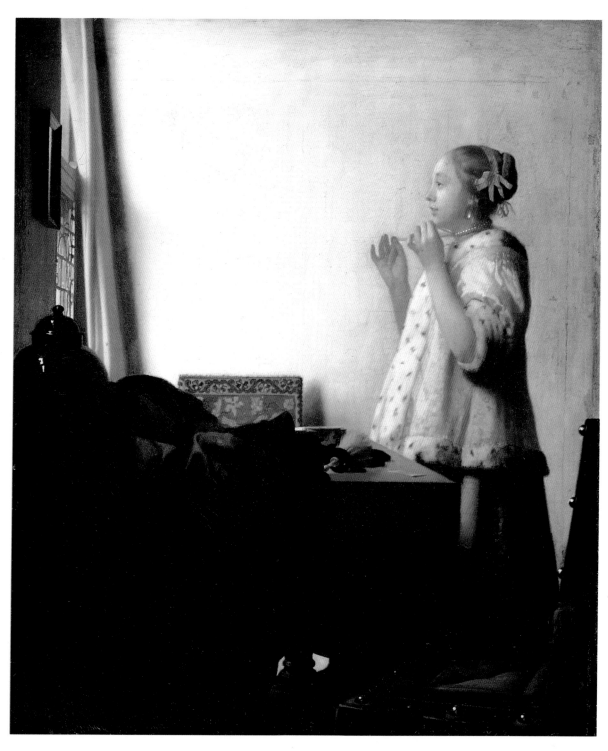

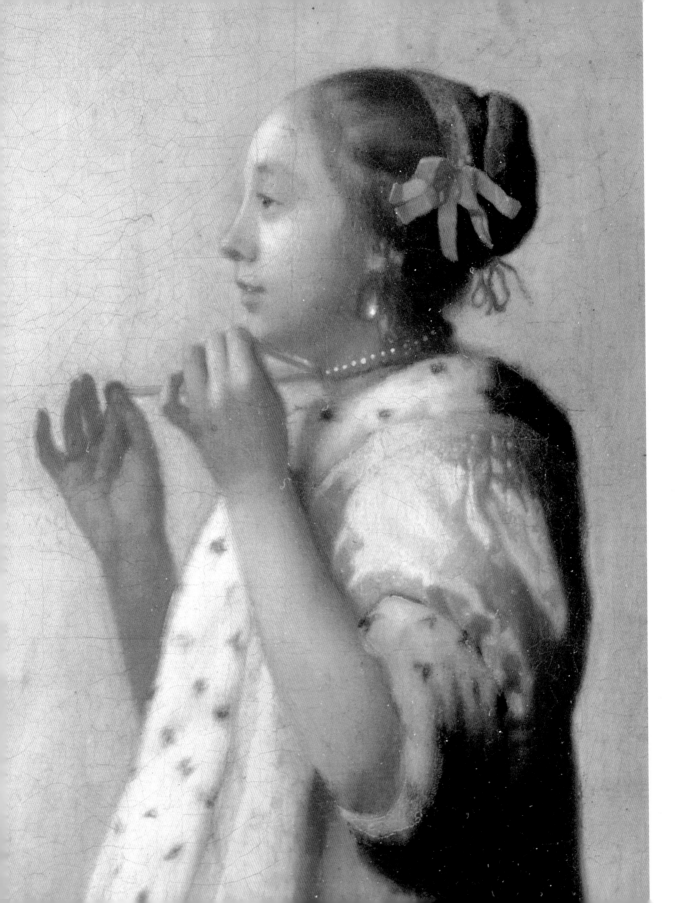

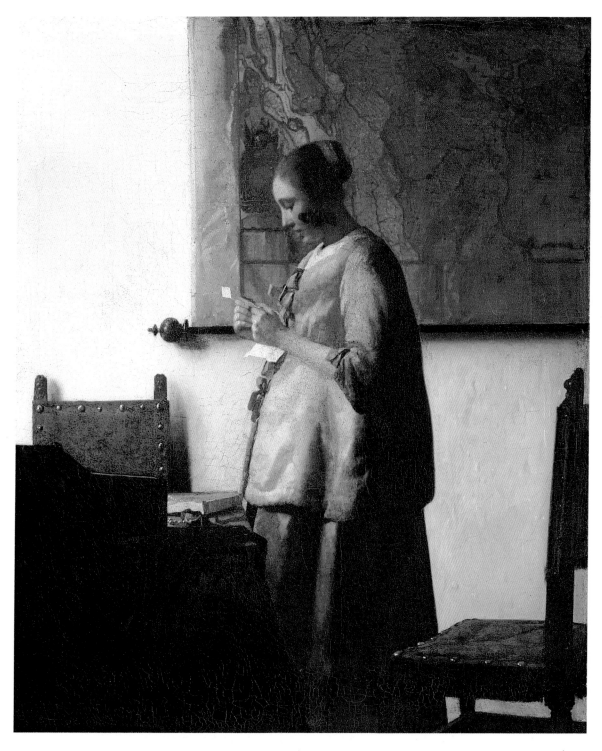

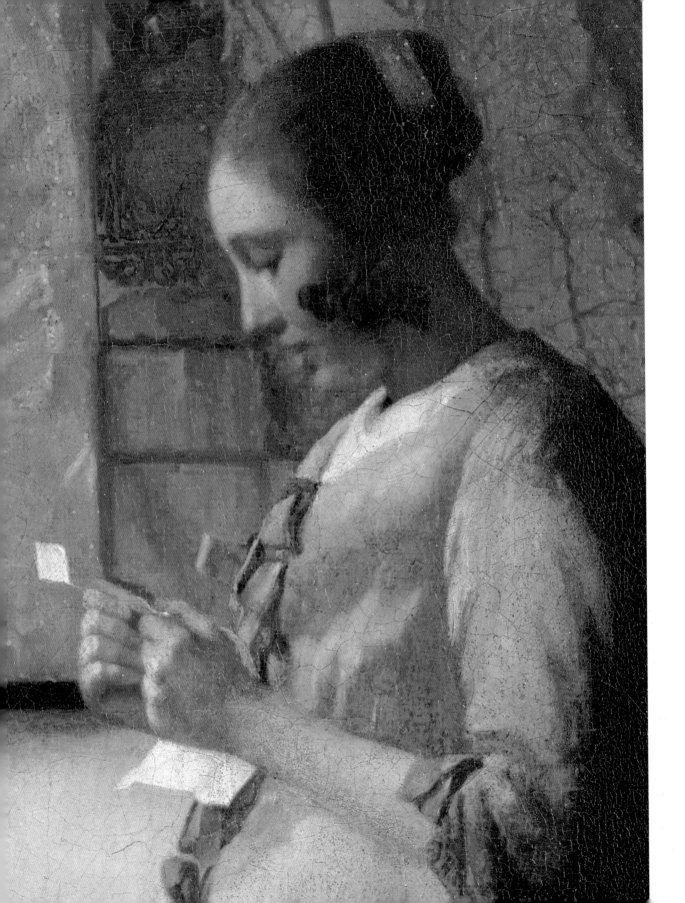

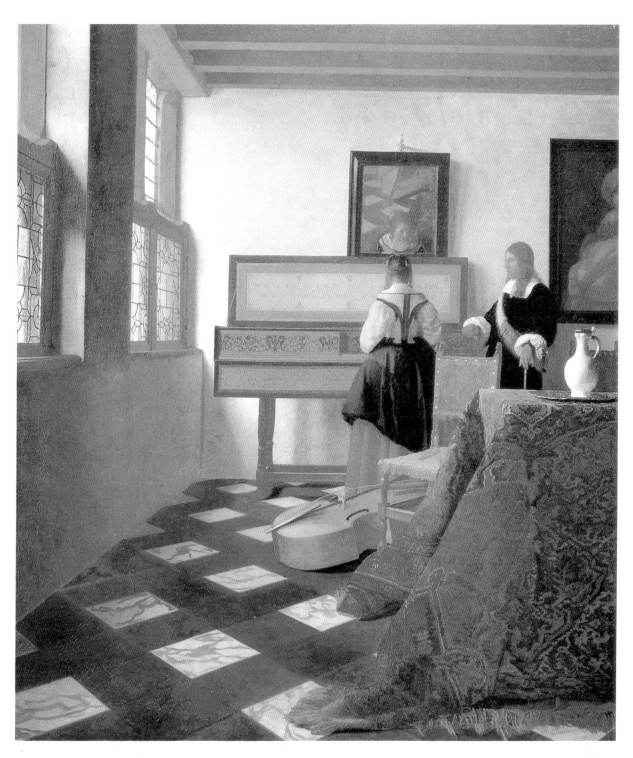

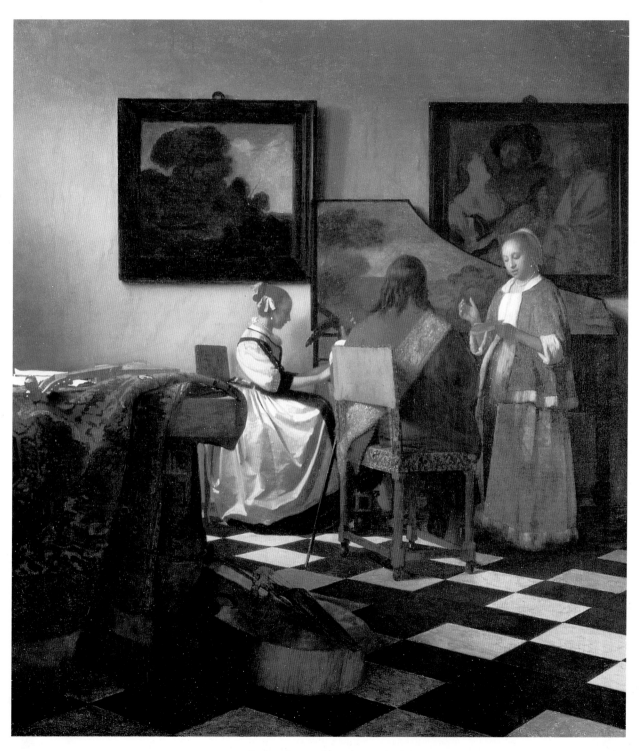

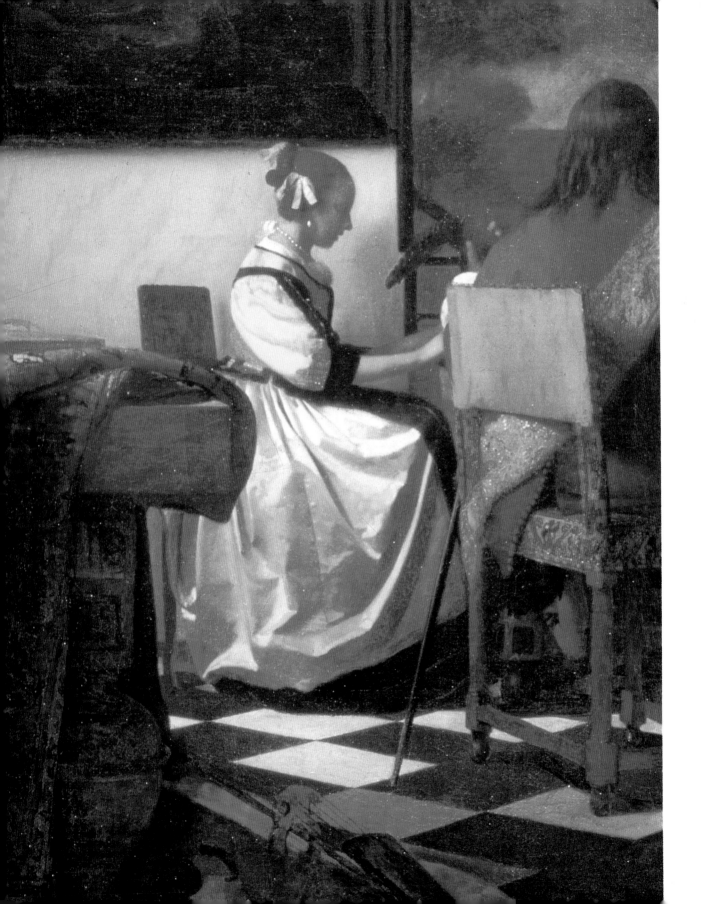

Portrait of a Young Woman
New York, Metropolitan Museum of Art
[cat. 16]

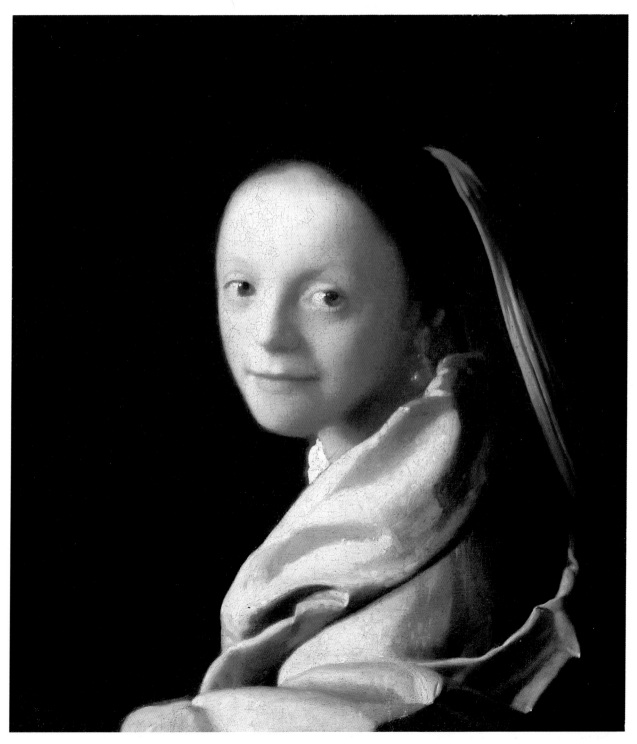

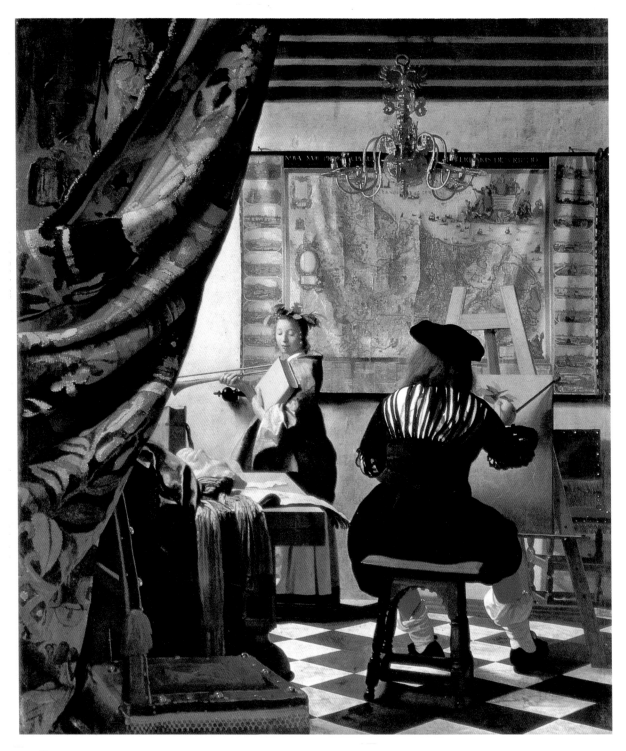

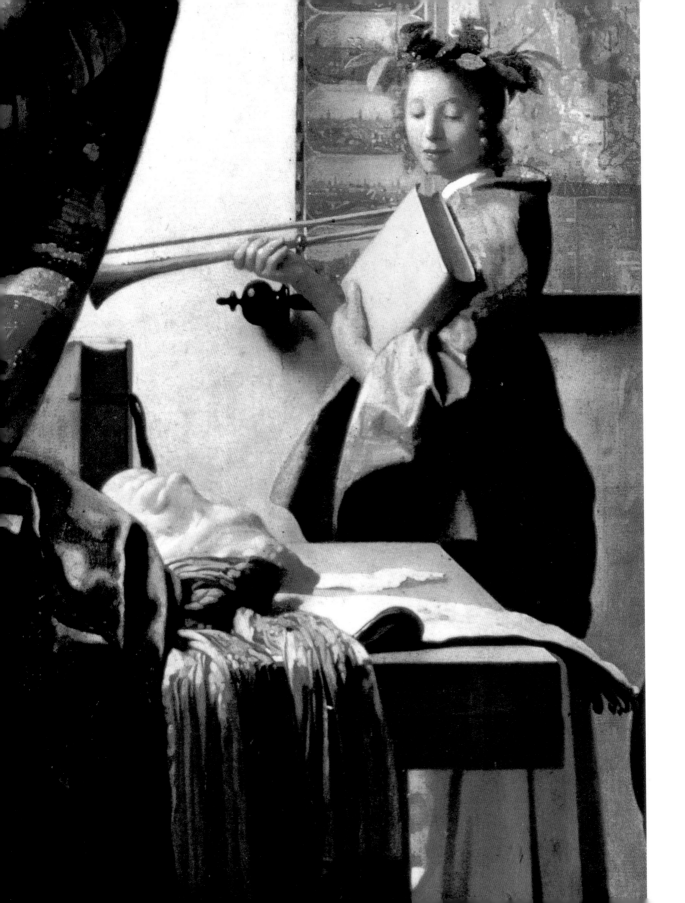

Writing Lady in Yellow Jacket
Washington, National Gallery of Art
[cat. 18]

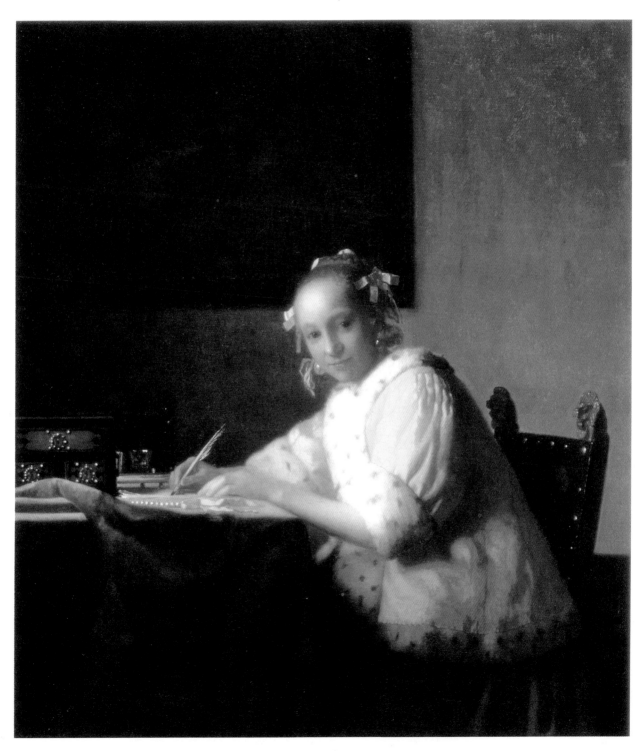

Lady with a Maidservant Holding a Letter
New York, Frick Collection
[cat. 19]

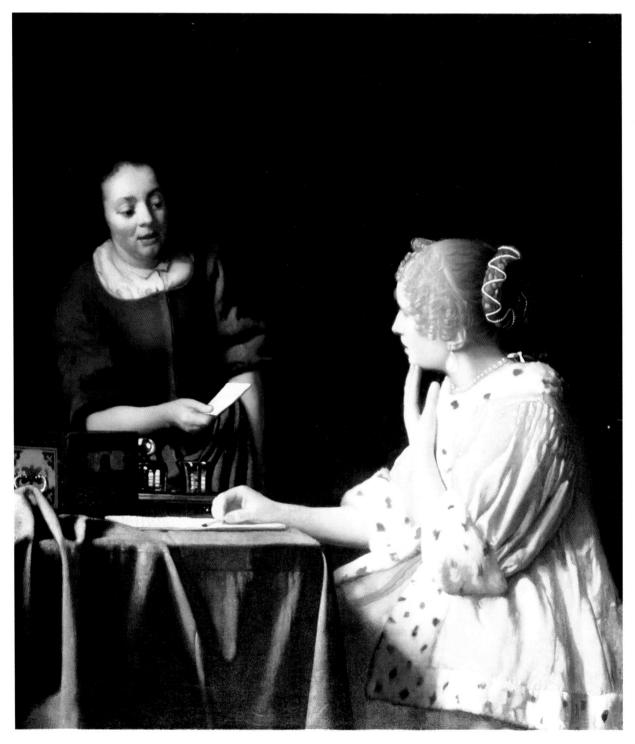

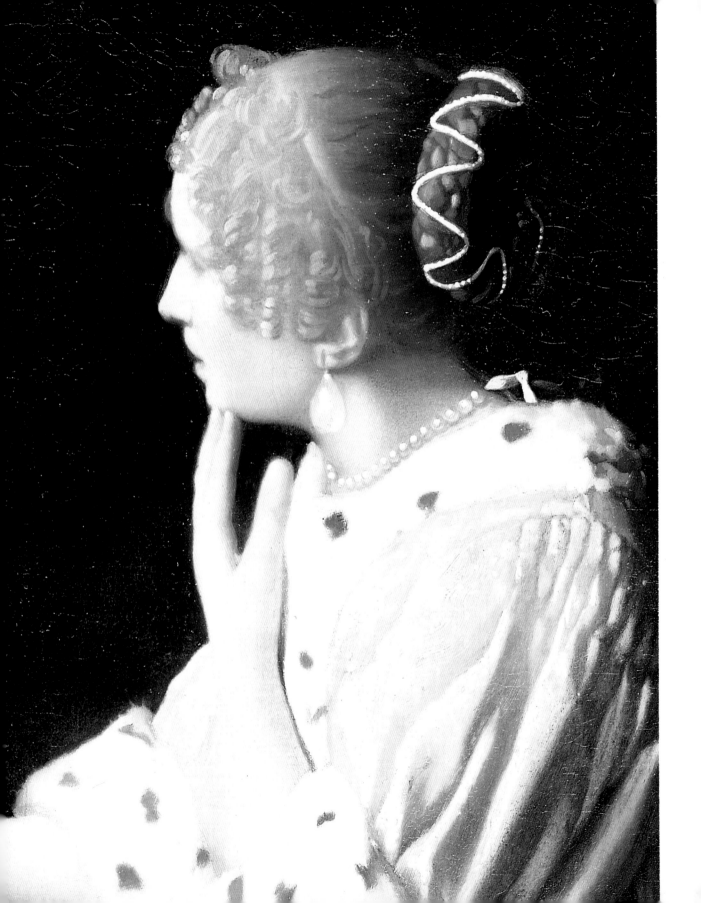

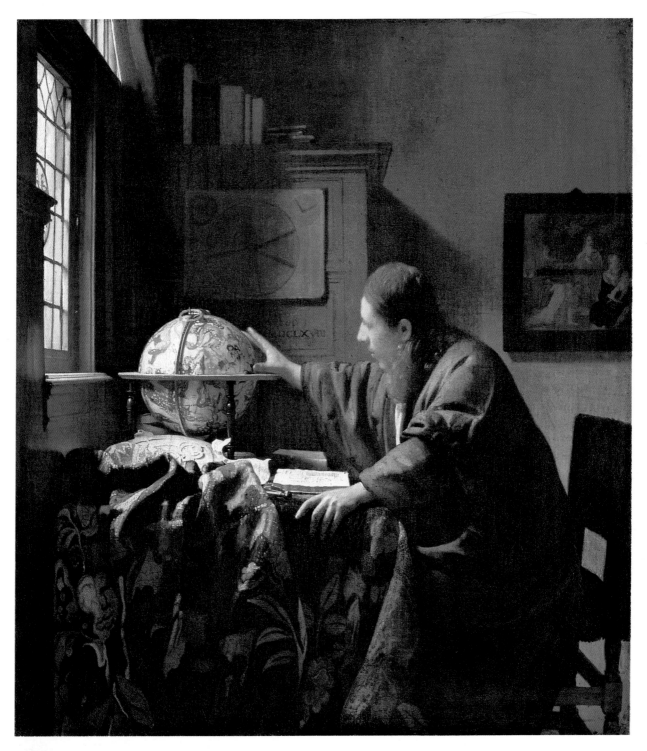

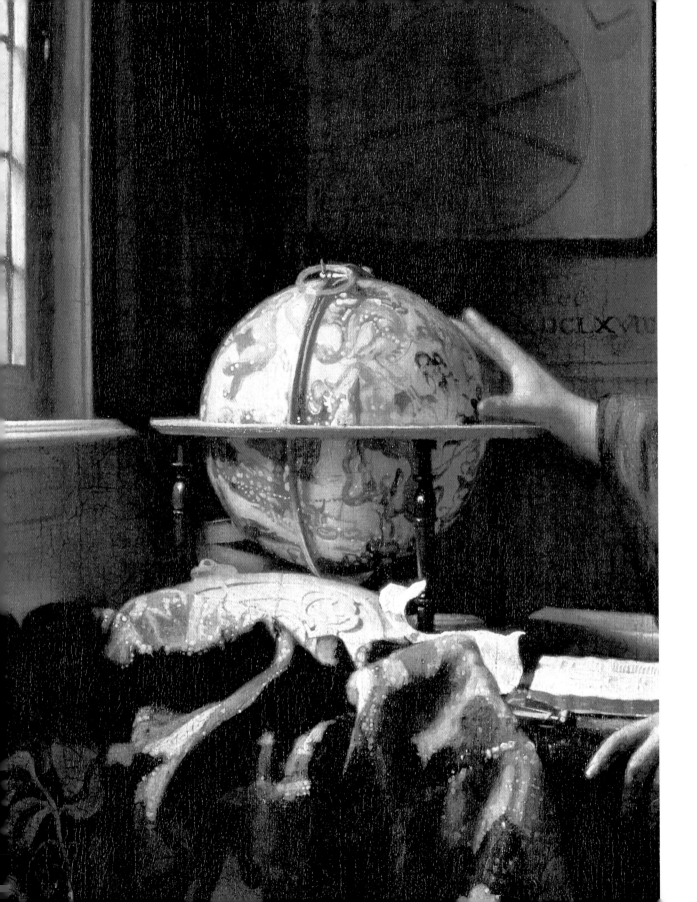

The Geographer
Frankfurt, Städelsches Kunstinstitut
[cat. 22]

following page: *detail*

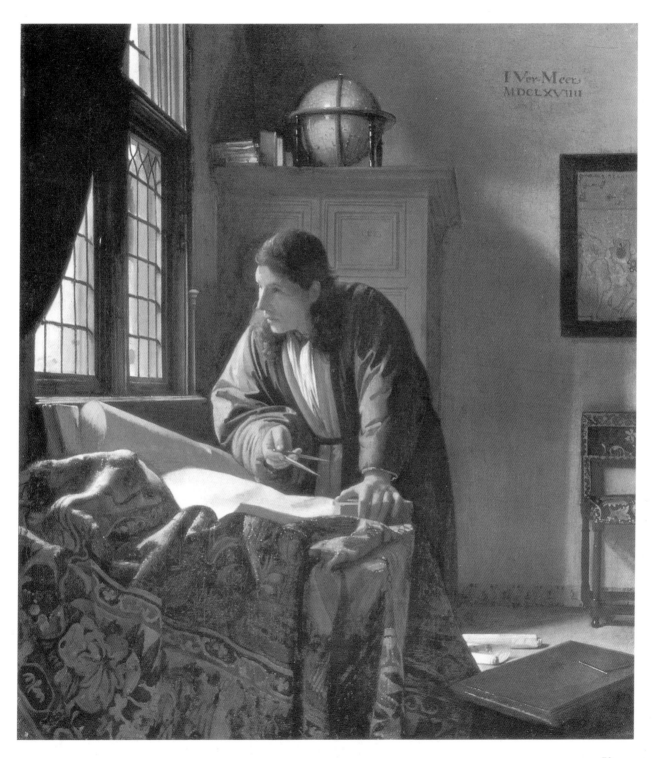

I Ver-Meer
MDCLXVIIII

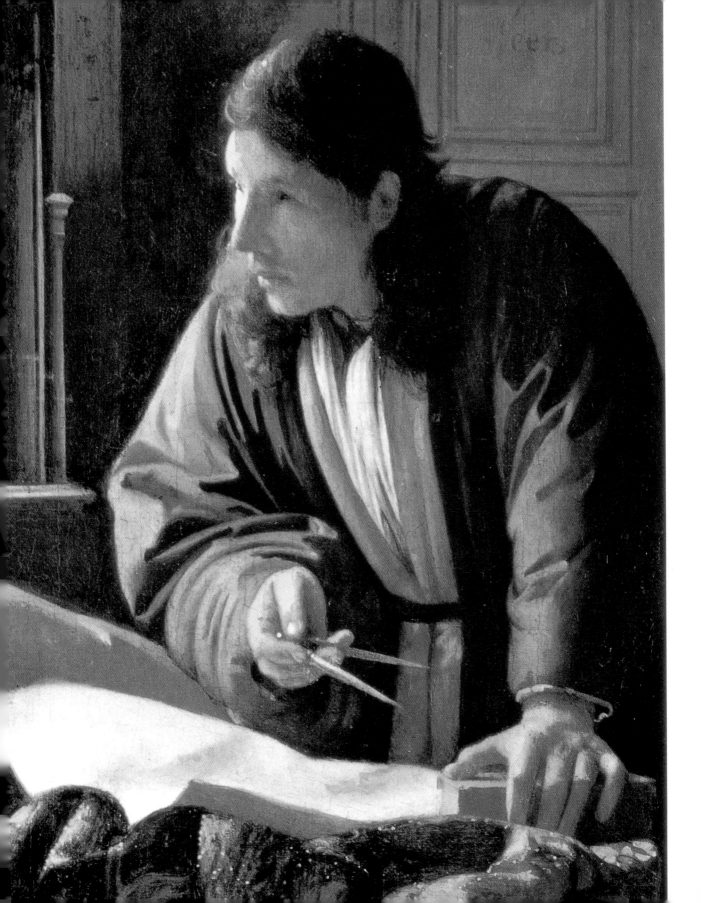

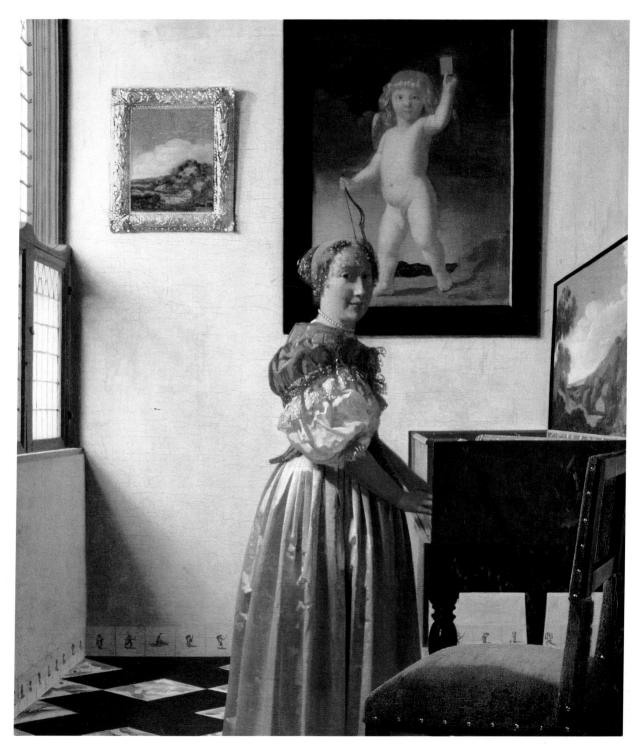

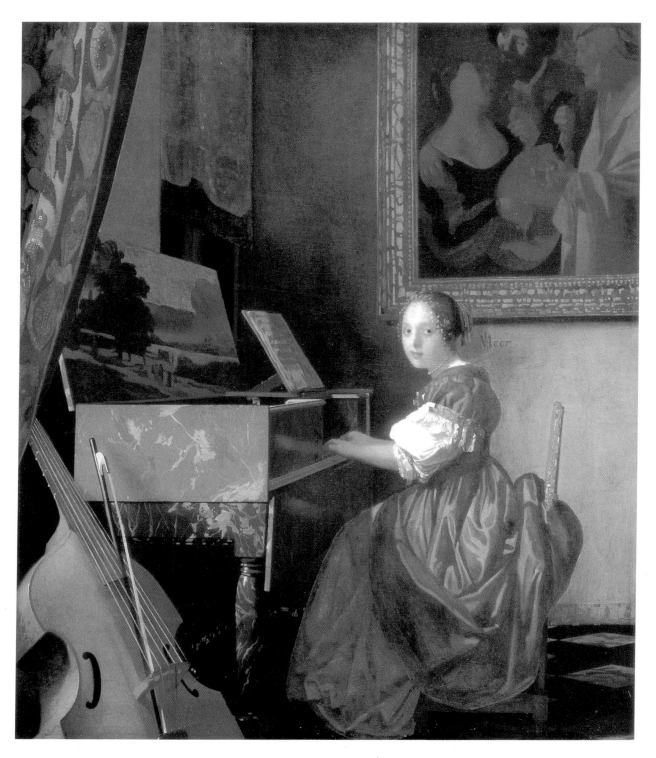

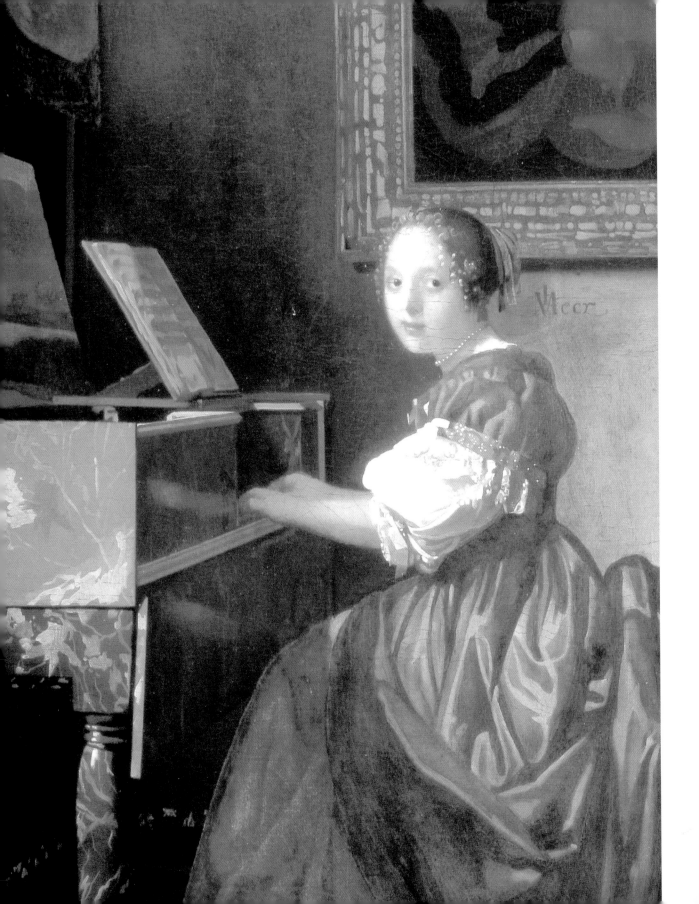

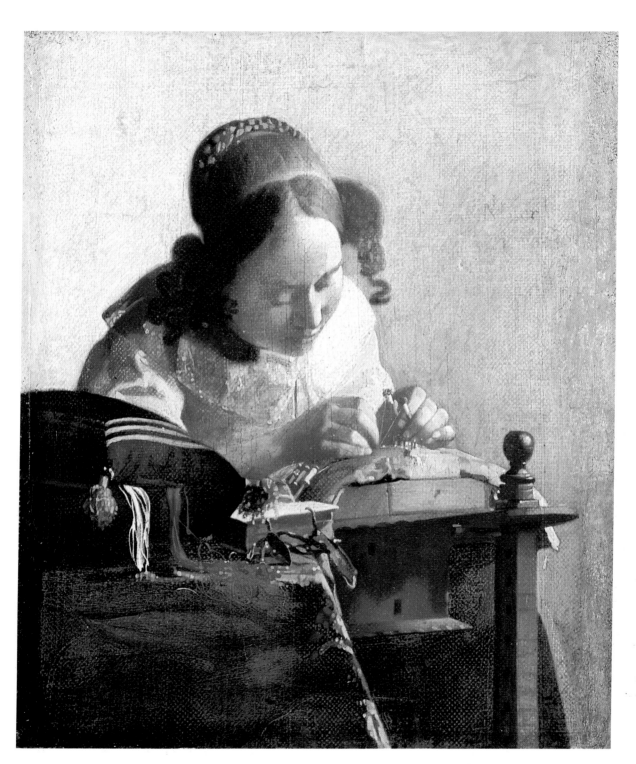

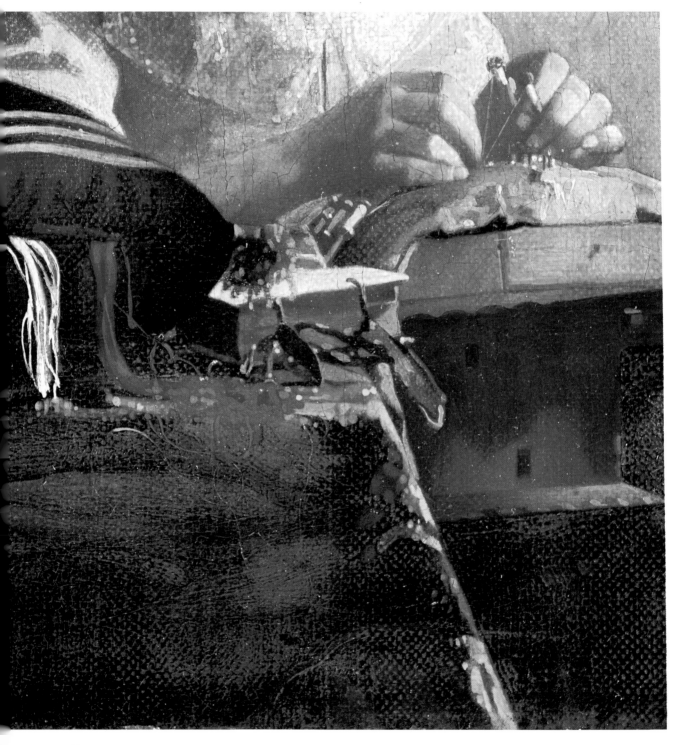

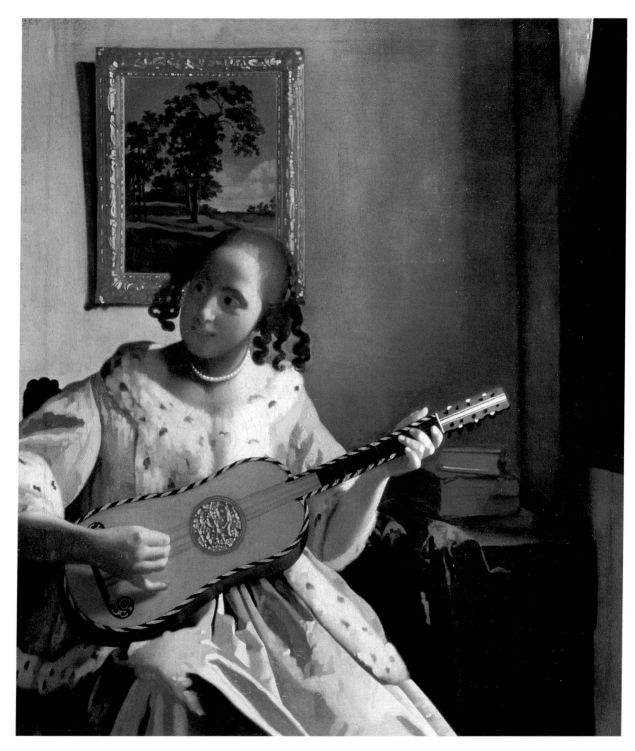

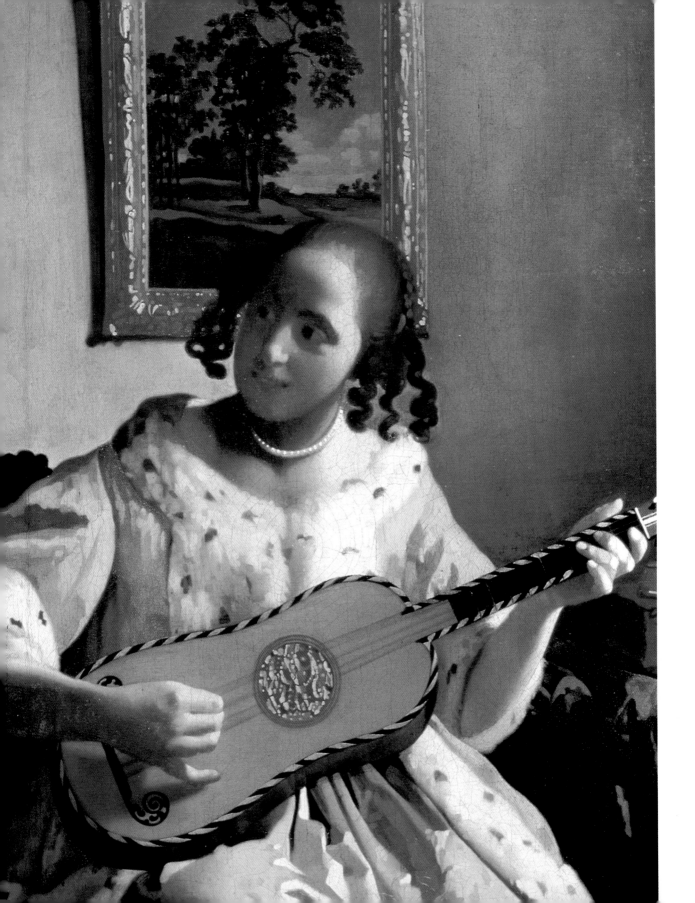

Lady Writing a Letter with Her Maid
Blessington, Russborough House, Beit Collection
[cat. 27]

following page: *detail*

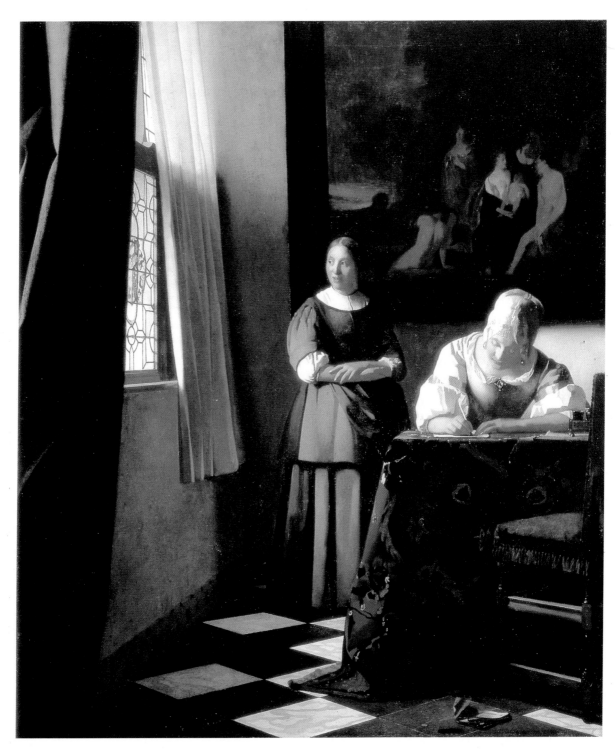

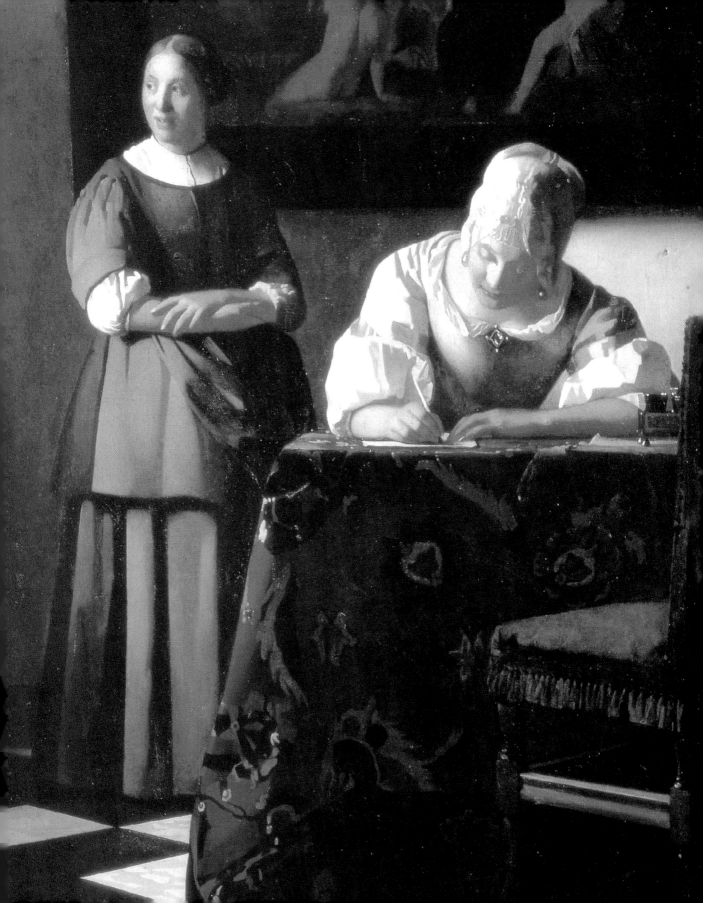

Catalog of Paintings

The catalog numbers highlighted in gray
refer to the oeuvres reproduced in the color
plates section of this volume.

1

Girl Asleep at Table

Canvas, 87.6 x 76.5 cm.
Signed on the upper left.
The Metropolitan Museum of Art,
New York. Ca. 1653–54.

This painting is the earliest indisputable work by the master. It may be identical with *A Drunken Sleeping Maid at a Table*, which was sold at the Amsterdam sale of 1696 under no. 8 for 62 guilders. In the nineteenth century, it passed through the hands of several Parisian collectors and dealers. Acquired by Benjamin Altman, New York, between 1907 and 1909, and bequeathed by him to the museum in 1913. Vermeer's earliest phase was Rembrandtesque. This can easily be ascertained from the rich and heavily impastoed pigments used in this painting. His subjects are always deceptively simple. He shows us in the left part of the composition a table covered with a glowing Oriental rug pulled up in front. On it is a Delftware plate with fruit, a white pitcher, and an overturned glass or *roemer* in the foreground. At the far end of the table is a young woman asleep, her head resting on her propped-up right arm and hand; the left one lies negligently flat. To the right is the back of a chair, and in the distance a half-open door that allows the viewer to see into another room. The theme goes directly back to Rembrandt. One of his drawings, *A Girl Asleep at a Window*, at the Tuffier Collection, Paris, shows a very similar pose. This, and the type of model, were also adopted by Nicolaes Maes in his *Idle Servant*, dated 1655, at the National Gallery, London, although there the maid sleeps on her left arm and hand. An identical stance can also be found in Maes's *Housekeeper* from a year later, 1656, at the art museum of Saint Louis. It has been suggested that Nicolaes Maes stayed in Delft after having left Rembrandt's studio, perhaps in 1653 or even later, to move to Dordrecht afterward (see Valentiner, 1932). In any event, there were ample possibilities for Vermeer to have had access to Rembrandtesque drawings, from a possible stay in the Rembrandt studio, as already suggested, to Leonard Bramer and Carel Fabritius. The handling of the light, as well as the deep coloring and heavy paste in the execution, derives from Rembrandtesque techniques of the early 1640s. Technical examinations revealed that Vermeer made major changes in the course of execution. Thus, he initially put a man in the second room instead of the mirror, and a dog in the doorway. He also enlarged the picture on the wall, which shows part of a cupid in the style of Caesar van Everdingen, which we shall encounter *in toto* in other of Vermeer's paintings (see M. A. Ainsworth et al., 1982; and John Walsh and Hubert von Sonnenburg, 1973). There have been various attempts at emblematic interpretation of the scene, but unless we have a clear case of double meaning, such as we shall encounter in a few isolated instances, this type of interpretation has to be taken with a grain of salt. The paint surface of the still life on the table has suffered from abrasions and restorations.

2

Girl Reading a Letter at an Open Window

Canvas, 83 x 64.5 cm.
Traces of signature(?). Staatliche
Kunstsammlungen, Gemäldegalerie,
Dresden. Ca. 1654.

Acquired in 1724 by August III, elector of Saxony, together with a number of other paintings bought in Paris. The seller threw in the picture as a present, to sweeten the deal. It was then attributed to Rembrandt, and the ascription was subsequently weakened to "manner" or "school of." In 1783, it was engraved as a work by Govaert Flinck. The name "Van der Meer from Delft" occurred for the first time in a catalog dating from 1806, to be changed back to Flinck in 1817. From 1826 to 1860, the appellation was altered to Pieter de Hooch. It is only since 1862 that the correct identification obtains. The only Dutch provenance that could possibly apply is the sale Pieter van der Lip, Amsterdam, 1712, no. 22, "A Woman Reading in a Room, by van der Meer of Delft fl 110," cited by Blankert (1988) *apud* Hoet. Unfortunately, the text is not specific enough to distinguish it from the one at the Rijksmuseum, *Woman in Blue Reading a Letter*. The above underlines the difficulties inherent to the establishment of Vermeer's catalog. Not a single work can be traced back to the painter's studio, nor are there any letters or contracts extant. The task of attribution rests squarely upon the shoulders of the individual critic, which explains the multiplicity of divergent opinions. In this painting, a young woman stands in the center of the composition, facing in profile an open window to the left. In the foreground is a table covered with the same Oriental rug encountered in the preceding work. On it is the identical Delft plate with fruit. The window reflects the girl's features, while to the right the large green curtain forms a deceptive frame. She is precisely silhouetted against a bare wall that reflects the light and envelops her in its luminosity.

We are here confronted for the first time with one of the salient aspects of Vermeer's sensibility and originality. It is the stillness that stands out, the inner absorption, the remoteness from the outer world. She concentrates entirely upon the letter, holding it firmly and tautly, while she absorbs its content with utmost attention. In the technique, the artist avows again Rembrandtesque derivation. He paints in small fatty dabs to model the forms, and obtains the desired effects by means of impasto highlights opposed to the deeper tonalities—just as the master from Leyden was wont to do. The painting is relatively large, and the smallness of the figure as opposed to its surroundings stresses immateriality and depersonalization. Vermeer consid-

erably changed the composition in the course of execution. Much has been written about the *trompe-l'oeil* effect of the curtain. It is a pictorial artifice used by many other Dutch masters and in keeping with an old European tradition. Rembrandt, Gerard Dou, Nicolaes Maes, and many still-life and even landscape painters made use of such curtains as a means of simulating effects that now seem theatrical. The light background can be found in many paintings by Carel Fabritius, the *Goldfinch* from 1654 at the Mauritshuis in The Hague being the most famous example.

3

Officer with a Laughing Girl

Canvas, 50.5 x 46 cm. The Frick Collection, New York. Ca. 1655.

This painting seems to be identical with the one listed in the Amsterdam sale of 1696 under no. 11: "A soldier with a laughing girl, very beautiful, by ditto, fl 44.10." Subsequently, it appeared at a London sale of 1861 as by Pieter de Hooch, and again under the same attribution at sales in Paris in 1866 and 1881. From there it went, via the collection of Samuel S. Joseph and his widow, to the New York art dealer Knoedler, from whom it was acquired by H. C. Frick in 1911. While painting with a brush loaded with pigments and applying them in a granulous fashion by thick dabs, as in the previous paintings, Vermeer ingeniously develops his mastery as a luminist. The young woman is bathed in light, which streams in through the half-open window to the left, and reflects itself from the cream-colored background that is enhanced to the left by very thin glazes of slightly pinkish tonalities. Her face, exceptionally conveying expression—joy and laughter—appears framed in a kerchief and the collar of her dress. That part of the figure, especially, reveals itself as a symphony of luminosity, set off by the dark sleeves of the yellow jacket on which glittering highlights dance. In contrast, the soldier in the black hat and

red jacket is placed close to the viewer, from whom he turns his back. He is hardly more than a silhouette, but rather overpowering, given the relative importance accorded his bodily appearance. The nearest foreground—the soldier on his chair and the dark-green part of the table cover—are so strongly enhanced that the use of an optical instrument by Vermeer for the structuring of the composition seems indisputable. We have here the typical effect of the inverted telescope: the foreground standing out in the manner of stage scenery, while the figure of the girl recedes into space. On the back of the wall, we find for the first time a map. This element of decoration reappears frequently in the artist's subsequent works. Contrary to the opinion of other critics, it is my contention that the priority of this and similar compositions belongs to Vermeer and not to Pieter de Hooch, whose "society" pictures are principally decorative, and much more superficial and shallow images. The creative impulse for the genre must have come from the master of Delft. Genius surpasses talent. Hence, another justification for my early dating.

4

The Milkmaid

Canvas, 45.5 x 41 cm. Rijksmuseum, Amsterdam. Ca. 1658.

Our Catalog No. 4 ranges among the most highly appreciated paintings by Vermeer, since shortly after his demise and also in subsequent years, second only to his *View of Delft*. It also fetched the second-highest price in the Amsterdam sale of 1696, no. 2: "A maid pouring out milk, extremely well done, by ditto, fl 175." The price is not excellent, as asserted by Wheelock (1988), but reasonable, given the mediocre level at which his paintings traded. The work never left Holland, and its attribution to Vermeer was upheld throughout. Blankert (1988) enumerates various Amsterdam sales

in which the *Milkmaid* is mentioned and highly spoken of, until the canvas became part of the Six collection, Amsterdam, in the earlier part of the nineteenth century. It was acquired by the museum in 1907–8 from this source.

Although the genre of "kitchen pieces" belongs to a long tradition in the Netherlands, with Joachim Beuckelaer and Pieter Aertsen in the sixteenth century being its initiators, it lost favor in the subsequent century, with the exception of Delft, where it endured. Vermeer's realization, however, has nothing in common with his archaic forerunners. His vision is concentrated on a single sturdy figure, which he executes in a robust technique, in keeping with the image that he wants to project. The palette features a subdued color scheme: white, yellow, and blue. But the colors are far from frank or strident, and are rather toned down, in keeping with the worn work clothes of his model. The still life in the foreground conveys domestic simplicity, and the light falling in from the left illuminates a bare white kitchen wall, against which the silhouette of the maid stands out. One gains from this deceptively simple scene an impression of inner strength, exclusive concentration on the task at hand, and complete absorption in it. The extensive use of *pointillé* in the still life lets us presume the use of the inverted telescope in an effort to set off this part of the painting against the main figure and alert the viewer to the contrast between the active humanity of the maid and her inanimate environment.

5

A Lady Drinking and a Gentleman

Canvas, 66.3 x 76.5 cm. Staatliche Museen, Preussischer Kulturbesitz. Gemäldegalerie, Berlin-Dahlem. Ca. 1657–58.

The painting first appeared in the sale Jan van Loon, Delft, 1736. It was subsequently bought by John Hope, Amsterdam, in 1774. His sons fled to England when the French invaded Holland in 1794, and the painting seems to have remained the property of the family until the whole collection was sold in 1898 to the art dealers P. and D. Colnaghi and A. Wertheimer. It was acquired by the museum in 1901.

The leaden window to the left was entirely overpainted at the time of the purchase by the museum and replaced by a curtain and a view upon a landscape through an open window. When the painting became part of the museum's collections, it was cleaned and the overpaints removed, restoring the original composition. This was the time when genre painting flourished, and artists like Pieter de Hooch, Jan Steen, Frans van Mieris, and Gerard Ter Borch, to name only a few, placed their figures into a light-filled room or courtyard, showing them either socializing or preoccupied with domestic chores. Vermeer's works set the tone for representations of the upper bourgeoisie, a social level more refined than that depicted by his contemporaries. This type of setting required finer and smoother pictorial rendition than, for instance, the *Milkmaid*.

Consequently, Vermeer adapted his brushwork to the new needs, and more than equaled a Frans van Mieris, for instance, in the delicacy and finesse of the execution. The theory of the so-called early works by the master being disproved, it now becomes obvious that Vermeer was the originator of the genre. It was he who influenced Pieter de Hooch, not the other way around, as was previously assumed. His elegance, sophistication, and majestic stillness assert the primacy of his conceptions over the more pedestrian de Hooch, who attained brief artistic heights only under Vermeer's impetus during his Delft sojourn in the late 1650s.

6

A Lady and Two Gentlemen

Canvas, 78 x 68 cm.
Signed left on the window.
Herzog-Anton-Ulrich Museum,
Braunschweig. Ca. 1657–58.

It is possible that the painting can be identified with one in the Amsterdam sale of 1696, no. 9, there described as "A merry company in a room, vigorous and good, by ditto, fl 73." The suggestion is from A. Blankert. Otherwise, we have the first certain mention of the painting in the Braunschweig catalog, ca. 1711, then again in 1744 and 1776. During the times of Napoleon I, the work was part of his spoils of war, and remained in Paris. Restituted afterward, it was again cataloged by L. Pape in 1846 as by Jacob van der Meer. The attribution to Vermeer van Delft originates with Thoré in 1860. A young woman wearing an elegant red dress is seated in the foreground turned toward the left and looking half-smilingly at the viewer. It is one of the rare instances when Vermeer animates one of his figures with a semblance of expression. She seems to be courted by a fine gentleman, bent over and encouraging the young lady to take a sip from the wine glass that she holds in her hand. Farther back, another gentleman sits behind a table featuring an exquisitely painted still life of a silver plate, fruit, and white pitcher. The second male figure sits in a pose reminiscent of the *Girl Asleep* (our Cat. No. 1), apparently befuddled by too much wine. A *Man's Portrait* in the background may be one of the family portraits mentioned in the inventory of Vermeer's widow in 1676, which was part of his stock as a dealer. As to the coat of arms prominently displayed in the window, it belonged to a former neighbor's family that used to live in a house next to the Vermeers. The painting has been overcleaned, the last time in 1900, and the sitting man in the background was overpainted during

the eighteenth century, as comes out of the descriptions of 1744 and 1776. The room where the artist placed the composition resembles others frequently used by him. Patterns, windows, and walls reappear with minor changes. In this respect, Vermeer did not show much originality. His mastery resides in the delicacy of the execution, the use of light, and the grouping of his figures. The work stems roughly from the same years as our Cat. No. 5.

7

The Little Street

Canvas, 54.3 x 44 cm.
Signed left below the window:
I V MEER.
Rijksmuseum, Amsterdam.
Ca. 1658.

This is one of the rare paintings that are correctly attributed to the Delft Vermeer since its earliest documentation. It first appeared in the Amsterdam sale of 1696 under no. 32: "A view of a house standing in Delft, by the same; fl 72.10." Later, it was in the estate of Mrs. Croon, widow of G. W. Oosten de Bruyn, 1799. Then it was in the sale Van Oosten de Bruyn, Haarlem, 1800, there bought by H. van Winter for F 1,040. Thence inherited by the Six family; later acquired by H. W. Deterding and presented by him to the Rijksmuseum in 1921.

Although the painting represents in truth two houses and was initially described as one house only, there does not seem to be any doubt about the identification. It is a very simple and appealing painting, which conveys to the viewer a typical aspect of Dutch life as one encountered it in the period. The habitation ensconces and protects its dwellers, while the facades show the viewer nothing but the outside of their intimate existence. This essential simplicity is translated by the artist into a representation of a quiet street imbued with dignity. Contemporaries like de Hooch and Jan Steen also

painted bricks and mortar, but their treatment is close only in appearance. Vermeer, as usual, elevated his aim into regions of philosophy that surpassed the pedestrian attempts of others by his calm majesty and feeling for shared intimacy, of which he alone was capable. If superficially, Vermeer resembles his Delft colleagues, he easily surpasses them by the depth of his mastery of light and mood. The painting must be chronologically ranged rather early, because he was the initiator of the genre in this particular fashion.

An X-ray shows that the artist had initially planned to add a standing girl to the right of the open alleyway, but eliminated her subsequently so as not to disturb the stillness and equilibrium of the composition. For numerous painted and watercolor copies after this composition, see A. Blankert, 1988, pp. 176–77.

8

The View of Delft
Canvas, 98.5 x 117.5 cm.
Signed with monogram, below left
on the boat. Mauritshuis,
The Hague. Ca. 1659–60.

This, the most famous painting by Vermeer, was part of the Amsterdam sale of 1696, no. 31: "The town of Delft in perspective, to be seen from the south, by J. van der Meer of Delft; fl 200." Sale S. J. Sinistra et al., Amsterdam, 1822, no. 112. For F 2,900 to de Vries. Purchased by the state of the Netherlands.

Topographic views of cities had become a tradition by the time Vermeer painted his famous canvas. Hendrik Vroom was the author of two such works depicting Delft, but they are more archaic because they followed the traditional panoramic approach that we remember from the two cityscapes by Hercules Seghers at the Berlin museum. The latter artist was one of the first to make use of the inverted Galilean telescope to transcribe the prelimi-

nary prints and their proportions (more than twice as high as wide) into the more conventional format of his paintings (for an extensive discussion of this phenomenon, see Larsen, 1962, chap. 4; and 1964). Vermeer executed his *View of Delft* on the spot, as established by John Nash (1991, p. 6), but the optical instrument pointed toward the city and providing the artist with the aspect translated onto canvas, which we admire for its conciseness and special structure, was not the camera obscura but the inverted telescope. It is only the latter that condenses the panoramic view of a given sector, diminishes the figures of the foreground to a smaller than normal magnification, emphasizes the foreground as we see it in the picture, and by the same token makes the remainder of the composition recede into space. The image thus obtained provides us with optical effects that, without being unique in Dutch seventeenth-century painting, as often claimed, convey a cityscape that is united in the composition and enveloped atmospherically into glowing light.

We admire the town, but it is not a profile view of a township, but a painting, an idealized representation of Delft, with its main characteristics simplified and then cast into the framework of a harbor mirroring selected reflections in the water, and a rich, full sky with magnificent cloud formations looming over it. This is chronologically the last painting by Vermeer that was executed in rich, full pigmentation, with color accents put in with a fully loaded brush. The artist outdid himself in a rendition of his hometown, which stands as a truly great interpretation of nature.

9

Woman with a Water Jug
Canvas, 45.7 x 40.6 cm. Metropolitan
Museum of Art,
New York. Ca. 1660–62.

This is one of Vermeer's paintings that came to light only relatively re-

cently. Blankert attempts to identify it with an entry in the Robert Vernon collection from 1838, where the ascription was to Metsu. This work was subsequently sold in the Vernon sale from 1877, again as a Metsu. It is by no means certain that this painting was identical with the one that was sold by the London dealer Colnaghi to Lord Powerscrout for 600 guineas and was exhibited at the Royal Academy, London, 1878, with for the first time the attribution to Jan van der Meer of Delft. It then passed into the hands of another London art dealer, Thomas Agnew, and finally the Paris art dealer Ch. Pillet, who sold it to Henry G. Marquand in 1887 for 800 U.S. dollars as a work by Pieter de Hooch. Marquand gave it to the museum in 1888. It was thus the first painting by Vermeer to enter an American public collection.

The *Woman with a Water Jug* is, as already stated by many critics, a very subtle work. Its composition is simple: a young woman standing in the corner of a room, turned to the left, opening a window with her right hand and holding in her left hand a brass water jug. The jug is placed on a bowl of the same material, standing with some other paraphernalia on a table covered with a red Oriental rug. The whole appears as a symphony in yellow and blue, standing out against the white headdress and large collar worn by the young woman. The background is light, in imitation of Carel Fabritius. A map animates the right corner of the wall. The very simplicity and Oriental stillness of the model make this work one of the most significant compositions by the master. There is light, grace, and distinction here, a tendency toward abstraction that characterizes the master's maturity, and a delicacy in the execution that accompanies his evolution from the early works toward a more artful manner of pictorial expression. No emblematic connotation has been associated with this picture. It expresses, in my opinion, Vermeer's preoccupation at the time with Buddhist philosophy and his search for

another world and its concomitant depersonalization, as opposed to stark Dutch realism.

10

Woman with a Pearl Necklace

Canvas, 55 x 45 cm.
Signed on the table.
Staatliche Museen,
Preussischer Kulturbesitz
Gemäldegalerie, Berlin-Dahlem.
Ca. 1662.

Sale Amsterdam, 1696, no. 36: "A young lady adorning herself, very beautiful, by ditto; fl 30." Sale Johannes Caudri, Amsterdam, 1809, no. 42. Sale D. Tengs, Amsterdam, 1811, no. 73. Sale Amsterdam, 1856, no. 93. Sale Collection H. Grevedon, Paris, 1853(?), not as Vermeer. Collection Thoré-Bürger, 1866. Sale Comte Cornet de Ways Ruart, Brussels, 1868, no. 49. For 3,500 Belgian francs to Sedelmayer. Collection Suermondt, 1874.
In this painting, along with our nos. 11 and 12, Vermeer attempted a composition in which he showed a single woman concentrating on some kind of occupation. In each case, the woman is shown turning inward with her thoughts, and using some minor physical activity to give herself some countenance.
In this case, she gazes into a mirror while holding two yellow ribbons attached to a pearl necklace around her neck. The distance between the solitary figure to the right and the mirror on the wall, next to the window to the left, is filled by a heavy table slightly to the fore.
This part of the painting is very dark, with nothing more than a Chinese vase and a rug irregularly covering the table to occupy the space.
The light falling in from the left, dispersed by the creamy bare wall, illuminates the meditative young woman admiring her reflection in the distant mirror.
In this instance, as well as in the

two following ones, all emblematic explanations or identifications, such as truth, prudence, or others, do not apply. During these years, the artist was obviously preoccupied and influenced by Eastern thought. The stillness and introspection of the models reflect the search for aloof withdrawal and serenity as taught by Buddhist writings. It is in this sense that we must understand and appreciate Vermeer's creations during his maturity.

11

Woman in Blue Reading a Letter

Canvas,
46.5 x 39 cm.
Rijksmuseum, Amsterdam.
Ca. 1662–65.

Perhaps no. 22 in the Sale Pieter van der Lip, Amsterdam, 1712. Inventory of the late Moses de Chaves, 1759. Sale, Amsterdam, 1772, no. 23 (the first certain allusion to this picture). Sale P. Lyonet, Amsterdam, 1791. Sale Amsterdam, 1793. Sale Herman ten Kate, Amsterdam, 1801, no. 118. Sale Lespinasse de Langeac, Paris, 1809. Sale Lapeyrière, Paris, 1825. Acquired by A. van der Hoop, Amsterdam, from J. Smith, London, 1839.
Bequeathed with the collection van der Hoop to the city of Amsterdam in 1854.
On loan to the Rijksmuseum since 1885.
As in the preceding catalog entry, a solitary figure of a woman is standing immersed in her thoughts, this time in the center of the composition. She reads a letter and seems completely absorbed by it.
This painting stands out by the simplification of the composition, which does away with the previously mandatory leaden window to the left.
Even the chairs and table surrounding the principal and single

figure have lost in importance. Only the map on the wall breaks the uniformity. Vermeer's palette has become very delicate and sophisticated. Blue predominates by its widespread use in the woman's jacket.
The foreground again gains in emphasis according to the precepts derived from the inverted telescope.
Otherwise, the viewer is only confronted with the pure majesty of the main figure, set against the clear wall, whose luminosity is balanced by the brownish map. In its classical simplicity, grandeur, and almost abstract conception, this is one of Vermeer's masterpieces.

12

Woman Weighing Gold or Pearls

Canvas,
42.5 x 38 cm.
National Gallery of Art,
Washington, D.C.
Ca. 1662.

The painting may be identical with one sold at Amsterdam in 1696, no. 1: "A young lady weighing gold in a box, by J. van der Meer of Delft, extraordinarily artful and vigorously painted; fl 155." Sale Amsterdam, 1701. Inventory of Paulo van Uchelen, Amsterdam, 1703 (valued at fl 150). Sale Amsterdam, 1767. Sale Munich (Roi de Bavière), 1862, no. 101 (Metsu or van der Meer). Sale Duc de Camaran, Paris, 1830. Sale Casimir Périer, London (Christie), 1848. Collection Comtesse de Ségur-Périer. Art dealer F. Lippmann, London. Art Gallery P. and D. Colnaghi, London. Collection P. A. B. Widener, Philadelphia. Widener collection in the museum, 1965.
Wheelock asserts (1988) that the scales of the balance are empty and that the woman holding it is waiting "for the delicate modulation...to come to rest; she stands transfixed in a moment of equilib-

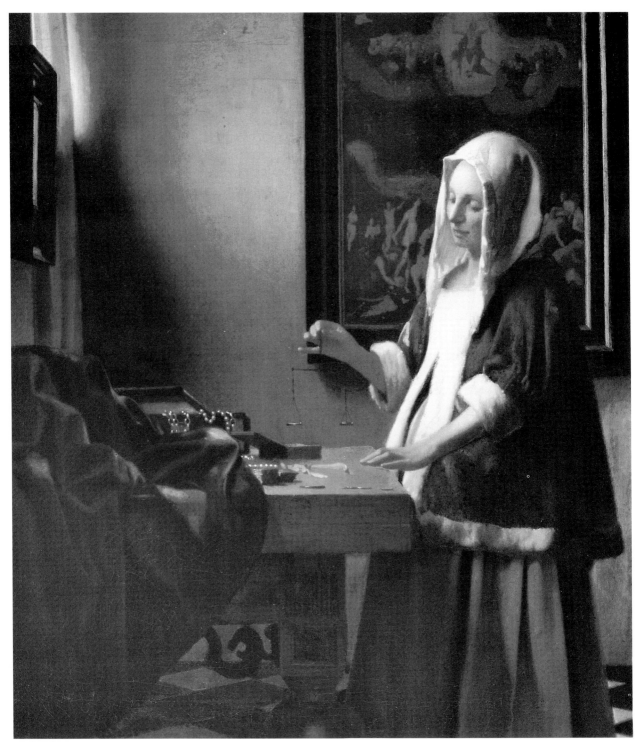

Cat. 12 Woman Weighing Gold or Pearls

rium." I beg to differ. First, the scales are deep enough to contain either gold or pearls. From the viewpoint of the onlooker, this cannot be determined. Second, the idea that the woman would hold the scales aloof in midair, just for the purpose of contemplation, strikes me as rather singular. Perhaps, as a good Dutch *Hausfrau*, she wanted to ascertain if they were in need of dusting. Third, the painting has been titled since 1696 *A Young Lady Weighing Gold*. If the title does not correspond with the content, the question arises if we really have the same picture to which the provenance relates. Looking at the work, we must conclude that very few gilded objects are involved. Also, they certainly are not *in* a box. From the 1696 description, it is not clear whether the objects are in a box, which does not agree with the picture, or whether the painting was *in* a box, which would point to a peepshow.

Anyway, the painting is certainly by Vermeer, and constitutes the third of the series of solitary women engaged in an occupation that covers and underlines their pensive attitude.

While the surroundings are in keeping with the professional duties of the models, it is the configuration that points to a sentimental mood, a feeling of inner peace and serenity. On the far wall, a large painting with the Last Judgment. Vermeer executed our Cat. No. 12 in somber pigments, which receive only occasional light from the left window and envelop the figure at the right with diffused illumination.

One may safely disregard the numerous attempts at interpretation, emblematic as well as philosophical. If Vermeer had really read and absorbed all the relevant literature needed for endowing his works with the shades of meaning credited to his intentions, he would have had even less time left for painting than he actually did.

13

The Music Lesson
Canvas,
73.3 x 64.5 cm.
Signed at right in lower edge of
picture frame.
Buckingham Palace,
London.
Ca. 1662–65.

The provenance of this painting is rather uncertain in its early stages. It may have been part of the collection Diego Duarte in Antwerp, 1682. Then in the Amsterdam sale of 1696, no. 6: "A young lady playing the clavecin in a room, with a listening gentleman, by the same; fl 80." Afterward, possibly in another Amsterdam sale, 1714. However, the description alludes only to a "woman playing the clavecin in a room," without mentioning the listening gentleman. Hence, doubt. Joseph Smith, English consul in Venice, bought in 1741 a number of Dutch paintings from the widow of the painter Giovanni Antonio Pellegrini (1675–1741). One was described in Pellegrini's inventory as *A Lady at the Spinet*—without mention of the gentleman. When Smith sold his collection to King George III, it contained a painting attributed to Frans van Mieris: *A Woman Playing on a Spinnet in presence of a Man seems to be her father*. The Mieris is certainly our Cat. No. 13, but whether we have here the painting formerly owned by Pellegrini remains questionable. From the collection of George III to the English royal collection.

In this imposing composition, Vermeer changed for the first time his handling of space, by moving the human figures and the center of the action to the far side of the room. The use of the inverted Galilean telescope becomes evident if one examines the perspective and the relative importance of the table at the right, covered with an Oriental rug, upon which stands a white pitcher on a silver plate. From there on, the bass viol lying on the floor and the figures at the clavecin recede into space. Vermeer, who indicates his presence by including in the mirror-image on the back wall parts of his easel and paint box, wants us to view the scene from afar: a distant happening that we are allowed to watch as intruders, but in which we may not participate. Vermeer outdoes even Frans van Mieris in the wealth of details. The tile floor, the rug, and the ornamentation of the clavecin are rendered with minute care. The same applies to the human figures. Altogether, the painting lacks the nearness and intimacy of former works, and seems posed perhaps to serve as model for a musical impromptu at some gathering of rhetoricians, who were numerous at the time.

14

The Concert
Canvas, 69 x 63 cm.
Isabella Stewart Gardner Museum,
Boston.
Ca. 1664–65.

The first reference to this painting can be found in the sale Johannes Lodewijk Strantwijk, Amsterdam, 1780, where it is already dubbed a work by Jan van der Meer, de Delfze. Subsequently, sale Monsieur van Leyden, Paris, 1804; sale London (Foster), 1835; sale Admiral Lysaght et al., London (Christie), 1860; sale Demidoff, Paris, 1869; sale (heirs) Thoré-Bürger, Paris, 1892; there acquired by Mrs. Isabella Stewart Gardner.

This painting superficially resembles our Cat. No. 13 in that it features the making of music in a domestic environment. But there the likeness stops. The *Music Lesson* was very rigidly constructed, pruned to the point of abstraction, and allowing the viewer only a glance from afar upon the principal scene. In the *Concert*, we are again part of the happening, although separated from it by the table covered with the familiar red Oriental rug and the bass viol on the floor.

However, the music-making trio in a compact group presents itself sufficiently close to our vision so that the viewer shares in the earnest concentration of the figures. This slightly removed part of the painting is particularly rich in details, almost pictures within the picture. On the far wall to the right, we find Baburen's *Procuress*, which was part of Vermeer's stock as an art dealer. To the left is a landscape in the style of Jacob van Ruisdael. The two are linked by the landscape on the raised cover of the clavecin done in the then-fashionable style of the Italianizing Dutch landscape painters such as Jan Both.

For Vermeer, such a crowding of decorative elements is rather unusual, and has therefore encouraged critics to attempt various interpretations of the meaning of the scene. They range from calling it a brothel (de Mirimonde) to a domestic scene with the lady to the right being the personification of temperance (I. L. Moreno)! In any case, the amateur seeking purely aesthetic pleasure will find delight in the perfection of the composition, the delicate execution of the figures, as well as of the paraphernalia, and the masterly use of diffused light enveloping the actors. In this work, Vermeer stands greatly above his contemporaries de Hooch, Jan Steen, Metsu, and many others, in harmony, grandeur, and artistic skill.

15

The Girl with a Pearl Earring

Canvas, 46.5 x 40 cm.
Signed top left. Mauritshuis,
The Hague. Ca. 1665.

The provenance of this painting cannot be traced back very far. All earlier documents or sales catalogs cited by Blankert are pure guesswork. Vermeer seems to have painted a number of "heads," and various cited *tronie*, as they were called, cannot be further identified. We only know for certain that the work was purchased at the beginning of 1882 for the collection A. A. des Tombe of The Hague for fl. 2.30(!) in the sale Braam of the same city. The des Tombe collection was a public collection and bequeathed the picture in 1903 to the Mauritshuis.

This charming portrait of a girl is unfortunately in a very poor state of conservation and suffered from numerous extensive restorations. It is furthermore marred by an ugly pattern of cracks. Nevertheless, it became famous after its rediscovery and was dubbed the "Gioconda of the North" by many enthusiastic critics. Fortunately, enough of the original is left to permit the savoring of a truly outstanding and partly exotic work. Its non-Western character is stressed by the blue and yellow turban, which clearly reflects Asia and has nothing in common with "antique dress." Our Cat. No. 15 and the following catalog entry are the most outstanding examples of Vermeer's adaptation of Indonesian patterns of thought and artistic rendering into his own form language. As I stated in 1955, one must admire the artist's technique, which features application of the pigments in juxtaposition and melting, avoiding precise lines, and therefore blurring the contours of different colors so as to obtain effects that foreshadow those of the impressionists. The dark backgrounds that Vermeer chose in these two portraits enhance the plasticity of the models, while the color gamut echoes Oriental prototypes: in this case, the frescoes of Ajanta. Both paintings, our Cat. Nos. 15 and 16, stand out for the depersonalization of the sitters. Expressionless, they gaze into the void in search of ultimate salvation.

16

Portrait of a Young Woman

Canvas,
44.5 x 40 cm.
Signed top left.
Metropolitan Museum of Art,
New York.
Ca. 1665–67.

Again, the catalog of the 1696 sale in Amsterdam enumerates three different *tronies* (one described as in antique dress) that may or may not be identical with our Cat. No. 16. Neither this young woman, nor the preceding one, wears antique costume. People in the seventeenth century were sufficiently aware of Easterners, such as Turks, so as not to have mistaken a turban for an antique dress. The adducing of the Rotterdam sale, 1816, by Blankert, seems more probable. Certitude starts only with the painting's presence in the collection of Prince Auguste d'Arenberg, Brussels, 1829. Hidden during World War I (the d'Arenbergs owned vast estates in Belgium but had always retained their German citizenship. Hence, all their belongings there were seized after 1918 as "enemy property" and sold. The Vermeer escaped this fate), it was acquired by Mr. and Mrs. Charles B. Wrightsman, of Palm Beach, Florida, and Houston, Texas, in 1955. It was presented by them to the museum in 1979.

This painting, as opposed to the previous entry, is very well preserved and permits us to judge Vermeer's approach, both technical and conceptual, in all its brilliance. The sitter has obvious Indonesian traits: a moon face, compressed lips, and relatively narrow eyes. We certainly do not have here a portrait, but again, as in Cat. No. 15, a generalized type that communicates with the spiritual world almost as if in a trance. This part of the painting is delicately executed, with contours obtained as described in the previous entry. The light-blue robe or loose cloak that the young person is wearing has been more broadly and crisply treated.

Interestingly, this painting was certainly the prototype that inspired the fake *Girl with a Red Hat*—our Cat. No. A7. Wheelock has pointed out the connection between the two works (loose

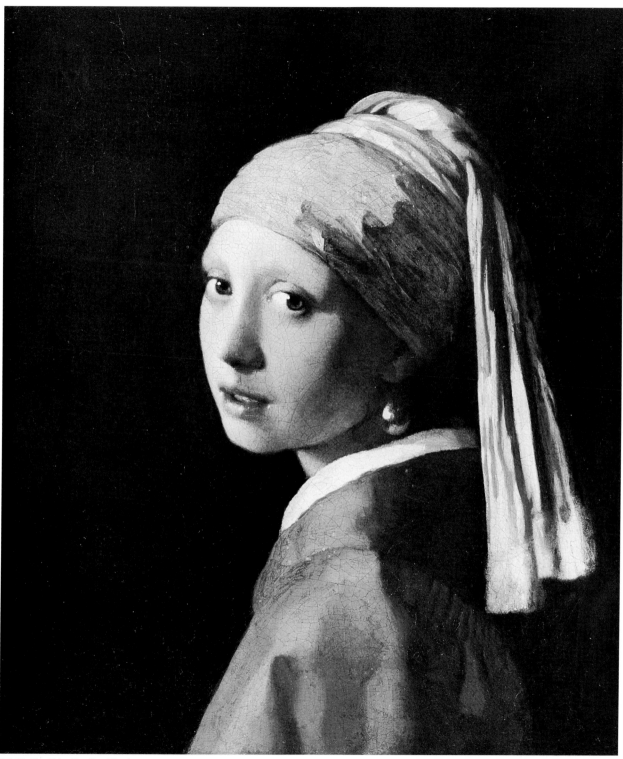

Cat. 15 The Girl with a Pearl Earring

robes and position of the arm) without, however, as yet drawing the correct conclusion. The former d'Arenberg Vermeer does not enjoy as much favor as the "Gioconda of the North," although it is, in many respects, a much better picture. What moves most critics and viewers adversely is the fact that they are, without knowing it, confronted with a non-Western person. The face, criticized by many as too broad and flat, and the small nose correspond to an Eastern, not an Occidental, ideal of beauty. Once this obstacle is removed and accepted as such, this painting should receive all due admiration, as soon as it is approached within a new aesthetic framework.

17

The Art of Painting
Canvas, 120 x 100 cm.
Signed on map, to the right of the girl.
Kunsthistorisches Museum, Vienna. Ca. 1665.

Mentioned in 1676 in an act signed by Vermeer's widow, conveying the painting to her mother. Acceptance by the mother in 1677. This is certainly not no. 3 in the sale of 1696 in Amsterdam. The description does not agree. Purchased by Johann Rudolf Count Czernin in 1813 from the estate of Gottfried van Swieten, via a saddlemaker. Count Czernin paid 50 Austrian guilders for it. The painting was then attributed to Pieter de Hooch. In 1860, the painting was recognized as a Vermeer by Waagen. In the possession of Adolf Hitler after 1938, and hung at his residence in Berchtesgaden. Acquired by the museum in 1946.

This painting was long called *The Artist in His Studio*, and we may in effect presume that the artist seen from behind was himself. However, the intention of representing an allegory is stronger here than in all other Vermeer's works. The heavy curtain on the left, which lets the viewer partake of the scene, has decidedly theatrical connotations. So does the young girl whom the artist portrays, and whose crown of laurel easily identifies her as Fame. A connection with Clio, the muse of history, also exists. She holds a trumpet and a book of Thucydides. The whole composition is a panegyric to the art of painting. Set in an elegant room, with a chandelier, chairs, the lush curtain, and a large map on the back wall, which shows the northern and southern Netherlands and indicates the area over which the reputation of the artist could spread, its overall meaning emphasizes the attainment of fame to the benefit of the man in the pursuit of his artistic endeavors as well as *qua* citizen of his hometown. The uncommonly large painting, considered from the pictorial viewpoint only, is rather decorative but lacks depth. Only its meaning makes it of particular interest. Repeated restorations may have contributed to the narrative rather than painterly excellence of the work. Such as it presents itself now, one cannot be astonished that it was formerly attributed to Pieter de Hooch.

18

Writing Lady in Yellow Jacket
Canvas, 45 x 39.9 cm.
Signed on the frame of the painting in the background.
National Gallery of Art, Washington, D.C.
Ca. 1665–66.

Probably identical with no. 35 in the Amsterdam sale of 1696: "A writing young lady, very good, by the same; fl 63." Sale Van Buren, The Hague, 1808. Sale Rotterdam, 1816. Collection "Kammerman," Rotterdam, 1819–23. Sale Rotterdam, 1825. Sale Amsterdam, 1827. Sale Comte F. de Robiano, Brussels, 1837. Art market, Paris, 1907. Collection Pierpont Morgan, New York. Art gallery Knoedler, New York. Collection Lady Oaks, Nassau, Bahamas. Art gallery Knoedler, New York, 1958. Collection Horace Havemeyer, New York. Gift of Harry Waldron Havemeyer and Horace Havemeyer, Jr., to the museum, in memory of their father, 1962.

We have again a single-figure composition. A lady dressed in a yellow jacket with borders of ermine occupies the center of the composition. She is seated at a table, turned toward the left. Her right hand firmly secures the quill that she is prepared to use. In the meantime, she gazes at the viewer. This is a very elegant, though somewhat dark, interior, the only light coming from an unseen source at the left. It bathes the lady and the table, leaving everything else in a warm penumbra. One used to think that this was a portrait in disguise, an assumption that cannot be maintained in view of the quizzical expression of the sitter, who looks pensively beyond the picture frame into space. The painting on the rear wall, probably representing a skull and other paraphernalia, has plausibly been identified with a work by C. van der Meulen.

Vermeer shows himself here again as an exquisite painter of detail. The style is that of his mature years. Having abandoned the clear back wall "à la Fabritius," he envelops the composition in warm brown tonalities that foster feelings of intimacy, and for once stresses a certain degree of individualization in the model depicted.

19

Lady with a Maidservant Holding a Letter
Canvas,
92 x 78.7 cm.
The Frick Collection, New York.
Ca. 1666.

The provenance of the painting is fraught with uncertainties, primarily because several times Vermeer treated the theme of a

lady receiving or writing a letter while a maid is present.

Thus, no. 7 in the Amsterdam sale of 1696 is described: "A young lady who is being brought a letter by a maid, by ditto; fl 70." It might apply to our no. 19, or to our no. 20.

The earlier provenance is therefore spotty. Sale Amsterdam, 1738.

Art gallery C. Lebrun, Paris, 1807–8. Sale Lebrun, Paris, 1810. Sale Paris, 1818.

Collection Duchesse de Berry, sale exh. London, 1834.

Sale Duchesse de Berry, Paris, 1837. Collection Dufour, Marseilles.

Sale E. Secrétan, Paris, 1889.

Collection A. Paulovstof, Saint Petersburg. Art gallery Lawrie and Co., London. Art Gallery Sulley, London.

Exh. Palais Redern, Berlin, 1906. James Simon, Berlin.

Art gallery Duveen, New York and London.

Collection H. C. Frick, New York, 1919.

The mistress, sitting at a table and turned to the left, wears the same yellow jacket with an ermine border as our Cat. No. 18. The maid interrupts her writing and hands her a letter.

Both figures are close to the foreground, strongly illuminated, and standing out against the dark background, which lacks further adornment and remains undefined.

For Vermeer, this is an unusually large composition, which focuses on a moment of interaction and interruption, rather than on a contemplation of stillness and introvert thoughtfulness.

This new approach enhances the monumentality of the scene.

20

The Love Letter
Canvas,
44 x 38.5 cm.
Signed on the wall,
to the left of the servant.
Rijksmuseum,
Amsterdam.
Ca. 1667–68.

The identification with no. 7 of the Amsterdam sale, 1696, can apply to this painting as well as to our Cat. No. 19. Collection Pieter van Lennep, and his wife, Margaretha Cornelis Kops, then their daughter Margaretha Catharina van Lennep, and her husband, Jan Messchert van Vollenhoven. His sale, Amsterdam, 1892. In the museum since 1893.

In this painting, the use of the inverted Galilean telescope is apparent without doubt. We look at the principal scene through a doorway. The foreground is enhanced, dark, and lacks precision in the map on the left wall.

The identical map recurs distinctly rendered in our Cat. No. 3. The other objects nearest the viewer are also muted and almost blurred. On the other hand, the mistress and her maid, as well as the room in which they are placed, are well defined in spite of their recession into space.

The composition is attractive and treated in a decorative manner, although the two figures are devoid of individualization and resemble puppets rather than persons.

Part of this shallowness may be due to damage from the theft and subsequent holding for ransom of

Cat. 20 The Love Letter

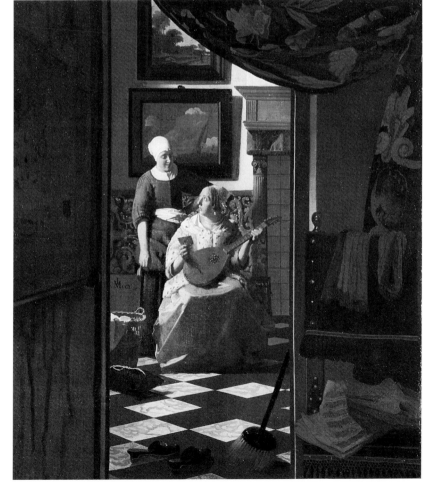

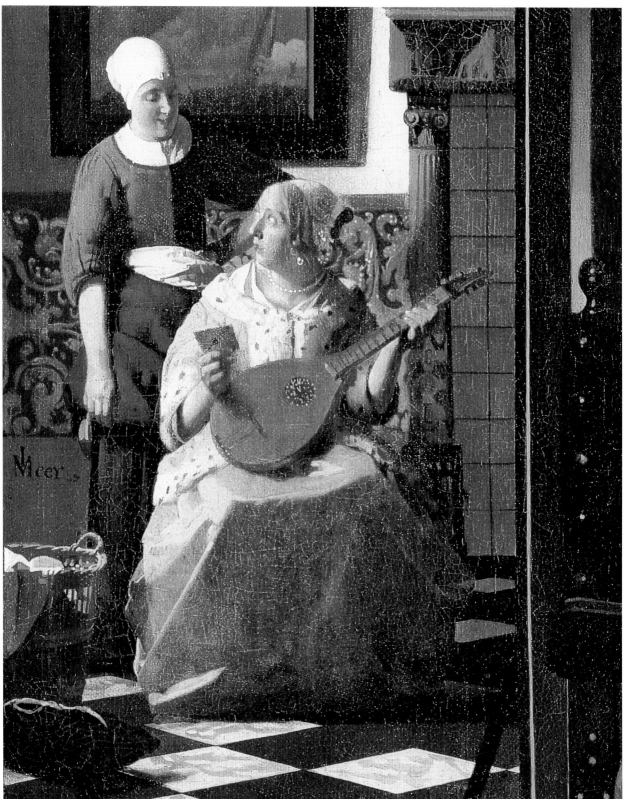

the painting, which occurred at an exhibition in Brussels in 1971.

The picture suffered much more than was later admitted, and no restorer, however skillful, can equal Vermeer.

For further details, see Larsen, 1946.

21

The Astronomer

Canvas,
50 x 45 cm.
Signed and dated 1668
on the cupboard
(spurious, later additions).
Musée du Louvre,
Paris.
Ca. 1668.

This painting and our Cat. No. 22 are probably companion pieces, in spite of the fact that the sitter is looking to the left in both of them. They share the same provenance until 1778.

Thus: sale Rotterdam, 1713; sale Amsterdam, 1720; sale Amsterdam, 1729; sale Amsterdam, 1778. For Cat. No. 21: Collection Jean-Etienne Fiseau; art dealer Lebrun, Paris; brought to Paris in 1785; sale Amsterdam, 1797; sale Amsterdam, 1800; sale Paris, 1881; collection Alphonse de Rothschild, Paris, 1888; collection Edouard de Rothschild.

Abducted by Hitler during World War II.

Restored to owner in 1945. Acquired by Musée du Louvre, Paris, 1983.

In view of the fact that the *Astronomer* and the following painting, the *Geographer*, are probably pendants, and are the only works in Vermeer's oeuvre that represent male figures involved in scholarly pursuits, we are treating them conjointly.

Until 1778, they remained together. The signatures and dates on both paintings are questionable, but they must have been executed toward the end of the 1660s.

None of these paintings appears in the sale of 1696, and were therefore commissioned by a patron who was especially interested in astronomy or the celestial sciences. Wheelock's contention, that they represent the Delft scientist Anthony van Leeuwenhoek, has been disproved by Blankert.

But in both paintings, the references to books, scientific instruments, and, in the portrait of the *Astronomer*, the celestial globe by Jodocus Hondius, are accurately depicted.

The latter painting features on the rear wall a picture representing the scene of the finding of Moses, which has been interpreted as being associated with the advice of divine providence in reaching, in the case of the astronomer, for spiritual guidance.

Although farfetched, it is likely that the content of the painting is associated in some way with the meaning of the work.

The sea chart on the wall of the *Geographer* does not have any religious association.

It must be remembered that the rise of interest in scientific research at the time, fostered by the newly established University of Leyden, and philosophers like Descartes, did not have any specific religious associations.

Quite to the contrary, the aim was to explore the universe, and simultaneously to further Dutch navigation in its conquest of faraway lands.

Both paintings, with their interiors of scholarly studios and scientific paraphernalia, award Vermeer the opportunity for lightening effects that envelop the scientists in the mystery of an atmosphere that lifts their occupations into the realm of spirituality.

22

The Geographer

Canvas,
53 x 46.6 cm.
Signed twice:
on the cupboard;

and signed and dated 1669
top right.
All these inscriptions
are dubious.
Städelsches Kunstinstitut,
Frankfurt
Ca. 1668.

Provenance after 1778: in 1785, Cat. Nos. 21 and 22 were brought to Paris by the art dealer Alexandre Joseph Paillet.

He intended to sell them to the French king, but was unsuccessful.

Sale Amsterdam, 1797; sale Amsterdam, 1803; collection Alexandre Dumont, Cambrai; collection Isaac Pereire, 1866; sale Pereire, Paris, 1872; collection Max Kann, Paris; sale Demidoff, Palais de San Donato, Florence, 1880; sale Ad. Jos. Bösch, Vienna, 1885. There acquired by the museum.

23

Lady Standing at a Virginal

Canvas,
51.7 x 45.2 cm
Signed on the instrument.
National Gallery, London.
Ca. 1670.

The early documents do not differentiate between a lady standing or seated at the clavecin. It is therefore not certain whether it is our Cat. No. 23 or No. 24 that was part of the collection of Diego Duarte in Antwerp in 1682. The same is true of no. 37 in the Amsterdam sale of 1696; and also of the work recorded in the Amsterdam sale of 1714. It is only since the Amsterdam sale of 1797 that the lady is identified as standing, and therefore refers to our Cat. No. 23. Collection E. Solly, London; sale Edward Lake, London, Christie, 1845; collection Thoré-Bürger, 1866; sale Thoré-Bürger, Paris, 1892; art gallery Lawrie, London. There acquired by the museum in the same month (December). This painting now hangs at the National Gallery, London, together with our next catalog entry, *A Lady*

Seated at the Virginal. There is no certitude that the two are companion pieces, but they obviously are closely related as to subject matter. The technique exemplifies in both instances Vermeer's late period. Both are decorative, superficial, flat, and empty of expression. The artist's inspiration seems to have reached its end, and what remains is craftsmanship—an exercise in technical skill devoid of further implication. We again encounter on the back wall of Cat. No. 23 the *Standing Cupid Holding a Card Aloft*, with which we are familiar from *Girl Asleep at a Table* at the Metropolitan Museum, New York. One now ascribes rather convincingly this painting to Caesar van Everdingen. The landscape to the left belongs to Jan Wynants, or his immediate *entourage.* Whether Vermeer really wanted to convey the emblematic meaning of pure love, as represented by the cupid, remains problematic. This writer is inclined to think that the artist was much more preoccupied with problems of light, structure, and perhaps metaphysics, than with the rather sterile emblematics that one wants to impute to him.

24

Lady Seated at a Virginal
Canvas,
51.5 x 45.5 cm.
Signed on the wall to the right
of the head.
National Gallery,
London.
Ca. 1672–73.

As stated previously (under Cat. No. 23), this painting may or may not have been part of: the Duarte collection in Antwerp in 1682; the Amsterdam sale of 1696, no. 37; and the Amsterdam sale of 1714. It was part of the collection of Count Schönborn, Pommersfelden, and sold in Paris in 1867. Acquired for Fr 2,000 by W. Bürger, and sold in the sale of his collection in Paris in 1892. Art Gallery Sedelmeyer, 1898.

Art gallery T. Humphry Ward, London, 1894(?).
Collection George Salting, 1900. Bequeathed by him to the museum in 1910.

Whereas our no. 23, the *Lady Standing at the Virginal*, is bathed in light, this putative companion piece features a subdued atmosphere. The shade is drawn here, and though we can make out every detail in the limpid light, Baburen's *Procuress* hanging on the back wall furnishes the main contrast. It is curious to observe that while inanimate objects—the clavecin, the bass viol in the foreground to the left, and the decorations of the musical instrument—are extremely detailed, the curtain to the left is stiff; and the lady making music is devoid of expression, depersonalized, and faultily drawn (see, e.g., her arms).

There can be no question that the paintings from these last years are vastly inferior to what we have been accustomed to by Vermeer.

This is but the empty husk of what used to be a great painter!

25

The Lacemaker
Canvas,
24 x 21 cm
(laid down on panel since at least 1778). Signed top right.
Musée du Louvre,
Paris.
Ca. 1671.

We have here a painting that appeared in the Amsterdam sale of 1696 under no. 12: "A young lady doing needlework, by the same; fl 28." Then, Amsterdam, 1778; sale Amsterdam, 1792; sale Amsterdam, 1813; sale Paris, 1817; collection Baron Nagell van Ampsen, The Hague, 1819–23; sale this collection, The Hague, 1851; collection Blokhuyzen, Rotterdam, 1860; sale this collection, Paris, 1870; resold by Ferral for 7,500 frs to the Louvre. At least four old copies are known, two by Jan Stolker (1724–85). The

others are known from two close tracings of the eighteenth century (see J. G. van Gelder, 1972).

This charming little work enables us to witness not only the intricate craft of lacemaking, but also the application of the young woman to her task. Vermeer again used the inverted Galilean telescope to project the act and divide the composition into two main parts. In the foreground, we see the sewing cushion and the different-colored threads falling out from it. Owing to the use of the optical device already alluded to, we have red and white coloring effects that strike us as almost brutal. Then comes the lacemaker herself, receding toward the middle-ground, and set off against a unified light wall without any ornamentation. The composition is reduced to essentials, and the color scheme depicting the young woman—the yellow of her jacket and the execution of the head and hair—remains subdued compared with the vivid accents of the foreground. Some "improvements," such as the curls of the girl's hair, are later additions.

In this work, as well as the ensuing *Guitar Player*, we encounter the apex of Vermeer's art. From then on, the decline sets in.

26

The Guitar Player
Canvas,
53 x 46.3 cm.
Signed on the right on the lower edge of the curtain.
Iveagh Bequest,
Kenwood, London.
Ca. 1671–72.

Mentioned in 1676 as the property of Vermeer's widow and given by her as security to the baker van Buyten, together with our Cat. No. 27, for a debt of fl 617. Subsequent sale Amsterdam, 1696, no. 4: "A young lady playing the guitar, very good, of the same; fl 70." Collection 2d Viscount Palmerston; collection W. Cowper-Temple at Broadland,

later Baron Mount-Temple, 1871; art gallery Thos. Agnew, London, 1888. Acquired by the Earl Iveagh, 1889.

An old copy, canvas, 48.7 x 41.2 cm, in the John G. Johnson collection, Philadelphia. Now, Museum of Art, Philadelphia. The only difference separating this copy from the Kenwood, London, version is the coiffure of the guitar player, whose style points toward ca.1700. It would be interesting to clean this painting and possibly ascertain, by X-rays, whether the original coiffure is still extant and was overpainted at a later date. Otherwise, both paintings are almost equal as far as pictorial quality is concerned. Together with our Cat. No. 25, this painting constitutes one of the best achievements by Vermeer, and certainly a towering success in his late maturity. By now, the artist had attained the mastery of light and colors, together with complete freedom of expressing himself technically by means of looser brushstrokes that are no longer bound to specifics of texture or materials. The model is not drawn inward but looks to the outside world in full communication and radiance of her pleasure simply to make music. Never was Vermeer more able to liberate himself from all constraints and convey his artistic viewpoint in a more masterly manner. The landscape on the back wall seems to be painted in the style of Hackaert and is certainly not a personal creation of the artist, as proposed by Stechow, 1960.

27

Lady Writing a Letter with Her Maid

Canvas, 72.2 x 59.5 cm.
Signed on the table, under the left arm of the lady writing.
Russborough House, Beit Art Collection,
Blessington, Ireland.
Ca. 1672–74.

This painting was stolen twice over

the last three decades by Irish extremists. Recovered undamaged the first time, it was still missing in 1988 after the second theft. This is the second work, together with our Cat. No. 26, given as security for a debt of fl 617 by the widow of Vermeer to the baker van Buyten, on 27 January 1676. Sale Rotterdam, 1730. Collection Franco van Bleyswyck, Delft. Mentioned in the inventory of his estate, 1734. Collection Hendrik van Slingelandt, 1752. Collection Miller von Aichholz, Vienna, 1881. Bought by art dealer Sedelmeyer, Paris, same year. Sold to Secrétan, same year. Sale E. Secrétan, Paris, 1889. Collection Marinoni, Paris. Art dealer Kleinberger, Paris. Collection A. Beit, London. Foundation Beit, Blessington.

In this work, we encounter the characteristics of Vermeer's late style, as opposed to his period of maturity: his compositions become less compact, the figures monumental but stiff, and their interrelationship negligible.

While the mistress sits at a table, writing and facing the viewer, the maid looks bored through the half-open window at some happening outside. Even the curtain to the left and the drapes of the window are treated in a most rigid fashion, sculptural rather than painterly. A large painting, representing the finding of Moses, animates the back wall.

Although works like this retain some of the attractiveness of the artist's earlier productions, they lack much of the creative spark of yore. While they are decorative, we miss the empathy that previously existed between artist and viewer.

28

The Allegory of Faith

Canvas,
114.3 x 88.9 cm.
The Metropolitan Museum of Art, New York. Ca. 1674.

Sale Herman van Swoll, Amster-

dam,1699. Sale Amsterdam, 1718. Sale Amsterdam, 1735. Sale Amsterdam, 1749. Private collection, Austria, 1824. Collection D. Stchoukine, Moscow. Art gallery Wachtler, Berlin, as by Eglon van der Neer, with a false signature of C. Netscher.

Bought from this gallery by A. Bredius. On loan to the Mauritshuis, The Hague (1899–1923). On loan to Boymans Museum, Rotterdam (1923–28). Art gallery F. Kleinberger, Paris. Collection Colonel M. Friedsam, New York. Bequeathed by the latter to the museum in 1931.

The subject matter for this allegory obviously did not suit Vermeer's taste.

In the *Art of Painting* (see our Cat. No. 17), he produced, in spite of the intrusion of iconographic material, a composition that conveyed a psychological approach joined to artistic execution.

Even so, it was not really as successful as other works that imply thoughtfulness or meditation.

The *Allegory of Faith* is fraught with details that evidently were prescribed by the spiritual fathers (probably the Jesuits, although the first known owner of the painting was a Protestant) of the composition, but that did not fit into an artistic image with which Vermeer could cope.

Hence, we have here an exercise in classicism, of abstract concepts, which led to a mediocre result. The artist's creativity had, in any case, declined by then into a brittle style with no more inner warmth or ability to communicate.

Thus, we are in the presence of a rather dry amalgamate, drawn in the main from Cesare Ripa's book *Iconologia*, to which a large *Crucifixion* by Jacob Jordaens on the back wall is added as a backdrop. Hence, this allegorical representation of the "New Testament" can have served as a didactic introduction to some aspects of the Catholic faith.

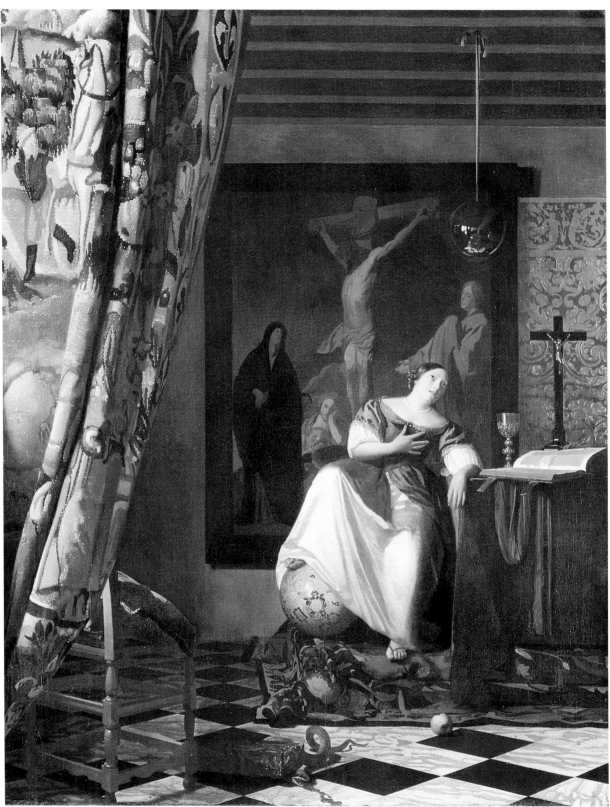

Cat. 28 The Allegory of Faith

Works Wrongly Attributed to Vermeer

It is only since the turn of the century that the idea of Vermeer van Delft being in his early years a painter of histories gained credence. Four paintings, our Cat. Nos. A1–4, generally cited in this connection, are the modern basis for the contention. The thesis completely lacks archival underpinning. One adduces as a similar, lost subject matter the mention of a painting entitled *A Person Visits the Grave* by van der Meer, fl 20, in the estate of the art dealer Johannes de Renialme in Amsterdam. The appraisal was made by a painter and gentleman dealer on 27 June 1657. Blankert and Montias convert the title of the painting to *The Three Marys at Christ's Tomb* without rhyme or reason. We do not know which Vermeer was meant. The low estimate of fl 20 certainly does not contribute to the credibility of the assertion.

Hence, the only thread that holds together these four paintings is signatures, which vary in each instance in the graphic execution and are obviously later additions. Otherwise, these paintings completely differ from one another in the conception, brushwork, and technique. They are obviously by four different hands; none of them shows any resemblance whatsoever with the accepted body of Vermeer's oeuvre.

Art history operates by fashion, like any other academic discipline. When a consensus is reached, contradiction is treated with scorn, and the argument of authority is used to silence the skeptic. One great exception is the late Ulrich Middeldorf, who publicly dared to announce that "art connoisseurship is not a public-opinion poll."

Just as it took more than eighty years to topple the *Man with a Gold Helmet* from its established podium as *the* Rembrandt masterpiece, so now is the time ripe to abandon the ludicrous thesis of the Italianizing young Vermeer, and correct the chronology of his authentic paintings, in the manner already proposed with prophetic insight by W. R. Valentiner in 1932.

A1

Diana and Her Companions
Canvas, 98.5 x 105 cm. Indistinctly signed(?) lower left on rock (J. v. Meer; highly unusual for the Delft Vermeer). Mauritshuis, The Hague.

This painting first turned up at the Dirksen art gallery in The Hague, and was sold to N. D. Goldsmid for fl 175; sale Goldsmid, Paris (Drouot), 4 May 1876, no. 68 as by Nicolaes Maes. There bought by the state of the Netherlands for the Mauritshuis for 10,000 French francs. In 1883, cataloged as "perhaps by Johannes Vermeer." Then again as N. Maes, later as Jan Vermeer van Utrecht, and now as Vermeer van Delft (since ca. 1901, date of discovery of the Edinburgh picture). The Maes signature was a forgery. The Vermeer signature is now only dimly visible. According to C. Hofstede de Groot, as reported by P. T. A. Swillens, the first letter should not be read as *J* but rather as a *P* or an *R* (which points to a painter other than Vermeer van Delft as the author). Hofstede de Groot (1907) proposed an "Italianate, more especially, a Titianesque" master as the author. The painting was considerably cut down on the right side and is overall in a very poor condition because of multiple cleanings and restorations. What remains is a colorful but very crudely executed work, which has only been given to the Delft master by comparison with the equally doubtful Cat. No. A2. Swillens relates the painting to "a great capital piece, being Diana with her nymphs, life-size, by De Vos...52," which was sold under no. 57 at the same Ams-

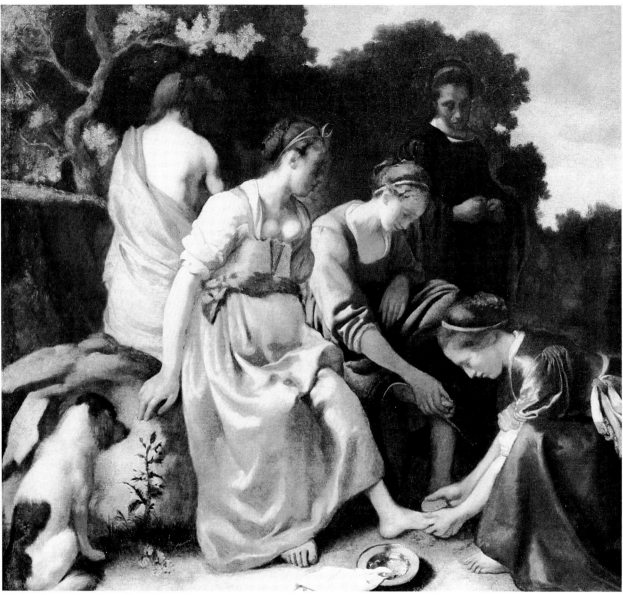

Cat. A 1 Diana and Her Companions

terdam sale of 1696, which contained a great number of authentic works by Vermeer. Jan Vermeer's father had adopted the surname "Vos" for his dealings as an innkeeper. He always used "Vermeer" as art dealer, as did his son Jan for his profession as painter and dealer. Swillens's suggestion—that the father of Vermeer, who was a caffa worker and thus, experienced in the drawing and handling of colors, might have been the author of

the piece—is not so farfetched as the detractors of the hypothesis are wont to make us believe. Furthermore, de Vos was a very common name in Holland and Flanders, and the Bénézit lists more than two dozen painters by this name who were active in the Low Countries at the time.

Jan Vermeer van Utrecht must not be forgotten as a possible attribution. He was very successful in his profession, renowned precisely in

the field of histories and had twice made a fortune by the exercise of his art. This means that he must have produced a considerable number of paintings in order to sell them with profit—quite the opposite of his namesake of Delft, who, with a small output, would have starved with his family without the constant financial succor of his mother-in-law. Modern art criticism has cut down the Utrecht Vermeer's work catalog to a minimum of mediocre

paintings, which mostly are not even by him. Again, one forgets that there were at least three Vermeers active in Utrecht at roughly the same period, and one has not even started to separate the different hands! In their zeal to stuff the Delft Vermeer's artistic production, his biographers have deliberately minimized the Utrecht Vermeer's achievements and consigned his works to the *oubliettes*.

Hale (1937) ascribes the painting to Anthonie Palamedesz. There are therefore multiple potential attributions for *Diana and Her Companions*. Jan Vermeer van Delft is the least probable one.

A 2

Christ in the House of Mary and Martha

Canvas, 160 x 142 cm. National Gallery of Scotland, Edinburgh. Signed(?) lower left on the small bench. The painting appeared out of the blue ca. 1900.

This painting was bought by an antique dealer from a family in Bristol for 8 sterling. Later, it became part of the Arthur Lewis Collection, London, and was exhibited in April 1901, Cat. No. 1 by the art dealer Forbes and Paterson, London. Mr. W. A. Coats is mentioned in the catalog as the owner. It was at that time that the signature had first become visible. Cataloged by the previous owner, Skelmorlie Castle, Scotland, 1904, no. 37. Bequeathed by the two sons of Coats in 1927 to the museum. As Swillens correctly states, "this painting coincides in no single respect with the authentic works of Vermeer" (1950, pp. 161–62).

On the basis of our No. A3, it seems likely that we have here an Italianate copy after a not yet identified original by a minor Italian master. The numerous borrowings from other artists that were easily discovered by art critics point to a pasticcio more than to the youthful work of a potential great. Italian sources, such as the figure of Christ in the picture by An-

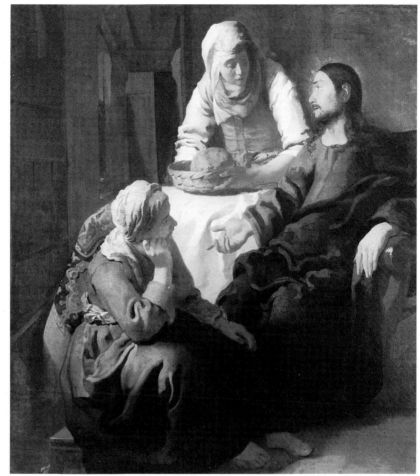

Cat. A 2 Christ in the House of Mary and Martha

drea Vaccaro (Naples, Pinacoteca Reggia di Capodimonte), the Christ in another painting by Alessandro Allori (Vienna, Kunsthistorisches Museum), or the gesture of the Christ's right arm in a work by Bernardo Cavallino (National Museum, Naples), join evident derivations from the Fleming Erasmus Quellinus (Musée des Beaux Arts, Valenciennes). Goldscheider points out that this figure "belongs to the repertory of Italian painters and was used in many studios in the sixteenth and seventeenth centuries" (p. 125).

Thus, the painting evidently lacks originality, aside from being foreign in conception and spirit from anything that we know of Vermeer. Swillens reminds us that neither the technical execution nor the expres-

sive features and gestures of Christ and the two women can be found in any of Vermeer's works. It may be useful to recall that the painting was first recognized as a Vermeer by A. Bredius. This is the same scholar who, almost four decades later, enthusiastically promoted *Christ at Emmaus* as an important addition to Vermeer's "italianizing" period—only to be later disillusioned when the new "discovery" turned out to be the child of the famous Dutch faker Hans van Meegeren. Bredius seems to have nourished a kind of *idée fixe* concerning the relationship of Vermeer and Italy, which never existed. The majority of twentieth-century art historians followed in Bredius's wake, with very few exceptions. There is no proof for his assertion,

certainly not in any of Vermeer's authentic works. We do know of one instance when Vermeer was asked to appraise a lot of Italian paintings in The Hague. The artist acted on this occasion within the purview of his second profession, that of art dealer. As such, he must have made many appraisals during his career. The fact that we have only scant knowledge of this facet of his occupations, and, incidentally, one single document to that effect, establishes by no means that he was considered a specialist in the field of Italian art. If the next time, the paintings submitted to him for evaluation had been German or Flemish, he would have appraised them just the same. This was, and still is, everyday business for an art expert.

The signature differs considerably in the writing from authentic ones. It must be considered spurious.

A3

Saint Praxedis

Canvas, 101.6 x 82.6 cm.
Barbara Piasecka Johnson Collection, Princeton, New Jersey.
Signed(?) twice: MEER 1655—*lower left.* MEER N... .R. *Lower right.*

Of all the recently proposed attributions destined to enlarge the body of Vermeer's so-called youthful period, this one is the most questionable. It has a checkered history. Discovered in 1943 in a small New York auction room by a couple of Belgian refugees, the late Jacob Reder and his wife, it was for a long time turned down by all Vermeer specialists. Jacob Reder, who dabbled in the Old Masters trade long before coming to America, was well known as an eccentric with a powerful imagination. After his death, the painting was acquired from his widow by a New York (now Los Angeles) dealer. From there, it passed into the collection of the current owner.

The painting is known to me from personal examination and study ca. 1948–49. We have here an Italianiz-

ing copy after a minor Florentine artist. Some connoisseurs believe that this copy was executed by an Italian in his customary technique. Others are inclined to admit that the painting could have been done by a northern artist, in close imitation of the Florentine original. The latter exists: it is by Felice Ficherelli (1605–69?) and belongs to a private collector in Ferrara. In any case, Cat. No. A3 is a mediocre painting. The main difference from the Florentine original is the cross in the hands of the saint, which was probably added at the request of a convent or church that had commissioned the work. An attribution to Vermeer finds its sole basis in the two signatures, because neither style nor pictorial quality are anywhere close to the artistic level of Vermeer. It is extremely important to remember, in this context, that false Vermeer signatures occur often and were probably affixed sometime during the eighteenth or nineteenth century. If such an inscription is two hundred years old, as compared with the age of roughly three hundred years for the painting, the contemporaneity becomes almost impossible to prove either way by so-called scientific methods.

The faker who applied the false signatures a hundred years after the origin of the painting certainly removed the varnish to put his additions directly upon the painted surface. In due course, the false inscriptions, as long as they do not contain pigments that were in use exclusively at a later period only, can hardly be discerned from the original layer of paint. The new pigments become bound with the old ones and reproduce the original cracks. Such falsifications even resist examinations with the microscope at considerable magnification. Here applies the famous dictum of the late C. Hofstede de Groot, who, when confronted with a signature that he did not trust, used to announce: "a painting has to be signed all the way, diagonally from the upper left corner to the lower right one." Experience and intuition have to take the place of

vulnerable scientific data. Hence, according to my own examination of the painting, I am convinced that the first signature in the lower left of the painting was applied about a hundred years later. Aside from its aspect, the graphic traits differ considerably from reliable examples of Vermeer's signature. The second signature in the lower right, in light ochre, is, in my opinion, much more recent—100 to 150 years old. As this signature has been painted very thinly, the original cracks have easily pierced the layer of new paint, giving it the aspect of authenticity.

The painting was first attributed to Vermeer by Michael Kitson in 1969. The main champion for its authenticity is A. K. Wheelock, Jr., whose rather strident defense does not become more credible with repetition. Blankert, the best current connoisseur of the topic, rightly rejects the attribution. Others upholding it are mainly cultural historians whose opinions in matters of connoisseurship do not count. An attribution to Michael Sweerts could possibly be considered.

A4

The Procuress

Canvas, 143 x 130 cm. Dresden, Staatliche Gemäldegalerie. Signed(?) and dated(?) lower right 1656.

Acquired for the collection of the elector of Saxony in 1741 from the Wallenstein collection. First mentioned in the Dresden catalog of 1765 as by Jean van der Meer, without specifying which Van der Meer. In the catalog of 1782 as by Van der Meer of Haarlem. In the catalog of 1826 as by Jacques van der Meer of Utrecht. First attributed to Jan van der Meer of Delft by Smith, and by Thoré in 1860. Both the signature and the date are old, but not necessarily contemporaneous. There is no relationship between this painting and other authentic works by the master, neither in the conception nor the execution. One has attempted to establish a connection between this work and the one by Dirck van

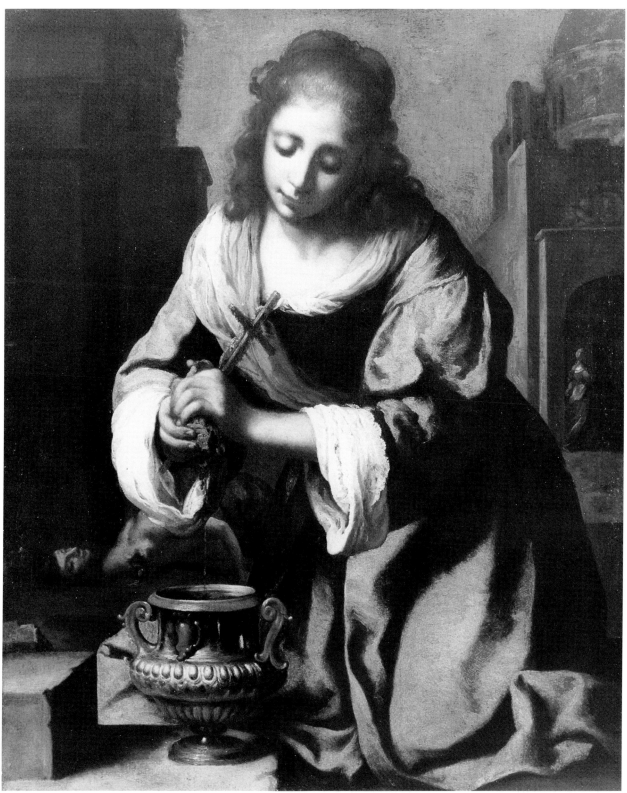

Cat. A 3 Saint Praxedis

Baburen from 1622, now in the Boston Museum of Fine Arts. However, aside from the subject matter, the Dresden painting has nothing in common with the one in Boston. The lat- ter seems to have been part of Vermeer van Delft's stock in trade and appears as such in two of his paintings. At one time, it must have been the property of his mother-in-law. The fact that Vermeer van Delft was a dealer and thus owned a number of works by other masters does not necessarily imply that he took them as models for his own productions, even

Cat. A 4 The Procuress

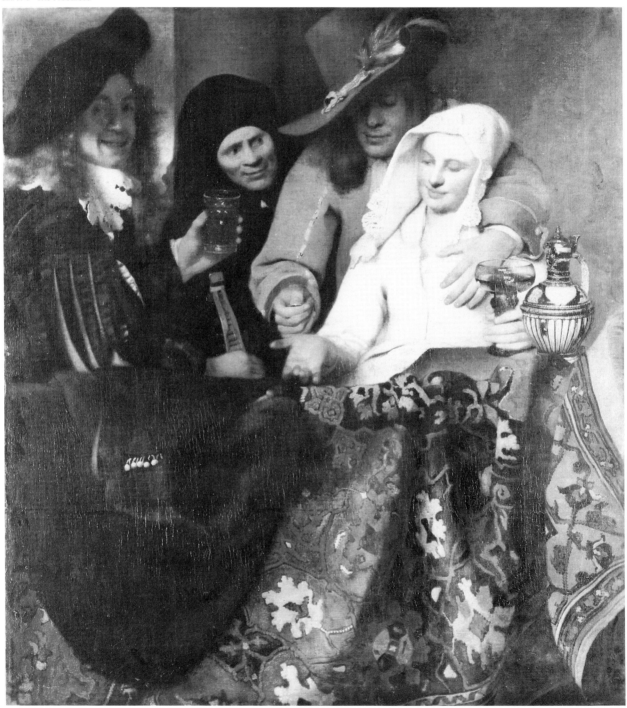

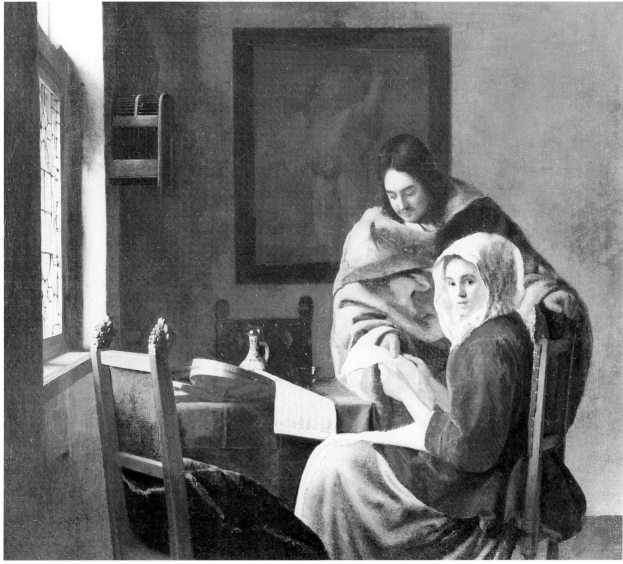

Cat. A 5 Girl Interrupted at Her Music

if he used some of them as back-ground decorations in his paintings. It is illogical to infer from such weak thematic inferences that the Delft Vermeer could have been the author of such a painting, which remains completely outside his authentic style and artistic conception.

A 5

Girl Interrupted at Her Music
Canvas, 39.3 x 44.4 cm. The Frick Collection, New York. Agrees with the style of Vermeer's paintings ca. 1660.

This painting first appeared at an Amsterdam sale in 1810 with the at-tribution to Jan Vermeer van Delft. Subsequently, at two other sales, the same city, in 1811 and 1820. It was then sold at Christie's in London in 1853, passed through the hands of the art gallery Lawrie and Co., Lon-don, and finally the art gallery Knoedler, New York, from which it was finally acquired by H. C. Frick in 1901. Owing to its very poor state of preservation, which has been re-marked upon by C. Hofstede de Groot in 1899, it is difficult to deter-

mine whether we have here an old copy or an almost completely ruined and overpainted original. The best part of the painting is the still life. In the background, we find the *Standing Cupid*, which is already familiar to us from our Cat. Nos. 1 and 2. Hofstede de Groot complained in his above-mentioned publication that the bird cage and a violin with a bow on the rear wall were completely new. We still find the bird cage. Violin and bow have been since taken off. In the composition, which seems to be based on a Vermeer original, we find

a new twist—the interruption in the interaction of the two figures. The young girl looks out at the viewer, and takes time off from the making of music. It has been suggested that the cupid on the wall conveys the emblematic meaning of unrequited love. Only the gentleman seems to be fully absorbed by his feelings, whereas the young woman appears distracted and inattentive. The treatment of light, falling in from the left, is also Vermeeresque.

A 6

Woman with a Lute near a Window

Canvas, 51.4 x 45.7 cm.
The Metropolitan Museum of Art, New York.
Indistinct remainders of a signature(?) on the wall below the tablecloth. Ca. 1656–57.

Sale Amsterdam, 1817, with the attribution to Vermeer van Delft, for fl 65; collection Collis B. Huntington, New York (bought in England). Bequeathed to the museum in 1897. We have here a much skinned and damaged painting, to the point where it is possible that we are in the presence of a copy only. Very little in this work seems to indicate Vermeer's original technique, brush stroke, and *savoir faire*. From what one can tell, it appears unlikely that the traditional dating proposed by the majority of critics (1663–65) can be upheld. The composition seems to belong to Vermeer, and to judge from the style and the light effects, the original must have been part of the series of Rembrandtesque compositions pertaining to the artist's early period. A date of ca. 1656 is therefore indicated. The left part (from the viewer's perspective) of the lady's figure is bathed in strong light, whereas the rest falls abruptly into penumbra, in concordance with the chiaroscuro pattern derived from the master of Leyden by many of his disciples, such as Leonard Bramer. On the back wall, a large map on which the word *EU-*

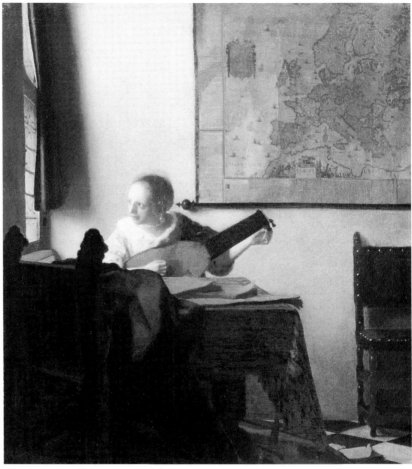

Cat. A 6 Woman with a Lute near a Window

ROPA can be made out. According to Blankert, this map was first published by J. Hondius in 1613 and republished by J. Blaeu in 1659. The artist obviously made use in this work of an optical instrument such as the inverted Galilean telescope, to obtain the emphasized foreground, set against the recession of the lute player into space.

A 7

Girl with a Red Hat

Panel, 23 x 18 cm.
National Gallery of Art, Washington, D.C.
Monogram(?) upper left.

The painting is only known since a Paris sale of 1822, in which it was described as a work by Vermeer van

Delft. It was sold for 200 French francs. Subsequently: collection Baron Atthalin, Colmar; collection Baron Laurent Atthalin; art gallery Knoedler, New York, 1925; collection Andrew W. Mellon, Washington. Since 1937, in the museum.
This painting is certainly not by Vermeer, but a later pasticcio. It, and the ensuing catalog entry, are painted on wood, whereas all authentic Vermeer paintings are done on canvas. Furthermore, the "snapshot" effect of this picture has nothing in common with seventeenth-century paintings, but is entirely consistent with the pictorial approach of the nineteenth century. Blankert, and earlier, Gudlaugsson, van Dantzig, and Swillens, contested the authenticity of the painting. This work has been painted on an

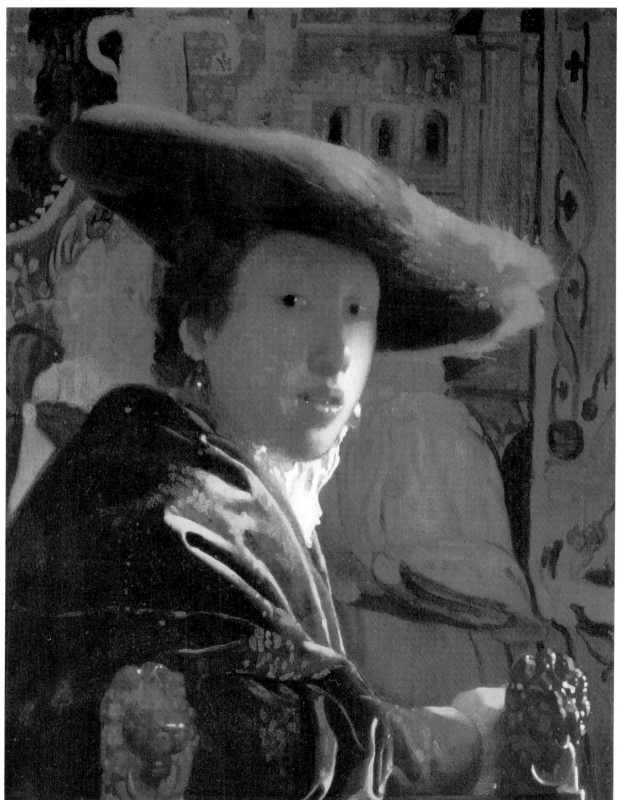

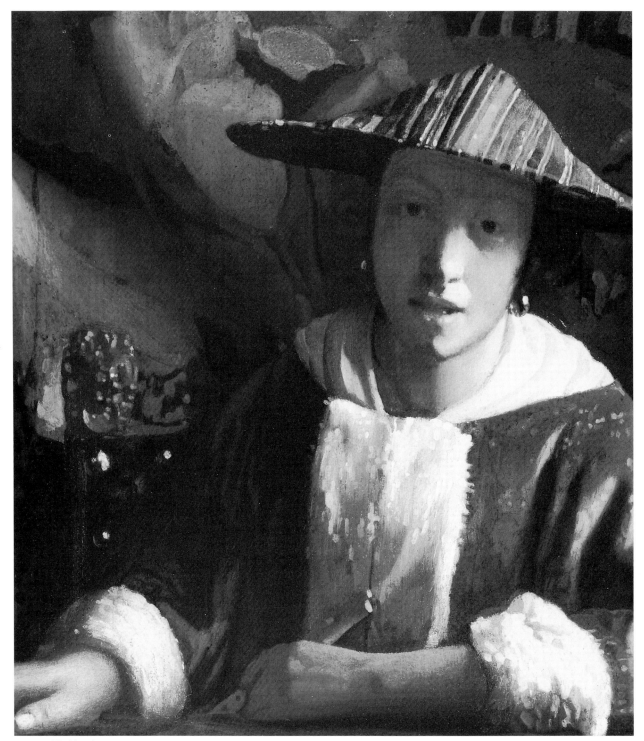

Cat. A 8 Girl with a Flute

upside-down Rembrandtesque portrait of a man, and pigments considered to be older than the nineteenth century found in this painting come from the original and not from the modern pasticcio. All monographs earlier than the Walsh and Sonnenburg study in 1973 stated erroneously that this picture was done on canvas. As we know, and as Blankert states, attributions to Vermeer from the eighteenth and nineteenth centuries are consistently unreliable. One must not forget that a whole school of fakers after Dutch paintings were active in Paris during the first half of the nineteenth century. Their products, especially imitations of Dutch seventeenth-century landscape artists and, more specifically, Jacob van Ruisdael, are all known to art connoisseurs. It is entirely probable that these fakers did not stop with Dutch landscape art, but also produced other works in imitation of the Dutch golden age. This painting may well be the product of one of these "artists." An authentic seventeenth-century work it is not.

A 8

Girl with a Flute
Panel, 20.2 x 18 cm. National Gallery of Art, Washington, D.C.

This painting stems from the following collections: Jan Mahie van Boxtel en Liempde, Bois-le-Duc; collection Maria de Grez-van Boxtel van Liempde, Brussels; collection Jhr. de Grez, Brussels. Noticed there by A. Bredius and exhibited in the Mauritshuis, The Hague, 1906–7. Collection August Janssen, Amsterdam. Art Gallery J. Goudstikker, Amsterdam, 1919. Art Gallery Knoedler, New York. Collection Joseph E. Widener, Philadelphia. Since 1942, in the museum.
The painting is on panel, and obviously originates from the same faker's studio as the preceding catalog entry. Note that it owes its attribution to Vermeer to the same art critic, A. Bredius, who was responsible

for the erroneous attribution of *Christ in the House of Martha and Mary* in Edinburgh, and the acceptance of the Van Meegeren fake *Christ at Emmaus* at the Rotterdam museum as an authentic work by Vermeer. Wheelock still defends the preceding number as a work by the master while now admitting that our no. A8 comes from the "circle of Vermeer." We know nothing about contemporary followers or imitators of Vermeer. It is my contention that this work, as well as the preceding one, are French fakes produced at the beginning of the nineteenth century.

Cat. A 9 Girl at the Clavichord

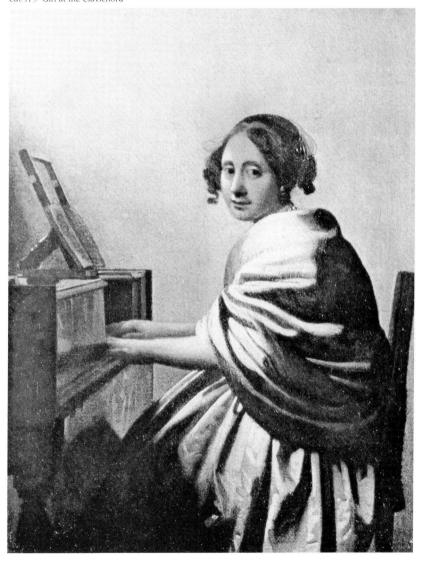

A.9

Girl at the Clavichord
Canvas, 24.5 x 19.5 cm.
Collection Baron Rollin, Brussels.
Unsigned.

W. Reyers sale, Amsterdam, 1814, no. 93 (sold to Gruyter for 30 guilders). Erroneously there described as painted on wood. Lady Beit Collection, London. This painting is of very poor quality, and its surface was skinned by impetuous cleaning. The composition derives from a late work by Vermeer, *Lady Seated at the Virginal*, in the Lon-

Cat. A 10 Portrait of a Man

tion, Vienna, which was bought *in toto* by the Hungarian government in 1865. We have here a very fine work from the direct Rembrandt circle, but hardly an original by the Delft Vermeer. The design and the modeling of the face bear a certain resemblance to Vermeer's draftsmanship, but hardly sufficient to warrant an attribution to him.

A 12

Young Woman with a Blue Hat
Canvas, 23.5 x 21.3 cm.
The Municipality of Lugano.

The painting first appeared at an auction at Fred. Muller and Co., Amsterdam, between 1890 and 1900. Then art dealer P. Cassirer, Berlin, and acquired by Dr. H. Baron Thyssen-Bornemisza. Pinacoteca Villa Favorita, Lugano. Bequeathed by the baron to the municipality of Lugano.
This painting, as well as Nos. A13, A14, A15, and A16, are falsifications. This is to say that some later painting with an acceptable subject matter was taken and "enhanced" by the faker in the manner of Vermeer.

A 13

Girl with Blue Bow
Canvas, Glenn Falls, New York,
Collection of Mrs. Louis F. Hyde
40 x 35 cm.

Mrs. Louis F. Hyde Collection, Glenn Falls, New York. Provenance: C. E. Carruthers Collection, Somerset. Sale Christie's, London, 1934, no. 62. Art dealer A. F. Reyre, London. Art dealer D. Katz, Dieren, Netherlands. This painting is a falsification. A period work by some minor master has been overpainted in the supposed style of Vermeer.

A 14

Laughing Girl
Canvas, 40 x 31 cm. National Gallery of Art, Washington, D.C.

don National Gallery, but is much weaker in every respect—invention as well as execution. It is either a simplified copy after a lost original, or a later pasticcio.

A 10

Portrait of a Man
Canvas, 87.5 x 66 cm. Private Collection, Netherlands. (False) signature: I. MEER *(the I and the M form a monogram).*

Provenance: An English collection.

This painting is attractive and seems to be the work of a previously unidentified Delft master. The signature was proved to be a fake. An attribution to Vermeer has by now been abandoned, in favor of the possible authorship of Jan Baptiste Weenix (de Vries, 1948).

A 11

Portrait of a Woman
Canvas, 82 x 65 cm.
Museum of Fine Arts, Budapest.

From the Prince Esterházy collec-

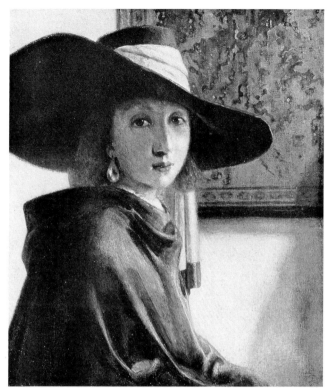

Cat. A 11 Portrait of a Woman

Cat. A 12 Young Woman with a Blue Hat

Cat. A 13 Girl with Blue Bow

Cat. A 14 Laughing Girl

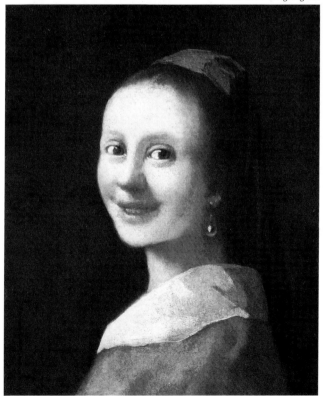

Cat. A 15 The Astronomer

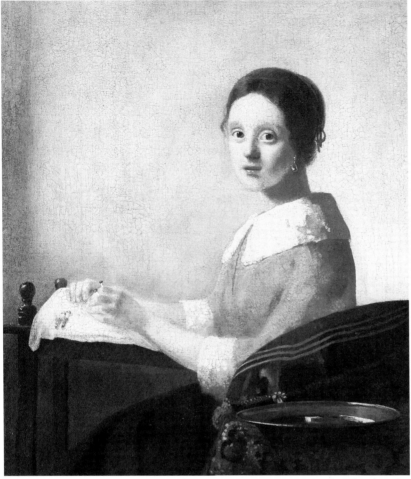

Cat. A 15 The Lacemaker

From the Walther Kurt Rhode collection, Berlin. Art dealers Duveen Brothers, London and New York.

Like the above catalog entries, this painting is a falsification dating from the 1920s and withdrawn from the walls of the museum in the 1970s.

A 15

The Lacemaker

Canvas, 45 x 39.5 cm.
National Gallery of Art,
Washington, D.C.

From the Harold R. Wright Collection, London. Art dealers Duveen Brothers, London and New York. Andrew W. Mellon Collection, Washington, D.C. Bequeathed to the nation by Andrew W. Mellon. Another falsification in the style of the preceding ones.

A 16

The Astronomer

Panel,
48.5 x 37 cm.

From: Is. Périère sale, Paris, 1872. 4,000 francs. E. Kums Sale, Antwerp, 1898, no. 114.
Vicomte du Bus de Gisignies Collection, Brussels. E. Jonas Collection, Paris. E. J. Magnin, New York.

This painting, which appeared in 1872, is a later imitation, probably

French nineteenth century.

A 17

Magdalen at the Foot of the Cross

Canvas,
154 x 135 cm.
Major F. H. Fawkes collection,
Otley.

Exhibited at Manchester in 1934. Vermeer exhibition, Rotterdam, 1935, cat. no. 79a. (first attribution to Vermeer).
Although it is not by Vermeer, it is an intriguing painting, probably either by a Delft or a Haarlem master.

A 18

Portrait of a Young Girl

Canvas, 37.5 x 32.5 cm.
Van Beuningen Collection,
Rotterdam.

From: art dealer J. Goudstikker, Amsterdam. Formerly attributed to Gerard Ter Borch. Exhibition of Dutch children's portraits, municipal museum, The Hague, 1924. Vermeer exhibition, Boymans Museum, Rotterdam, 1935, no. 89.
As we know, Ter Borch and Vermeer were acquainted in Delft. The

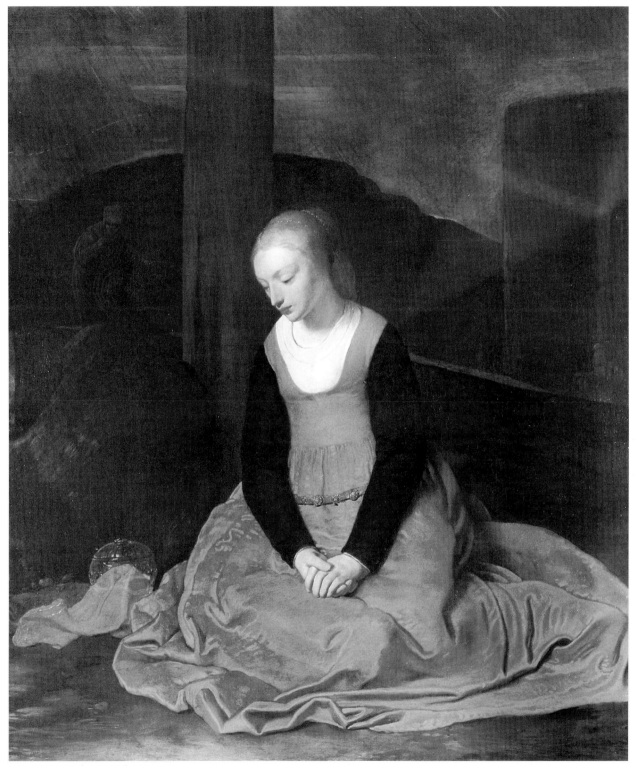

Cat. A 17 Magdalen at the Foot of the Cross

Cat. A 18 Portrait of a Young Girl

painting is, however, by neither of these artists but a good work by some unknown Delft artist.

Portrait of a Man

Canvas, 73 x 59.5 cm.
Musées Royaux des Beaux-Arts,
Brussels.

Sold in 1898 by the dealer Sedelmayer in Paris as a work by Nicolaes Maes. Then Otlet collection, Paris. Again Paris, where it was acquired by the Brussels museum at the Cotley Dupont sale in 1900. Sometimes called Rembrandt on the basis of a forged signature, then Vermeer van Delft, on the grounds of its stylistic affinity with the *Portrait of a Woman* in Budapest (see our Cat. No. A11), its current attribution remains uncertain. An old copy exists in the Dijon museum, formerly in the Magnin collection.

Bust of a Young Man

Canvas, 59.7 x 49.5 cm.
J. S. Bache Collection,
New York.

From: collection Y. Perdoux. Art dealers Duveen Brothers, London and New York. Formerly attributed

Cat. A 19 Portrait of a Man

to Sebastian Bourdon, and attributed to Vermeer by Hofstede de Groot. This latter identification was already doubted by 1926 and subsequently abandoned.

Young Woman Reading

Canvas, New York
19 x 14 cm.

Bought in 1928 by J. S. Bache, New York. From the Rademaker collection, The Hague. Art dealer Wildenstein, Paris.
Exhibited in 1926 by the Reinhardt Galleries, New York.
First accepted by Hofstede de

Groot. Rejected by Hale and all modern critics. The painting has since been ignored in all contemporary catalogs.

Domestic Interior

Private Collection, New York

This painting was joined together through juxtaposition of the two halves: left, 106 cm x 83.3 cm; right, 111.2 x 69.3 cm. As can be seen, the two so-called halves do not concord. It currently belongs to an American collector. Monogrammed *IRVM* on the lid of the jewel box on the table near the window. This most unusual

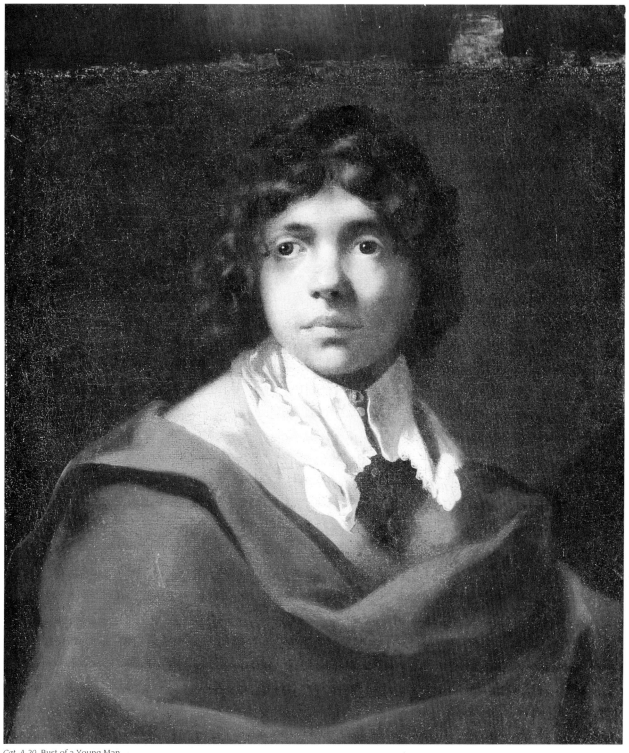

Cat. A 20 Bust of a Young Man

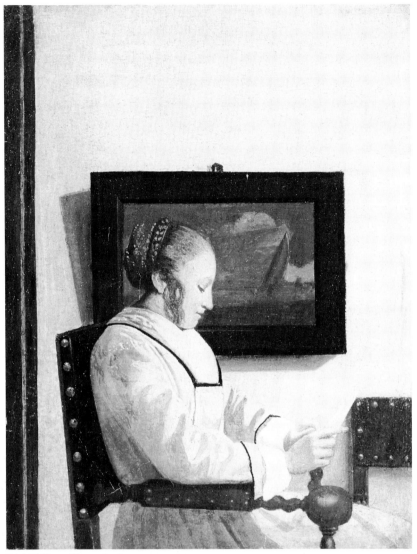

Cat. A 21 Young Woman Reading

with the description. The former attribution to Brekelenkam makes much more sense, although we would favor an ascription to Cornelis de Man.

Christ at Emmaus

Canvas, 117 x 129 cm.
Museum Boymans-Van Beuningen,
Rotterdam.

This is most probably the most famous fake by Hans van Meegeren, executed ca. 1936, which was published by Abraham Bredius in 1937 as a newly discovered masterpiece by Vermeer. It succeeded partially because art historians, especially Bredius, had wrongly attempted to establish the mythos of an Italianizing young Vermeer, and therefore were eager to find supplementary "proof" for their theory. Van Meegeren painted a number of other Vermeer forgeries, which are not necessary to cite in this context.

monogram is highly suspicious. The painting has been identified by some critics as no. 3 in the Amsterdam sale of 1696, there described as "The portrait of Vermeer in a room with various accessories, uncommonly beautiful, painted by him; fl 45." The left part of the painting was sold at the Hotel Drouot in Paris in 1956 with an attribution to Quiryn Brekelenkam. It was consigned by Anthony Reyre of London, owner of the Vermeer Gallery in that city. Reyre apparently bought the painting in—and both halves were later sold at, with the same attribution—the Savoy

Art and Auction Galleries in New York in 1959. The two halves were bought by two different collectors, and the present owner succeeded in acquiring them from an American and a French collector. The painting, currently joined and restored, was accepted as a work by Vermeer by Piero Bianconi. However, modern critics have not followed him in his judgment. In our opinion, the style and the quality of this work do not support an attribution to Vermeer. The identification with no. 3 of the 1696 Amsterdam sale appears extremely doubtful and does not tally

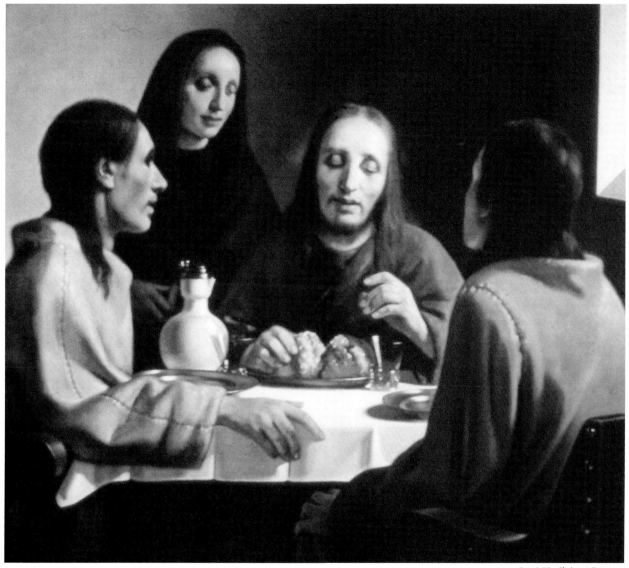

Cat. A 23 Christ at Emmaus

There are a number of other attributions to the young Vermeer, which have been of extremely short duration. We cite in this respect J. Q. Van Regeren Altena, "Een jeugdwerk van Johannes Vermeer," *Oud Holland* 75 (1960): 175–94, which contains some paintings as well as a drawing; D. Hannema, *Over Johannes Vermeer, twee onbekende jeugdwerken*, Stichting Hannema-de Stuers Fun-

datie, 1972, with very questionable attributions; and C. Wright, *Vermeer*, London, 1976, p. 9, who came up with an *Esther and Ahasverus* with a forged signature, "Meer fecit 1654." The painting has since been identified by L. J. Slatkes as a work by Johannes van Swinderen (1594–1636).

All these attributions, and many more, can be safely disregarded.

Topographic Index

Historical Dates of the Epoch

1609

Signing of the twelve-year truce between Spain and the seven rebel northern provinces. Implies de facto recognition of their independence.

1615

Marriage in Amsterdam of Reynier Jansz. and Digna Baltens, the parents of Jan Vermeer. They must have moved to Delft shortly afterward.

1621

Expiration of the truce between Spain and the United Provinces. Resumption of hostilities.

1631

Inscription of Reynier Jansz. Vos (the latter name adopted when he became an innkeeper in Delft) in the Delft guild of Saint Luke as an art dealer.

1632

Birth of Jan (Joannis) Vermeer, second child of Reynier Jansz. Vos and Digna Baltens.

1648

Peace of Münster between Spain and the United Provinces. The latter obtain definitive recognition of their independence. Gerard Ter Borch paints *The Swearing of the Oath of Ratification of the Treaty of Münster.*

1650

Carel Fabritius documented in Delft.

1651

Reynier Vos, father of Vermeer, dies.

1652

Carel Fabritius admitted as master in the Delft guild of Saint Luke.

1653

Jan Vermeer marries Catharina Bolnes. He obtains the same year his inscription as a master in the Delft guild of Saint Luke, at the age of twenty-one.

1654

Explosion of the Delft powder magazine. Carel Fabritius loses his life in the conflagration. Jan Steen worked in Delft 1654–57.

1655

Enrollment of Pieter de Hooch in the Delft guild of Saint Luke. He leaves for Amsterdam ca. 1660.

1662

Vermeer elected an officer of the guild of Saint Luke.

1663

Visit of Balthazar de Monconys in Vermeer's studio, as recorded in the Frenchman's journal.

1667

A. Bon publishes the *Description of the Town of Delft* by Dirck van Bleyswyck, which includes a poem whose last stanza refers to Vermeer.

1670

Vermeer again elected to office in the guild of Saint Luke.

1672

The French invade the United Provinces, and the Dutch flood the land. Appraisal of a lot of pictures in The Hague for the elector of Brandenburg.

1673

The French invasion is repelled, but the Dutch economy suffers vastly.

1675

Vermeer makes a trip to Amsterdam to borrow a thousand guilders. He dies the same year and is buried in Delft.

1676

Vermeer's widow hands two paintings over to the baker van Buyten to settle a debt for bread. She transfers title to the *Art of Painting* to her mother. Inventory of Vermeer's possessions. Van Leeuwenhoeck appointed administrator of the estate by Delft magistrates.

1688

Vermeer's widow, Catharina, dies.

1696

Sale at auction in Amsterdam of a private collection, probably that of Dissius, of twenty-one paintings by Vermeer.

1699

The *Allegory of Faith* is sold for fl 400.

1822

The newly opened Mauritshuis, in The Hague, acquires Vermeer's *View of Delft* for 2,900 guilders.

1866

Thoré-Bürger rediscovers Vermeer. Three articles in the *Gazette des Beaux-Arts.*

Bibliography

Adhémar, H.

"La Vision de Vermeer par Proust, à travers Vaudoyer," in *Gazette des Beaux-Arts,* 6th series. 1966, 68: 291 ff. Aillard, Gilles, et al. *Vermeer.* Paris, 1986; U.S. ed., New York, 1988.

Ainsworth, Maryan Wynn, et al.

Art and Autoradiography: Insights into the Genesis of Paintings by Rembrandt, Van Dyck, and Vermeer. New York, Metropolitan Museum of Art, ca. 1982.

Alberti, Leo Battista

Della Pittura. 1435–36.

Arasse, Daniel

Vermeer, Faith in Painting. Princeton, N.J., 1994.

Bianconi, Piero

The Complete Paintings of Vermeer. New York, 1967.

idem, and Joseph Guttmann

A Rediscovered Youth Work [sic!] *by Vermeer van Delft.* Privately printed, Los Angeles, 1977.

Blankert, A.

Vermeer of Delft. Complete Edition of the Paintings. Oxford, 1975. Reviewed by H. Gerson in "Recent Literature on Vermeer," *Burlington Magazine* 119 (Apr. 1977): 288–90. *Vermeer's Work: Vermeer and His Public,* in Aillard, Gilles, et al. New York, 1988, listed above.

Bleyswyck, D. van

Beschryvinge der Stadt Delft. Printed by Arnold Bon, bookseller, Delft, 1667.

Bloch, V.

Tutta la Pittura di Vermeer di Delft. Milan, 1954. English language ed., 1963.

Bonafox, Pascal

Vermeer. Paris, 1992.

Bosse, Abraham

Manière universelle de Mr. Desargues pour pratiquer la perspective. Paris, 1648.

Bredius, A.

"Iets over Johannes Vermeer," in *Oud Holland* 3 (1885): 217 ff.
"Nieuwe bijdragen over Johannes Vermeer," in *Oud Holland* 28 (1910): 61 ff.
"Italiaansche schilderijen in 1672 door Haagsche en Delftscheschilders beoordeeld," in *Oud Holland* 34 (1916): 88 ff.
"Schilderijen uit de nalataneschap van den Delftschen Vermeer," in *Oud Holland* 34 (1916): 160 ff.

Bürger, W. (Thoré)

"Van der Meer de Delft," in *Gazette des Beaux-Arts* 21 (1866): 297–330, 458–70, 542–75.

Cennini, C.

Il libro dell'arte o Trattato della pittura. 1437. Reprint Mi-

lan, 1975.

Claudel, Paul

Introduction à la peinture hollandaise. Paris, 1946.

Descamps, J. B.

Vie des Peintres Flamands et Hollandais. Original ed., Amsterdam, 1752–63; my reference, the Marseille 1842 ed., vol. 2.

Dürer, Albrecht

Underweysung der Messung. Nürnberg, 1525.

Fink, D. A.

"Vermeer's Use of the Camera Obscura: A Comparative Study," in *Art Bulletin* 53 (1971): 493–505.

Gelder. J. G. van.

De schilderkunst van Jan Vermeer. With comments by J. A. Emmens. Utrecht, 1958.

Goldscheider, L.

Johannes Vermeer, the Paintings. London, 1967.

Gowing, L.

Vermeer. London, 1952, 2d ed. London, 1971.

Grimme, E. J.

Johannes Vermeer van Delft. Cologne, 1974.

Gudlaugsson, S. J.

Gerard Ter Borch. The Hague, 1959.

Haak, Bob

The Golden Age: Dutch Painters of the Seventeenth Century. London, 1984.

Hale, P. L.

Vermeer. Boston, 1937. New ed. by Frederic W. Coburn and Ralph T. Hale.

Havard, H.

Van der Meer. Paris, 1883.

Hoet, G.

Catalogus of Naamlijst van Schilderijen, met derzelver prÿzen. 2 vols. The Hague, 1752; vol. 3 by P. Terwesten, The Hague, 1770.

Hofstede de Groot

C. *Jan Vermeer van Delft en Carel Fabritius.* Amsterdam, 1907. A *Catalog Raisonné of the Works of the Most Eminent Dutch Painters of the Seventeenth Century.* 9 vols. London, 1908 ff. See especially vol. 1, pp. 587 ff.

Hyatt Mayor, H.

"The Photographic Eye," in *The Metropolitan Museum of Art Bulletin 5_* (1946): 15–26.

Kemp, Martin

The Science of Art: Optical Themes in Western Art from Brunelleschi to Seurat. New Haven, Conn., 1990.

Kitson, Michael C.

"Florentine Baroque Art in New York," in *Burlington*

Magazine 3 (1969): 409–410.

Koslow, S.

"De Wonderlijke Perspectyfkas: An Aspect of Seventeenth-Century Dutch Painting," in *Oud Holland* 82 (1967): 35–56.

Larsen, Erik

"L'Exposition de la Peinture Hollandaise. Réflexions peu orthodoxes" in *Pictura*, Jan. 1946, vol. 2, pp. 28 ff.

"La Peinture Ancienne. Faux et Vrai," in *La Revue de l'Université Laval,* Québec, Jan. 1949, pp. 392 ff.

"The d'Arenberg Vermeer Redivivus," in *Apollo.* London, Oct. 1955, pp. 102 ff.

Frans Post, Interprète du Brésil. Amsterdam and Rio de Janeiro, 1962. See chap. 4, "Descartes et la Conception Visuelle de la Nature," pp. 75–93.

"Descartes and the Rise of Naturalistic Landscape Painting in Seventeenth-Century Holland," in *The Art Journal* (fall 1964): 12–17.

Rembrandt and the Dutch School. New York, 1967.

"The Proof of the Use of the Inverted Telescope in Dutch Seventeenth-Century Landscape Art," in *Gazette des Beaux-Arts* (May–June 1977):_ 172–74.

with Davidson, J. *Calvinistic Economy and Seventeenth-Century Dutch Art.* University of Kansas Studies 51, Lawrence, Kan., 1979.

Seventeenth-Century Flemish Painting. Freren, 1985.

"Jan Vermeer van Delft and the Art of Indonesia," in *Revue Belge d'Archéologie et d'Histoire de l'Art* 54 (1985): 17–27.

Liedtke, A.

"The View of Delft by Carel Fabritius," in *Burlington Magazine*, Febr. 1976, pp. 62 ff.

Malraux, André

Les Voix du silence. Paris, 1951.

Mirimonde, A. P. de

"Les sujets musicaux chez Vermeer de Delft," in *Gazette des Beaux-Arts* 57 (January–June 1961): pp. 29-50.

Michel, Henri

Les instruments des sciences. Rhode-St. Genése, Belgium, s.d.

Mistler, Jean

Vermeer. Paris, 1981.

Monconys, Balthazar de

Journal de voyage de Monsieur de Monconys, 2 vols. Lyon, 1666.

Montias, J. M.

"New documents on Vermeer and His Family," in *Oud Holland* 91 (1977): 267–87.

Artists and Artisans in Delft: A Social-Economic Study of the Seventeenth Century. Princeton, N.J., 1982.

Vermeer and His Milieu: A Web of Social History. Princeton, N.J., 1989.

Vermeer, une biographie. Le peintre et son milieu. Paris, 1990.

Nash, John

Vermeer. Amsterdam, 1991.

Naumann, Otto

Frans van Mieris the Elder. Doornspijk, 1981.

Peer, A. J. .J. M. van

"Was Jan Vermeer van Delft Katholiek?" in *Katholiek Cultureel Tijdschrift* 2 (1.1946): 468–70.

Plietzsch, Eduard

Vermeer van Delft. Charlottenburg, 1911. 2d ed., Munich, 1939.

Ripa, Cesare

Iconologia, overo descrittione di diverse imagine cavate dall'antichità' e di propria inventione. 1603.

Schwarz, Heinrich

"Vermeer and the Camera Obscura," in *Pantheon* 24 (1966): 170–82.

Sedlmayr, Hans

"Zu einer strengen Kunstwissenschaft," in *Kunstwissenschaftliche Forschungen* 1, Vienna, 1931.
Jan Vermeer- Der Ruhm der Malkunst, in *Festschrift fur H. Jantzen*, Berlin, 1951, pp. 169–77.

Seymour, C.

"Dark Chamber and Light-Filled Room: Vermeer and the Camera Obscura," in *Art Bulletin* 46 (1964): 323–31.

Stechow, W.

"Landscape Paintings in Dutch Seventeenth Century Interiors," in *Nederlands Kunsthistorisch Jauerboek,* 11, 1960, pp. 160 et seq.

Sutton, P. C.

Pieter de Hooch. Oxford, 1980.

Swillens, P. T. A.

Johannes Vermeer, Painter of Delft. Utrecht-Brussels, 1950: At this date, still a most remarkable monograph.

Thienen, F. van.

Vermeer. Amsterdam, 1939.

Ubaldi, Guido

Perspectivae. Pisa, 1600.

Valentiner, W. R.

"Vermeer und die Meister der holländischen Genremalerei," in *Pantheon* 10 (1932): 305 ff.

Vanzype, Gustave

Vermeer de Delft. Paris-Brussels, 1925.

Viator (Jean Pélerin)

De artificiali perspectiva. Toul, 1505.

Vredeman de Vries

Jan, Artis perspectivae formulae._ Antwerp, 1568.

Vries, A. B. de

Jan Vermeer van Delft. Amsterdam, 1939; and subsequent editions after World War II.

Walsh and Sonnenburg

"Vermeer," in the *Metropolitan Museum of Art Bulletin* 31, no. 4 (summer 1973): 17 ff.; followed by Sonnenburg's technical comments.

Wheelock, A. K., Jr.

"Zur Technik zweier Bilder die Vermeer zuge-schrieben sind," in *Maltechnik, Restauro* 4, 84 (October 1978): 242–58.
"St. Praxedis: New Light on the Early Career of Vermeer," in *Artibus et historiae* 7 (1986): 71–89.
Jan Vermeer. New York, 1981, 2d ed., 1988. This author, although prolific, is very unreliable in his attributions.

Wild, A. Martin de

"L'Examen Chimique des Tableaux," in F. E. C. Scheffer, *Mouseion, Office International des Musées* 13–14, 1931.

Wurzbach, Alfred von

Niederländisches Künstler-Lexikon. 3 vols. Vienna, 1906–11. See especially vol. 2 for the entries on Vermeer van Delft and Van der Meer van Utrecht.

Ziloty, Alexandre

La Découverte de Jean van Eyck. Paris, 1941. Important for new viewpoints concerning the early stages of the oil technique.

Index